DIGITAL COLOUR
in
GRAPHIC DESIGN

to
Fiona
Jason
Claire
&
Simon

DIGITAL COLOUR
in
GRAPHIC DESIGN

Ken Pender

OXFORD BOSTON JOHANNESBURG MELBOURNE NEW DELHI SINGAPORE

Focal Press
An imprint of Butterworth-Heinemann
Linacre House, Jordan Hill, Oxford OX2 8DP
225 Wildwood Avenue, Woburn, MA 01801-2041
A division of Reed Educational and Professional Publishing Ltd

A member of the Reed Elsevier plc group

First published 1998

TRADEMARKS/REGISTERED TRADEMARKS
Computer hardware and software brand names mentioned in this book are
protected by their respective trademarks and are acknowledged.

British Library Cataloguing in Publication Data
A catalogue record for this book is available from the British Library

ISBN 0 240 51527 7

Library of Congress Cataloguing in Publication Data
A catalogue record for this book is available from the Library of Congress

Printed and bound in Italy by Vincenzo Bona ⁄ Torino

Contents

Introduction

ike it or not, we live in an increasingly digital world. Many of my generation can still remember, with some nostalgia, winding up the clockwork mechanism of a post-war radiogram housed in its polished mahogany case, then inserting a fresh needle into the pick-up arm, before placing Eddie Calvert's 78 rpm bakelite rendering of *Oh Mein Papa* carefully on the turntable. Who among us then, as we listened to the crackly strains of Eddie's golden trumpet, could have imagined today's roller-blading teenager listening through micro-earphones to Oasis on a CD Walkman clipped to the waistband of their Levi's, while en route to a cyber cafe for a session surfing the Internet!

From the arrival in the shops of the first clunky digital calculators, the pace at which digital technology has permeated every corner of our society has been astonishing. Hard on the heels of the calculator came the digital watch and then something which had a keyboard, like a typewriter, could plug into a TV set and came complete with plug-in cartridges featuring games like *Paddle Ball* and *Brick in the Wall*. From what small acorns do mighty oak trees grow! It is probably not putting it too strongly to say that what seemed then like little more than a novelty gadget signalled the beginning of a new phase in mankind's evolution – an Information Revolution which would be as far reaching in its social and economic consequences as the Industrial Revolution before it. From industry to the financial markets, from education to the media, from health care to military defence and space travel – the list of areas being fundamentally altered is endless.

The power of today's desktop computer is already awesome by comparison with the earliest IBM and Apple

machines and the pace of development continues unabated. Steady growth of the market for hardware is attracting an increasing number of application developers able to offer ever more sophisticated programs, including CAD, 3D modelling, animation and videoediting which, until only a few years ago, would have required investment in an expensive workstation far beyond the means of the average user.

We live in a highly visual world. Most of what we do is supplemented by graphics and images to help convey meaning. An earlier book by the author – *Digital Graphic Design* – was conceived as a DIY guide to the rich array of resources now available to the digital designer and to the use of these resources to create a wide range of graphic effects. Over 300 black and white graphics created with the use of leading edge drawing, painting, photoediting and three-dimensional applications were demonstrated and explained in a monochrome environment. *Digital Colour in Graphic Design* is a DIY guide to the creation of an even wider range of dramatic graphic effects and introduces the additional dimension of colour.

From the earliest origins of graphic design, the importance of colour in the effective communication of a message or an idea – to add emphasis or to clarify complexity – was intuitively recognised. More recently, research has shown that, as well as simply attracting more attention, the correct use of colour leads to higher viewer retention of the graphic message.

The objective of *Digital Colour in Graphic Design* is to use a suite of complementary applications, both vector and bitmap, to demonstrate the evolving potential of digital design. Part 1 deals with the basic principles underlying the use of colour on the desktop, including colour models and the ways in which devices like scanners, monitors and printers handle colour. System calibration methods are covered, as are the many fascinating colour processing features of the leading desktop drawing, painting and 3D applications. The steps to be taken to ensure that an image created on the screen can be successfully converted to printed copy are also explained. Part 2 then expands on the techniques covered in *Digital Graphic Design*, showing how the use of colour greatly extends the range of opportunities for the graphic designer. Advanced techniques are explained using a wide range of examples. Any suggestions on how the contents could be further improved would be welcome ✐

Ken Pender
(kpender@vrv493k.demon.co.uk)

Part 1
Digital Colour
The Theory and the Practice

Light, sight and colour

Working with digital colour

Colour output

1
Light,
sight
and colour

 n the beginning, as the Earth formed 4.5 billion years ago from the condensation of a cloud of primordial cosmic dust and gas, its surface was initially bitterly cold and dark. As the dust slowly settled and swirling gases began to form a primitive atmosphere, the first glimmer of light broke through the gloom to illuminate a landscape torn by earthquakes and volcanoes and ravaged by fierce electrical storms. *And then there was light,* as the Bible says. Since then, the Earth has been illuminated by light from the Sun by day, when it reaches the Earth's surface directly, and by night when it arrives courtesy of reflection from the surface of the Moon. According to scientists, we can expect to continue to enjoy the Sun's generous bounty for several billions of years to come, or until we render the planet uninhabitable – whichever comes sooner!

Light

Visible light is only a small part of the electromagnetic radiation which originates from the Sun, from our own galaxy and from more distant galaxies, subjecting the Earth to continuous bombardment. The electromagnetic spectrum extends from gamma and X-rays through ultraviolet radiation, visible light, infrared radiation, microwaves, and radio waves.

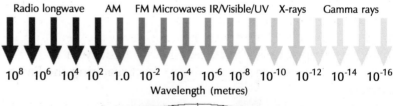

Radio longwave | AM | FM | Microwaves | IR/Visible/UV | X-rays | Gamma rays

10^8 10^6 10^4 10^2 1.0 10^{-2} 10^{-4} 10^{-6} 10^{-8} 10^{-10} 10^{-12} 10^{-14} 10^{-16}

Wavelength (metres)

The Earth is constantly bombarded by electromagnetic radiation, but much of this radiation – including some visible light – is filtered out by the atmosphere before it reaches the Earth's surface

While the Sun appears yellow to us on Earth, a simple rainbow demonstrates, by refracting sunshine through rain water droplets, that the light emitted consists of a continuous spectrum of colours ranging from violet to red. Closer scientific investigation, using a prism instead of water droplets and a spectrophotometer instead of the human eye, shows that the spectrum actually extends continuously beyond the visible colours into the ultraviolet at one extreme and blends into the infrared at the other extreme. Such measurements show that the colours to which our eyes are sensitive have wavelengths in the range of about 300 nm to 750 nm (1 nanometre, or nm, equals one billionth of a metre). Like other forms of electromagnetic radiation, visible light can be characterised in terms of its wavelength and amplitude. The wavelength determines its hue – what the human eye perceives as its colour, e.g. as opposed to , while the amplitude denotes the brightness of the colour.

The visible spectrum

As its spectral distribution curve shows, the reason that the Sun appears yellow is that the intensity of light radiated by its surface gases is a maximum at wavelengths near 500 nm, in the yellow part of the spectrum. The Earth's atmosphere – the gaseous envelope which surrounds the solid body of the planet – acts as a filter to the Sun's radiation, the ozone layer fortunately absorbing much of the harmful ultraviolet radiation, while water vapour absorbs some radiation in the infrared region and at several parts of the visible region. High levels of atmospheric pollution in the vicinity of industrial areas can also reduce the quality of light reaching the Earth's surface.

Light passing through a uniform medium, like space or the Earth's atmosphere, travels in straight lines. This is not the case, however, when it passes, at an angle, from one medium to another with a different refractive index, as in the air to prism example mentioned already, or in the common case of light passing from water to air – an example well known to the spear fishermen of ancient civilisations who went hungry until they learned to aim their spears 'off target'. The Sun is also sufficiently distant from the Earth – 149 591 000 km –

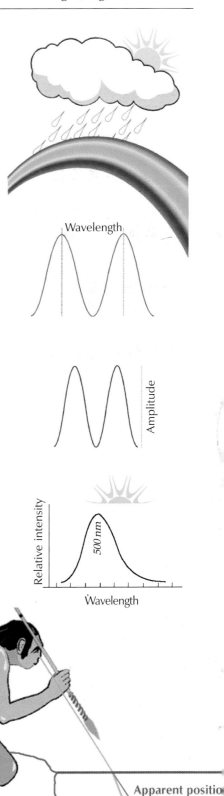

Apparent position

Actual position

Examples of the use of directional lighting

that its rays can be considered to be parallel on arrival and of equal intensity over short, terrestrial distances. The same, of course, is not true of room lights – an example of a class of lights called 'omnilights' – which emit light radially in all directions, with an intensity which falls off with the square of the distance between light source and object illuminated. Dramatic effects can be created in graphics using light from simulated spotlights, which are directional and of variable intensity.

When light strikes the surface of an object, part of the light is turned back from the surface by reflection. The remainder of the light is transmitted into (absorption) or through the material (transmission). If the surface of the object is smooth, then the angle of reflection equals the angle of incidence (specular reflection). If the surface is rough, the reflected light goes off in all directions (diffuse reflection).

Shade and shadow can be thought of as the inverse of light. The surface of an object which is turned away from direct light, receiving only light reflected from other surfaces, is said to be shaded. A shadow occurs when an opaque object prevents light from reaching a surface which would otherwise be illuminated. In the real world, objects are illuminated by direct sunlight, by light reflected from neighbouring objects and by light scattered from dust and other particles present in the atmosphere, producing complex results which are not easy to predict. The summation of all these sources of background lighting is commonly called 'ambient' light. Before creating graphics which attempt to simulate real life lighted scenes, a careful study of photographs can be a source of useful guidance.

Light's electromagnetic waves can 'interfere' with each other in the same way as do the ripples from two stones thrown into a pond. When two ripples are in phase they interfere additively, reinforcing each other; when they are out of phase, they interfere destructively, cancelling each other out. It is this phenomenon which is responsible for the colours seen in soap bubbles. The light waves which reflect off the inner surface of the bubble's soap film interfere with light waves of the same wavelength which reflect off the outer surface of the film. Some of the wavelengths interfere constructively, so that their colours appear bright, while others interfere destructively, so that their colours are not seen. The

same effect causes the colours seen in films of oil on the surface of water. In graphic design, incorrect alignment of the halftone screens used for printing the four process colours can cause undesirable interference between the reflected colours – the moiré effect – but the interference principle can also be exploited positively by overlaying coloured grids to produce interesting effects.

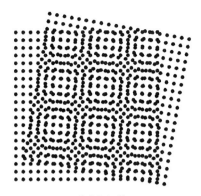

Moiré effect

Light sources and the artist

As life took hold and evolved on Earth, our earliest cave-dwelling ancestors apparently discovered that fire, as well as offering some deterrent to passing predators, provided enough light to paint by, albeit a flickering reddish light, as the spectral output from the relatively low temperature of a wood fire peaks in the red part of the spectrum. Centuries later, artists and sculptors worked by the light of torches made from dried rushes or resinous wood, oil lamps and then candles (beeswax candles were used in Egypt and Crete as early as 3000 BC). The term 'candlepower' was coined to provide a benchmark against which to measure the ability of other sources to give off light and was based on the light emitted by a standard candle. It was not until the early nineteenth century that gas was used to provide street, factory and then domestic lighting, with its characteristic blue glow. The first gas burners were simple iron or brass pipes with perforated tips, but development of the gas mantle, impregnated with cerium and thorium compounds, which became incandescent when heated by the gas flame, produced a much whiter light.

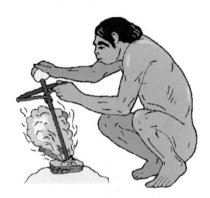

In 1879, Thomas Edison developed a successful carbon filament lamp which evolved into the ubiquitous light bulb, employing a tungsten alloy filament heated to an incandescent 3000 °C. Although operating at a lower temperature than the Sun (the wavelengths emitted by the Sun are close to those of the radiation emitted by a heated source – called a black body source – at a temperature of 5500 °C), the light bulb emits wavelengths across the whole visible spectrum. Today, of course, the common light bulb is being replaced more and more by lighting based on gas discharge technology. Many football matches are now watched in the blue/white light cast by clusters of high intensity arc lights, while motorway interchanges are illuminated by the rather sickly yellow/orange glow of sodium lights. As well as its lower running costs,

The measurement of temperature is based on a theoretical substance called a black body which, when heated, radiates colour from red at low temperature to violet at high temperature. The measurement scale is in degrees Kelvin (K). A 60-watt incandescent light bulb is measured at about 2800 K, a white fluorescent lamp at 4400 K, and midday sunlight is about 5500 K.

fluorescent lighting is generally whiter than that of ordinary light bulbs, as its equivalent black body temperature of 4100 °C is closer to that of the Sun. The interiors of fluorescent lamps are coated with phosphors which glow when excited by cathode rays. The phosphors absorb the invisible but intense ultraviolet components of the primary light source and emit visible light. In fact, if the chemicals in the interior phosphor coating are varied, different light tones – such as the 'plant light' which mimics sunlight – can be produced.

Best known to the public through spectacular 'light shows', the relatively recently discovered laser (light amplification by stimulated emission of radiation) is a device which amplifies light and produces coherent light beams (beams with a single wavelength), ranging from infrared to ultraviolet. Laser light can be made extremely intense and highly directional.

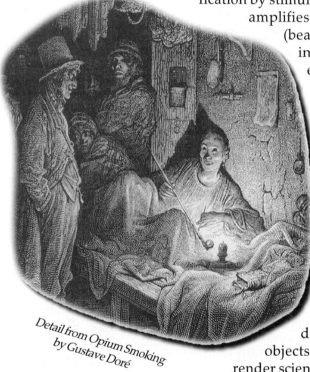

Detail from Opium Smoking by Gustave Doré

The interior lighting conditions experienced (endured is perhaps a more accurate description) by artists over the centuries is reflected in the sombre, even gloomy, nature of much of their work, but their appreciation of the nature and importance of light is also evident in examples such as Gustave Doré's *Opium Smoking* and, of course, in the work of artists like Constable and Turner who produced remarkable works depicting the effects of light and atmosphere. For Claude Monet, the prime exponent of Impressionism, the world was composed not of objects but of a dazzling display of light reflected from those objects, while Georges Seurat even attempted to render scientifically the impressionist perception of light with the use of small dabs or dots of paint in the style which became known as Pointillism. Those who have visited Provence, in the south of France, will also understand why the extraordinary interaction between light and landscape in that region had a compelling attraction for the Impressionists.

The discovery of the photographic process was to prove an important milestone in the understanding and application of light in the design process, directly influencing the work of artists like Degas, who painted subjects in movement, as though captured by a camera lens.

Photographers quickly discovered how the manipulation of the lights used to illuminate a scene could dramatically alter the appearance of the final image. As the technology evolved, the mobility of the camera also allowed the photographer to explore and capture conditions of light and shade which were denied to his fellow artists.

Pointillism

Sight

The eye

Eyes are as varied as the animals which possess them. The eyes of the myriad species which inhabit the planet vary from simple structures capable only of differentiating between light and dark, to complex organs, such as those of humans and other mammals, which can distinguish minute variations of shape, colour, brightness, and distance.

Human vision has the widest colour gamut, that is the widest range of visible colour. It also has the widest dynamic range, capable of discerning gradation in shadow that is one millionth the brightness of the highlights in the field of view.

The psychology of visual perception

Sight – perhaps the most miraculous of the senses, which we sadly tend to take for granted – is a process which in fact takes place in the brain, not in the eye. The amount of light entering the eye is controlled by the pupil, which has the ability to dilate and contract. The cornea and lens, the shape of which is adjusted by the ciliary body, focus the light on to the retina, where receptors convert it into nerve signals which pass to the brain. The function of the eye, therefore, is to translate the electromagnetic vibrations of light into packets of nerve impulses which are transmitted to the brain for interpretation. The retina consists of approxi-

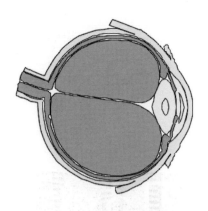

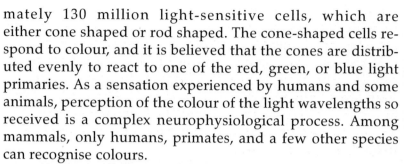

Structure of the human eye

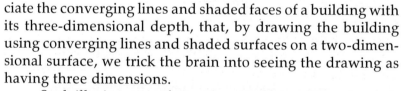

mately 130 million light-sensitive cells, which are either cone shaped or rod shaped. The cone-shaped cells respond to colour, and it is believed that the cones are distributed evenly to react to one of the red, green, or blue light primaries. As a sensation experienced by humans and some animals, perception of the colour of the light wavelengths so received is a complex neurophysiological process. Among mammals, only humans, primates, and a few other species can recognise colours.

Perceptual psychologists believe that, once the nerve impulses have been received and an object has been perceived as an identifiable entity, it tends to be seen as a stable object having permanent characteristics, despite variations in its illumination, the position from which it is viewed, or the distance at which it appears. Thus, an individual viewing a new scene interprets it by synthesising past experience with sensory cues present in the new scene – using depth cues such as linear perspective, partial concealment of a far object by a near one or the presence of aerial perspective 'haze'. Fortunately for the graphic designer, however, the brain can be deceived! Indeed, this deception is the very basis of much graphic design. For example, it is because the brain is conditioned to associate the converging lines and shaded faces of a building with its three-dimensional depth, that, by drawing the building using converging lines and shaded surfaces on a two-dimensional surface, we trick the brain into seeing the drawing as having three dimensions.

Such illusions are of great practical importance in environmental and architectural design and in the theatre, as a means of creating a sense of depth and space in a confined area. The concept has also been carried over to the design of the desktop PC GUI (Graphic User Interface) where subtle shading of buttons on a flat computer screen creates a powerful 3D illusion – which is further reinforced when we click the button and the shading alters in the way that our brain is conditioned to expect. To learn more about graphic illusion, the reader is advised to study the work of the Dutch graphic artist Maurits Corneille Escher (1898–1972) who devoted his life to the creation of an intriguing world of impossible perspectives, optical paradoxes and visual puns.

Illusions are believed to result from the erroneous application of learned depth or colour cues and can occur in

10

nature. I remember well, during a cycling holiday in Ayrshire in Scotland, coming across a famous (but unknown to me) stretch of road called the *Heely Brae*. As all my senses told me that the road was on a downward incline, I sat back in the saddle, expecting to freewheel down the slope. Instead, I found that I quickly came to a stop and had to resume pedalling in order to reach the bottom! The illusion was created by an unusual relationship between the contours of the adjoining hills and hedgerows.

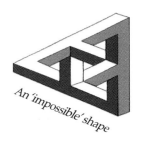

An 'impossible' shape

Illusions are also common in colour perception, notably in the phenomenon called 'simultaneous contrast', in which the appearance of a particular area of colour is greatly altered by changes in its surroundings. This effect is of practical importance in fashion and textile design as well as in graphic design. The relationship of text colour to background colour is also important to ensure legibility. The colour of ambient lighting can also have a significant effect on the way we perceive colour; many readers will have experienced the mysterious change in colour undergone by a sweater wrapped under the fluorescent lights of a store and later unwrapped in daylight!

As individuals, not only do we vary in our description of colour, but our perception of colour is influenced by experiences, memory, and even, research tells us, by the use of hallucinogenic drugs. Research has also shown that certain colours and types of lighting can effect us subliminally. We describe some colours as 'slimming' and some lighting as 'flattering'. We are apparently soothed by a green environment and excited by red, but feel welcomed by a combination of red and yellow, as patrons of MacDonald's will know.

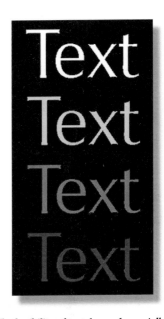

The legibility of text depends crucially on the relative colours of text and background

For average members of the population, differences in how we perceive colours don't seriously affect our lives. In some members of the population, however, defects in the retina or in other nerve portions of the eye can cause colour blindness. Dichromatism – partial colour blindness – is manifested by the inability to differentiate between the reds and the greens or to perceive either reds or greens. Dichromatism is a hereditary condition which affects as many as seven percent of the male population, but a much lower percentage of females. In the realm of commercial printing, differences in colour perception may determine the success or failure of a print job. Being aware of how different factors influence colour perception and determine the appearance of printed colours will maximise the probability of success.

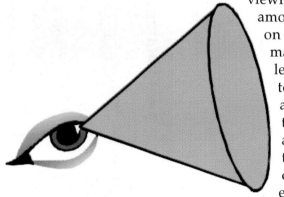

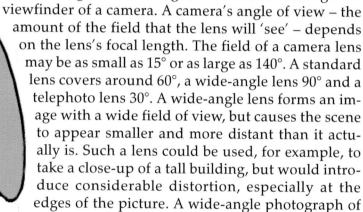

Cone of vision

Stereoscopy and the cone of vision

The fact that nature endowed us with two eyes, which are separated by a few centimetres, means that the objects we view appear slightly different to each eye; this effect provides a sense of depth and can be used, in graphic design, to produce stereoscopic three-dimensional images on a two-dimensional surface.

Experimentation has shown that, if we view a scene with the eyes at rest, then our field of view is defined by a cone – our 'cone of vision' – of angle approximately 60°. This field of view can be thought of as analogous to that seen through the viewfinder of a camera. A camera's angle of view – the amount of the field that the lens will 'see' – depends on the lens's focal length. The field of a camera lens may be as small as 15° or as large as 140°. A standard lens covers around 60°, a wide-angle lens 90° and a telephoto lens 30°. A wide-angle lens forms an image with a wide field of view, but causes the scene to appear smaller and more distant than it actually is. Such a lens could be used, for example, to take a close-up of a tall building, but would introduce considerable distortion, especially at the edges of the picture. A wide-angle photograph of a person with hands reaching out would make the hands appear disproportionately large. Therefore, when creating graphics depicting objects or scenes as they would normally appear in perspective in the real world, it is important to ensure that the objects or scenes fall within the 60° cone unless the objective of the graphic is to create effects similar to those produced by special camera lenses such as the wide-angle or fisheye lenses.

Perspective

As children grow up, observing and interacting with their surroundings, the rules of perspective are learned intuitively, helping the children to understand the world around them. Those of them who choose to become graphic designers, however, need to learn how to translate these three-dimensional rules on to a two-dimensional surface, if convincing results are to be achieved.

Rule 1 Convergence

As parallel lines recede into the distance, they appear to converge at a constant rate.

Rule 2 Foreshortening

Equally spaced objects appear to become closer together, at a constant rate, as the distance from the observer increases.

Rule 3 Diminution

Equal sized objects appear to become smaller, at a constant rate, as the distance from the observer increases.

In addition to being aware of these three rules, the designer of three-dimensional scenes must allow for aerial perspective – whereby atmospheric effects cause distant objects to appear fainter than objects close to the viewer.

Colour

Colour is, of course, simply the way we describe light of different wavelengths. When we see colour, we are really seeing light. When we look around us, the light which enters our eyes does so in three ways – directly, e.g. from a light source such as the Sun or a light bulb, indirectly, by reflection from any smooth reflective surface, or by transmission through a transparent material, such as coloured glass. When we look at an object, the colour it appears to have depends on which wavelengths of the light falling on it are absorbed, reflected or transmitted. A yellow flower is yellow because it reflects yellow light and absorbs other wavelengths. The red glass of a stained glass window is red because it transmits red light and absorbs other wavelengths. The process by which we perceive the colours of natural objects around us can therefore be described as a 'subtractive' process. Subtractive, because the objects 'subtract' certain wavelengths from the white light falling upon them before reflecting and/or transmitting the wavelengths which determine their colour. The colours we see when we look at an original old master depend on the optical properties of the pigments used to produce the original paint employed by the artist and on how these properties may have altered over the centuries since the work was created.

Some of the earliest cave drawings were created using charcoal from burnt sticks mixed with a natural binder such as animal fat, fish glue or the sap from plants, or using natural chalks – white calcium carbonate, red iron oxide or black carboniferous shale. The first 'paint' used by the earliest cave painters was a crude rust-coloured paste made from ground-up iron oxide mixed with a binder.

Colour was introduced to early three-dimensional works of art by applying coloured pieces of glass, stone, ceramics, marble, terracotta, mother-of-pearl, and enamels. Although mosaic decoration was mainly confined to floors, walls and ceilings, its use extended to sculptures, panels, and other objects. Tesserae – shaped pieces in the form of small cubes – were embedded in plaster, cement, or putty to hold them in place.

By the time of the Ancient Egyptians, the artist's palette of colours had expanded to include pigments predomi-

nantly made from mineral ores – azurite (blue), malachite (green), orpiment and realgar (yellow), cinnabar (red), blue frit and white lead. Additional pearly or pastel-like colours offered by gouache – a form of watercolour which uses opaque pigments rather than the usual transparent water-colour pigments – were also developed by the Egyptians. The wall paintings of ancient Egypt and the Mycenaean period in Greece are believed to have been executed in tempera – a method of painting in which the pigments were carried in a medium of egg yolk. The Romans added to the palette the blue-purple organic pigment indigo, extracted from the Indigo plant, as well as Tyrian purple and the green copper oxide, verdigris. Many years later, the thirteenth century saw the introduction of lead tin yellow, madder (red), ultramarine (blue green) and vermilion (red).

In contrast to the older water-based media, such as fresco, tempera and watercolour, oil paints, developed in Europe in the late Middle Ages, consist of pigments ground up in an oil which dries on exposure to air. The oil is usually linseed but may be poppy or walnut. In the late eighteenth century the Industrial Revolution boosted the palette with chromes, cadmiums and cobalts, but it was not until the following century that paint consisting of prepared mixtures of pigments and binders became commercially available on a wide scale.

In parallel with the gradual evolution of the types and colours of paint available to the artist, inks used for printing also evolved. Lampblack – a black pigment produced by the incomplete burning of hydrocarbons – was in use in China as early as AD 400.

For many centuries, black was the accepted colour for woodblock printing, with decorative colour being added by quill pen. Early letterpress printing used inks composed of varnish, linseed oil, and carbon black. In the eighteenth century the first coloured inks were developed and in the nineteenth century a wide variety of pigments were developed for use in the manufacture of these inks. Manufacture of modern printing inks is a complicated process often using chemically produced rather than natural pigments and containing as many as fifteen separate ingredients, including modifiers or additives and dryers which control appearance, durability and drying time.

Simple colour models

Although the spectrum contains a continuous range of visible colours, it can be broken down into three colour 'regions' – red (and its neighbouring colours), green and its neighbours, and blue and its neighbours – each region representing one-third of the visible spectrum. Conversely, when colours within these same three regions are projected on top of one another, white light is recreated. Early optical experiments also showed that if only two of the three regions overlapped, a totally different colour was created – red and green producing yellow; red and blue producing magenta; green and blue producing cyan. Because the red, green and blue combine to produce white light, they became known as additive primaries. Because the yellow, magenta and cyan were formed by taking away, or subtracting, one of the three additive primaries, they were called subtractive primaries. The figure below right summarises the interaction of the subtractive primaries. The two figures are crude colour 'models' – methods of representing the relationship of primary colours within the spectrum.

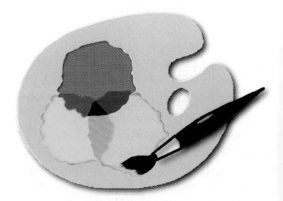

Subtractive colour model

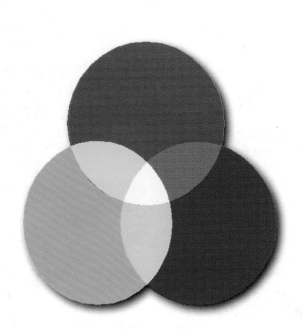

Additive colour model

The colour wheel is a more helpful model, displaying the compositional relationships between the spectral colours. Mixing any two of the primaries produces a 'secondary' colour which appears midway between them on the wheel. Further subdivisions can be created by continuing to mix adjacent colours. Opposite colours on the wheel are complementary; placed side to side, they produce a harmonious result, but mixed together, they effectively cancel out. A number of pairs of pure complementary spectral colours also exist; if mixed additively, these will produce the same sensation as white light. Among these pairs are certain yellows and blues, greens and blues, reds and greens, and greens and violets.

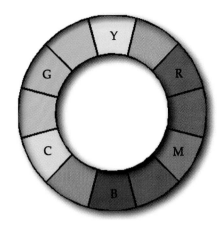

Colour wheel

As well as describing colour in terms of the visible spectrum, it can be described in terms of three characteristics – hue, lightness, and saturation. Hue is the name of the colour, such as red or orange; lightness (sometimes called value) indicates the darkness or lightness of a hue – in other words, how close it is to black or white; saturation (also called chroma) refers to the spectral purity of the hue, described using terms like vividness or dullness. The figure on the right shows a representation of the three variables. Hue is represented by angular position around the circle; saturation increases radially from the centre of the circle outwards; lightness, or value, is represented by positions along the vertical scroll bar.

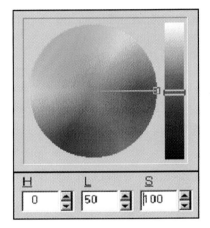

HLS model

Tints, shades and tones

The relationship between tints, shades and tones is best explained by reference to the HLS model. The hue values range from 1° to 360° – equivalent to settings on a colour wheel – where 0° is the same as 360°. The hue values for primary colours are red (0°), yellow (60°), green (120°), cyan (180°), blue (240°), and magenta (300°). The standard setting for a hue is 50% lightness and 100% saturation. If, for example, pure red (R255, G0, B0) is highlighted in the palette, the HLS values display hue 0°, lightness 50%, and saturation 100%.

The hue setting selects a starting colour value. Varying the lightness value adds a percentage of white or black to the hue. Increasing lightness adds white, producing a 'tint' of the selected colour; decreasing lightness adds black, producing a 'shade' of the selected colour.

Tints
(adding white with H and S constant)

Shades
(adding black with H and S constant)

Tones
(adding grey by decreasing S while keeping H and L constant)

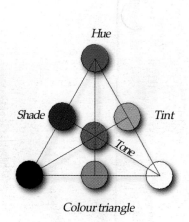

Colour triangle

A pure colour has a saturation value of 100%. Decreasing saturation, while keeping lightness constant, adds grey to the colour, reducing its purity and producing a 'tone' of the colour. A continuous tone image – e.g. a colour photograph – is one in which colours and shades flow continuously from one to another.

The relationship between tints, shades and tones can be summarised in a colour triangle. Tints offer the designer a range of subtly different variations around a single colour in one pass though an offset press, while two colour printing extends the possible variations to shades and tones. Varying the brightness and saturation of object surfaces within a graphic design also provides a simple means of creating the illusion of depth or distance ↗

2

Working with digital colour

nderstanding light and colour is at least as important to the serious digital designer as it was to his traditional counterpart. It could even be considered more important, in the sense that the digital designer is virtually 'painting with the colours of light'. The diagram below summarises the process by which the digital designer captures the image of an object for inclusion in a composition, works on the composition while viewing it on a monitor screen and then outputs the result to a printer. Understanding this colour reproduction process, with all its limitations and conversions, is important if unexpected and disappointing results are to be avoided.

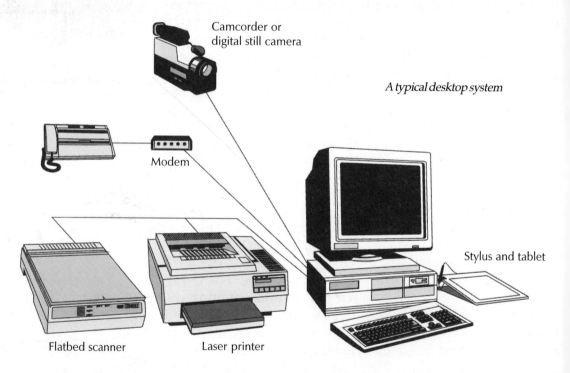

Camcorder or digital still camera

A typical desktop system

Modem

Stylus and tablet

Flatbed scanner

Laser printer

Colour reproduction

Camera

A key element of many graphic projects is a photographic image captured with a conventional optical camera. Light reflected from the object or scene passes through the camera's aperture and lens system and impinges on the

surface of the light-sensitive film placed in the camera's focal plane. Colour film has three layers of emulsion on a cellulose acetate base. Each of the three layers is sensitive to only one of the primary colours red, green or blue. The emulsions are thin, gelatinous coatings containing light-sensitive silver halide crystals in suspension. When exposed to light, each emulsion reacts chemically, recording areas where its particular colour appears in the scene and forming a latent image on the film. When the film is developed, particles of metallic silver form in areas which were exposed to light and each emulsion releases a dye which is the complementary colour of the light recorded – blue light releases yellow dye, green light releases magenta dye and red light releases cyan dye. Complementary colours are used because they reproduce the original colour of the scene when the film negative is processed to produce the final colour print or transparency. Because the sizes of the silver halide particles in the film emulsion and the silver particles formed during the development process are very small, the resolution of detail in the final image is very high. To the unaided eye, the image appears to have continuous tone, with colours blending smoothly from one to another. Only when the image is considerably enlarged does the 'graininess' of the particles become visible.

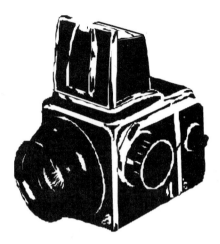

A conventional optical camera

Scanner

The principles underlying the operation of drum, flatbed, sheet feed or hand-held scanners are essentially the same. To use a typical flatbed scanner, the photograph or transparency to be scanned is placed face down on the scanner bed or transparency attachment and the cover is lowered on top of it. A light source inside the scanner, running the full width of the bed, then traverses the image. Light reflected from the image passes via a lens and a series of mirrors on to an array of CCD (Charge Coupled Capacitor) devices which also span the full width of the bed. A CCD is a semiconductor chip – usually silicon – the surface of which has been doped to make it light sensitive. The light reflected from the source image impinges on the surface of the chips and is converted into electrons in numbers proportional to the intensity of the light beam. The resulting changes in voltage across the chip are then amplified and converted to an analogue 'picture' of the image. In order to detect the colour information in the image, rather than just the intensity variations,

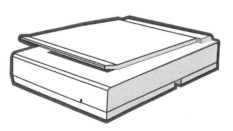

A flatbed scanner

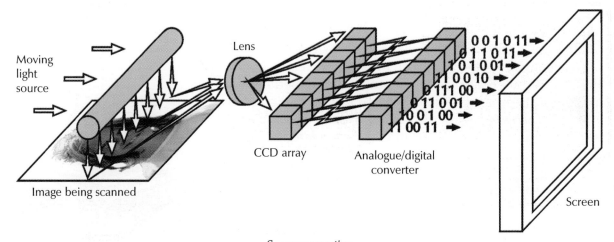

Scanner operation

the reflected light is sampled, in turn, via red, green and blue filters, so that intensity variations are recorded separately for each of the three primary colours. After RGB separation, an analogue to digital converter converts the analogue picture of the image to a digital one before passing it to the PC. A black and white scanned image is considered to be only '1 bit' deep because all the information (on or off, black or white, 0 or 1) to describe each of the dots in the image can be stored in a 1-bit number (2^1). A greyscale image is considered to be 8 bits deep because to store the information to describe 256 (2^8) levels of grey, 8 bits of information must be stored for each dot. A full colour scan requires 8 bits for each of the three primary colours red, green and blue and is therefore 24 bits deep, i.e. the scanner records 24 bits of information for each dot (2^{24}).

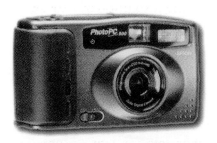

Digital camera

The role of the conventional scanner is likely to be taken over increasingly by the fast evolving digital camera which operates using the same CCD technology as the scanner, but receives and digitises light from a scene via a conventional optical camera 'front end'. Digitised images are saved to an internal disk and can be downloaded directly to a PC for processing. Prices are still high for cameras capable of producing high resolution images, but will undoubtedly fall rapidly as the technology is applied to the consumer market.

Monitor

A colour monitor has a screen coated internally with three phosphors capable of emitting red, green or blue light when excited by an electron beam. The phosphors are laid down in bands (trinitron tubes) or patterns (shadow mask tubes). To illuminate the phosphors and produce spots of colour, the cathode ray tube contains three electron guns – one for each of the three phosphors. As the three electron beams track across the screen (from left to right and top to bottom, as in a normal TV tube, they cause red, green and blue light to be emitted

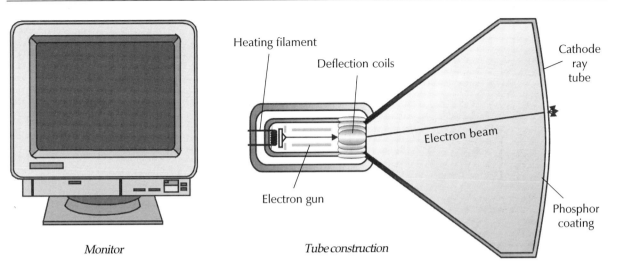

Monitor Tube construction

from phosphor dots so close together and so small that the colour seen on the screen is the addition of light from all three dots. Instead of seeing this moving dot of coloured light, persistence of vision deceives the viewer's eye into seeing the coloured screen image built up by the moving spot. To create colours such as orange or yellow, the three 'primary' colours are mixed together in varying degrees by independently controlling the intensities of the electron beams and, therefore, the intensity of the light emitted by the phosphors. As the intensity of each beam can be varied in steps from 0 to 255, the number of possible colour combinations for the combined spot = 256 256 256 = 16.7 million – a palette which our artistic predecessors would have killed for!

For serious graphics work, at least a 17" – and preferably a 21" – non-interlaced monitor is recommended. The ability of a monitor to display colours depends critically on the graphics adapter card which drives it. To display graphics at an ideal working resolution of 1024 768 in 24-bit 'photorealistic' colour on a 21" monitor requires a card with 4 Mb of on-board video memory and appropriate software drivers. For many graphic design tasks, however, an acceptable compromise is a 17" screen operated at a resolution of 800 600 in 16-bit colour.

Desktop printers and the offset press

Colour printing systems are based on the subtractive colour model, mixing the subtractive primaries, cyan, yellow and magenta, to produce other colours. Unfortunately, the reflective properties of printing inks are affected by impurities and experience showed that printing black, which should theoretically be possible by combining cyan, yellow and magenta, produced instead a muddy brown. To overcome this, most colour printers include black ink as a fourth 'colour' in the print process. As well as allowing correct printing of black, this results in improved shadow density and overall contrast. The nineteenth-century discovery of the halftone process showed how the juxtaposition of small enough dots of cyan, yellow, magenta and black inks could produce an image which, to the naked eye, would appear to produce continuous tones, colours being produced not by the physical mixing of the inks, but in the optical mixing of primary colours by the viewer's eye. The majority of

Halftone dot pattern

modern low resolution desktop printers use this principle, laying down dots in various 'dither' patterns to produce colour output ranging from crude – with the dot pattern clearly visible – to a quality verging on photorealistic.

In the offset process, the dot pattern is created by photographing the original artwork through a halftone screen. To separate a full colour image into yellow, magenta and cyan, it is necessary to photograph the copy three times, through filters which are the same colour as the additive primaries – red, green and blue. When the copy is photographed through the red filter, green and blue are absorbed and the red passes through, producing a negative with a record of the red. By making a positive of this negative we will obtain a record of everything that is not red, or more specifically, a record of the green and blue. The green and blue, as we have seen earlier, combine to produce cyan; therefore, we have a record of cyan. The process is repeated, using a green filter to produce a record of magenta and using a blue filter to produce a record of yellow. As each filter covers one-third of the spectrum a record of all the colours in the original copy has been created. Finally, to improve shadow density and overall contrast, a black separation is made by using a yellow filter. When printed with the subtractive colours – cyan, yellow and magenta – plus black, all the colours and tones of the original are reproduced.

Please see Chapter 3 for a more detailed description of printer types and techniques.

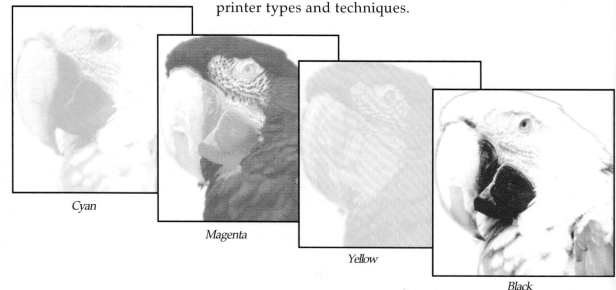

Cyan

Magenta

Yellow

Black

Separation of image into CMYK components

As the above summary shows, scanners and colour monitors use a different colour model to describe colour from that used by cameras, desktop printers and offset presses As colours move from the original image through the camera and transparency via the scanner to the computer screen and then on to the desktop proofing printer and, finally, to the printing press, they are converted from one colour model to another several times.

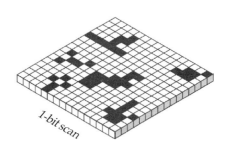

1-bit scan

Colour depth and colour modes

Colour depth, sometimes called bit depth, refers to the maximum number of colours which can be stored in an image file. A 1-bit file stores two colours (usually black and white) and can be described as 1-bit deep since all the information required to specify each of the dots making up the image can be stored in a 1-bit number (0 for black or 1 for white). A 2-bit file stores four colours, a 4-bit file stores 16 colours, an 8-bit file stores 256 colours and a 24-bit file stores 16 million colours. A greyscale image is an 8-bit file, with 254 shades of grey plus black and white. The greater the colour depth of an image, the more space it takes up on disk. A number of applications now use 32 bits to specify the colour of each pixel in an image. The extra 8 bits are used to describe the transparency of the pixel in 256 steps from completely transparent to completely opaque.

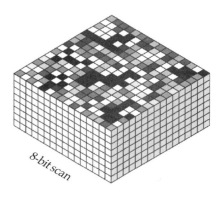

8-bit scan

A colour mode determines the colour model (see below) used to display and print compositions. The most commonly used modes are Greyscale, for displaying black-and-white documents, RGB, for displaying colour documents on the screen and for printing slides, transparencies, and RGB colour prints, CMYK, for printing four-colour separations and L*a*b for working with Photo CD images. Other modes are Bitmap, and Indexed colour.

Colour mode is specified when a new painting or photo editing process is started, but can be altered midway through the task or when saving or exporting the finished work. If the original image has many colours, and it is converted to a lower colour depth (e.g. 24-bit RGB colour to 256 colours), the file will create a palette of colours and use combinations of these to simulate the original colour of each pixel. The colours in the palette will be derived from the colours in the original image. Indexed colour files are much smaller and easier to manipulate than 24-bit files and can provide a very

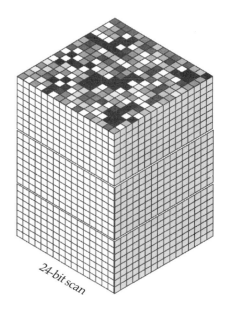

24-bit scan

SHADES VERSUS BIT DEPTH		
1 bit	2^1	2 shades (B or W)
2 bit	2^2	4 shades
4 bit	2^4	16 shades
8 bit	2^8	256 shades
16 bit	2^{16}	65 536 shades
24 bit	2^{24}	16 777 216 shades

good colour approximation if the number of colours in the original is limited. Indexed colour images are widely used for multimedia animation applications. Another common reason for changing the mode of an image – from RGB to Greyscale – would be to preview the work before printing to a monochrome printer.

Monitors and graphic display cards vary widely in their capacity to display colour. At the most basic level, a monochrome display and its card can only vary the moving spot on the screen between black or white, displaying a 1-bit image. A low-end colour monitor/card combination can display images 8 bits deep, i.e. made up of 2^8 or 256 colours. Moving up the range, an image which approaches 'photorealistic' colour requires 8 bits of information for each of the three primary colours, red, green and blue, making it 24 bits deep. If converted to CMYK format, the same image becomes 32 bits deep, as 8 bits are required now for each of four colour channels.

Colour models

Each device type is associated with a specific colour space – an imaginary three-dimensional space enclosing all the colours which the device is capable of reproducing and defined by means of a coordinate system. There are several digital colour models which can be used to define these colour spaces. Such models, which, like colour matching systems, are supplied with most drawing and painting applications, provide an interactive means for the designer to explore colour space and to specify colours for a project with great accuracy. Two of them (the RGB and CMYK models) also describe the means by which mechanical devices reproduce colour.

The RGB model

An additive colour model in which three primary colours of light (red, green and blue) are combined in varying intensities to produce all other colours. An additive colour model is used for any colour system which mixes light to generate colours, including monitors, desktop scanners and film recorders.

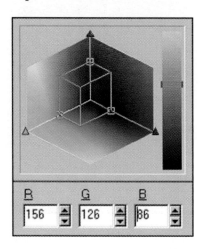

RGB model

CMYK model

The CMYK model

A subtractive colour model producing colour when light is reflected off an object or surface. The reflected light determines what colour we see when we look at that object. A perfectly white surface reflects all wavelengths of light. A black surface absorbs all wavelengths. The three primary colours in the subtractive colour model are cyan, magenta and yellow. In theory, combining all three primaries produces black. In practice, impurities in the ink pigments degrade the black to a muddy brown, as mentioned earlier. To resolve this, black is added to the model. The K designation represents the black component of the CMYK model. This is the model used for colour systems which use reflected light to generate colours, including desktop printers and the printing presses.

The HSB model

This mode approximates the way in which the human eye perceives colour. Colour is defined by three components – hue, saturation and brightness. Hue refers to the name of the colour, for example red. Saturation defines the intensity of the colour, i.e. how vibrant the colour is. Brightness defines the lightness or darkness of the colour.

The HLS model

Similar to the HSB model, the HLS model contains three components – hue, lightness and saturation. The lightness component is similar to the brightness component in the HSB model. Hue and saturation are the same as in the HSB model.

L*a*b model

Based on the original CIE (Commission Internationale de l'Eclairage) model, the L*a*b model is based on the way the human eye perceives colour. It contains a luminance (or lightness) component (L) and two chromatic components – the 'a' component (green to red) and the 'b' component (blue to yellow).

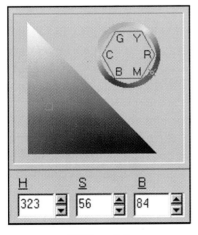

HSB model

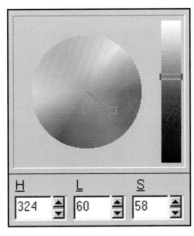

HLS model

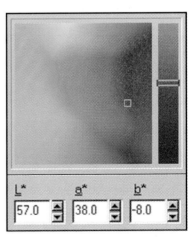

*L*a*b model*

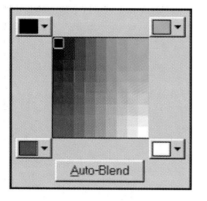

Custom Palette

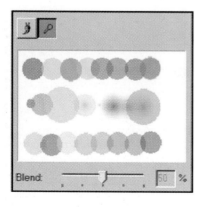

Colour blending dialog box

Colour mixing palette

The digital palette

For many centuries, a tedious but essential part of the preparation of the traditional artist before beginning a new project was the mixing of paints, from the limited number of pigments available. Once mixed, the colours could be applied directly to the canvas or other medium selected for the work in hand, or could be first blended, lightened or darkened on the surface of the artist's palette. Testing how a colour, or blend of colours, would appear on canvas was a simple matter of applying paint to a test sample.

By comparison, the digital artist is spared the tedium of mixing colours and enjoys the advantage of having literally millions of choices, selectable from any of the colour models described above. Specific colours selected from any of these models can also be stored on a custom palette which can be saved with the project in which the selected colours have been used; this ensures ready availability of the correct colours if further work on the project is necessary, or if the same colour set is required for use on a related project. Such palettes can also include selected spot or process colours dragged from any of the colour matching systems described below, as well as colours mixed using either a colour blender or mixed by hand. While the colour blend is limited to a maximum of any four colours in the blend, the mixing area is unlimited in the number of colours used. The mixing area emulates an artist's palette on which colours can be blended using a brush tool. By varying the blend setting in the mixing area, extremely subtle variations in colour can be achieved. Any bitmap can be loaded into the mixing area, permitting further choice of colours from photographs or drawings.

For projects being composed for the screen – for example, those to be transmitted via the Internet for viewing on the screens of other users – the designer can be reasonably confident that the colours seen on the screens of the other viewers will closely approximate those used to create the original (such variations that do occur will be caused by slight variations in phosphors used by different screen manufacturers, variations in brightness and contrast adjustments from screen to screen, variations in background lighting conditions and so on).

For projects being composed for printing to a desktop printer, or for separating and printing on a four colour offset

28

press, the situation is very different. As we have seen, within the digital publishing process, colour is device-dependent, i.e. the output colour at each stage of the process depends on the device (scanner, monitor, printer, or press) which produces it, and device colour output is based on different models (scanner and monitor colour output being additive, while printer and press colour output are subtractive). To make matters worse, the devices involved have progressively diminishing colour-reproduction capabilities. The human eye discerns a wide colour spectrum, while a colour monitor displays only a fraction of those colours, and a desktop printer or printing press reproduces even fewer. The colour gamut – the range of colours which can be reproduced – of each device is provided by the manufacturer in a file called a device profile. Colour publishing, therefore, presents the designer with something of a challenge!

Fortunately, help is at hand and the challenge can be met in different ways, depending on the nature of the design project, by using colour matching systems and/or colour management systems, which are explained below.

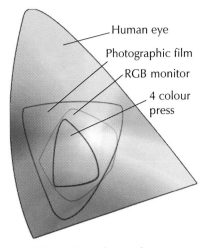

Comparison of spectral ranges

Colour matching systems

Spot colours

The principle behind colour matching systems is most easily explained by using a simple example like spot colour. Spot colours are opaque printing inks created by ink manufacturers like Pantone in an assortment of hundreds of pre-defined, pre-mixed hues. The designer (and client, where appropriate), can select spot colours to be used in a project from a swatch book of samples provided by Pantone. The designer then simply selects the agreed colours on screen from a proprietary Pantone Spot Colour Matching System (supplied with most drawing or painting applications). By selecting and assigning a spot colour (e.g. Pantone 507 CV) to elements of a composition and by specifying the corresponding Pantone 507 CV ink for colour printing the same elements in the final work, the designer can be assured that the colour will print as it appears on the swatch, regardless of how it appears on screen or on the output of a proofing desktop printer. (Note that the palette dialog box displays the CMYK values corresponding to the spot colour selected, which implies that the same result could be achieved by four colour printing, but

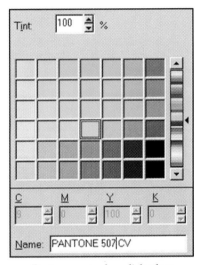

Pantone spot colour dialog box

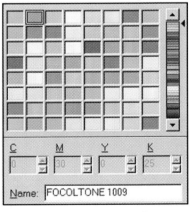

Focoltone spot colour palette

Swatch book

overlaying opaque spot colours can produce unpredictable results and is not recommended.) Once a spot colour is selected in the palette dialog box, a tint of the colour can be selected by choosing a percentage in the Tint window. The range of spot colours includes some – e.g. gold or silver – which could not be reproduced by combining the four basic CMYK inks.

FOCOLTONE is an alternative spot colour system which provides a range of spot colours built from the process colours, cyan, magenta, yellow and black. The colours in the palette are organised so that the user can easily choose pairs of colours with at least 10% of a process colour in common, minimising the need for trapping and making it an ideal system to use for colour separation.

Process colours

Process colour is the collective name given to those colours which can be created by combining the four standard printing inks – cyan, magenta, yellow and black. Process colour inks are largely transparent, incident light passing through them and then reflecting back off the paper into the eye of the viewer. This transparency is what makes four colour printing possible and predictable. Like spot colours, process colours can be pre-selected from a paper swatch and then specified by the designer, using a process colour matching system. When a colour is selected from the Pantone System palette – e.g. Pantone S146-2 – the CMYK percentages which will be used to print the colour are displayed below the colour name. Other proprietary colour matching systems based on process inks include the following.

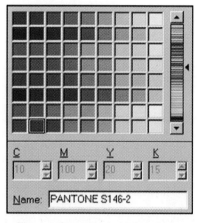

Pantone process colour dialog box

TRUMATCH (the palette of which organises colours according to the principles of the Hue, Saturation, Brightness model)

DuPont's SpectraMaster, with colours based on the L*a*b colour space, printed by means of colours available through the DuPont solid colour library

Toyo, which consists of colours available through the Toyo Colour Finder system. These colours are defined using the L*a*b colour space and are shown as CMYK for display. The colours offered include those created using TOYO process inks

Dainippon's DIC palette, which is arranged into categories – gay and brilliant, quiet and dark, greys and metallics, basic – available through the DIC Colour Guide and created by mixing DIC brand inks

So, when the designer is preparing a four colour printing job, specifying colours from a process colour matching system will ensure that these colours print as expected during the subsequent print run. The use of specified process colours ensures that a chosen colour is never out of gamut and helps to ensure consistency of colour reproduction within a publication and from one publication to another.

> **COLOUR GAMUT**
> The gamut of a colour system is the range of colours which it can display or print.

Colour management

While a colour matching system gives the assurance that selected colours will print correctly on an offset press, it does nothing to help with the problem of those colours appearing quite differently on screen or when printed from a desktop proofing device. Neither does it do anything for the accurate colour reproduction of bitmapped images – e.g. scanned photographs or images created in a painting program – to be included within a project. A desktop system typically includes a scanner, a monitor and one or more printers. As stated earlier, these devices do not reproduce colour consistently from one to the next, each device reproducing or displaying a limited set of colours called its colour gamut. Also devices from different manufacturers will display different colours for the same digital colour data; even two devices of the same model may display subtle colour differences using the same colour data.

> **DEVICE PROFILE**
>
> A device profile is a file which contains a description of the colour gamut of the device. Profiles may be provided on software accompanying the device or may be downloaded from the manufacturer's bulletin board. Alternatively, colour management systems usually provide profiles for a wide range of devices from which the user can select.

Colour management systems

Colour management systems are designed to address the problem of device variability, adjusting the colour relationships between devices to ensure consistent colour throughout the publishing process. A CMS translates colours from the colour gamut, or colour space, of one device into a 'neutral' device-independent colour space, and then fits that colour information to another device's colour gamut by a process called colour mapping. The CMS obtains the colour characteristics of each device from its device profile. In one

A loupe – useful for close inspection of printed colour

method, the relationship between colours is preserved as they are shifted into the device's colour gamut. In another method, only the out-of-gamut colours are replaced by colours that the device can produce, without preserving the relationships between the colours.

Profiles for the most popular devices are usually supplied with the CMS software and those matching the devices on the user's system are installed at the same time as the CMS software. Profiles for other devices are usually supplied with the device installation software. Manufacturer's device profiles are based on a particular set of calibration settings for a given device. To use a colour management system effectively, devices first have to be calibrated to match the expected performance defined in the device profile. The quality of the final result depends on how well the devices match their profiles.

Calibration

There are various methods and techniques used for calibration of devices, the necessary instructions and software often being bundled with a CMS or with individual application programs. The following provides an overview of the calibration process.

Scanner target sheet

Since a scanner's light detectors are affected by prolonged use, the RGB output signals will vary over time, affecting colour balance and linearity. This means that updating the scanner's profile is needed, from time to time, by recalibration of the scanner. Scanner calibration requires a target sheet of colour swatches and a data reference file, both supplied by a vendor. The target sheet is first scanned to produce a TIFF file of the scanner's output, and software then compares the values in the TIFF file with the values in the data reference file. Any differences which are detected are then used to update the profile for the scanner.

Like the output of CCDs in a scanner, the output characteristics of a monitor's phosphors can change with time. Monitor output is also subject to a second set of variables related to environmental conditions, like the characteristics of ambient lighting. Calibration of a monitor involves adjust-

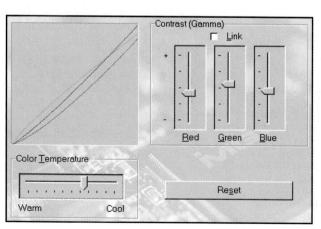

Monitor calibration dialog box

ment of the gamma values for red, green and blue, and the white point value. The chromaticity may also need to be adjusted, but this is generally not required. Adjustments can be made by sight, comparing output to a target photograph, or can be made with the use of measurement devices such as a colorimeter or a spectrophotometer.

During normal use, the output of a printer will vary as colorants – for example, inks or toners – are consumed. Colorants also vary slightly in their purity from batch to batch. To compensate for these factors, occasional recalibration of the printer is needed to keep its profile up to date. The simplest calibration method involves printing a target file and scanning it through a calibrated scanner, providing the information needed to update the printer profile. A more accurate method involves printing a target sheet and then measuring each colour swatch on the sheet with a spectrophotometer. The results, which are typed into a measurements file, are used to adjust the TAC (Total Area Coverage) and K-curve (black Keyline curve). Software controls adjust the amount of ink transferred to the paper (TAC) and the amount of grey component replacement or undercolour removal (K-curve shape).

Spectronic Genesys spectrophotometer

The work environment

The way colour appears on a monitor or on the output from a proofing printer is influenced by factors in the work environment. For average, day-to-day colour projects, these factors are not critical, but if high quality, accurate and consistent colour reproduction is to be assured, then certain precautions need to be taken.

The walls and ceiling of the work area should be painted in a matt, neutral coloured emulsion such as pale grey to minimise any interference by the background with the perception of either monitor colour or printed colour.

Control of workstation environment is important in ensuring consistency of results

Ambient lighting should be controlled. Changing sunlight through windows will change the way colours appear on screen. Artificial lighting – ideally 5000 K lighting – provides a more consistent ambient, eliminating the yellow cast from normal fluorescent lighting. The light intensity should be comparable with that of the monitor.

Operating systems for the PC or the Mac permit the use of patterns and bright colours on the virtual desktop. Use of

these should be avoided as they may interfere with accurate perception of the colours in a working project.

Installing a colour management system

The simplest procedure for installing a CMS involves simple step-by-step guidance such as that provided by Corel's CMS 'Wizard'. Prompted by a series of Wizard screens, the user has only to respond to step-by-step guidance:

Choose one from three alternative colour mapping methods. (i) Photographic mapping which maintains the relationship between colours and is recommended for printing photographs and illustrations with continuous tone, (ii) Saturation mapping which expands or contracts the source gamut to fit the destination gamut and is recommended for printing business graphics, (iii) Automatch, which automatically detects the type of image to be printed and selects Photographic or Saturation mapping accordingly.

Choose a scanner profile from a dropdown list to match the scanner in use. The scanner profile is needed so that the CMS can measure the variance between the scanner's output and a set of fixed reference values. This is essentially software calibration of the device to a standard.

Choose the appropriate monitor manufacturer and model number from the lists displayed in order to select the corresponding monitor profile.

Finally, choose the appropriate output printing device from a list displayed to set up the correct printing profile. After this final choice is made, the CMS proceeds to set up a system profile based on the choices made.

In circumstances where more than one scanner or more than one output device is being used, different system profiles can be created for each combination. The appropriate profile is then selected at the start of each new project. After creating a publication using a CMS, original photographs, proofs and the final printed publication can be used as references to assess how well the process has worked and to indicate the need for any further fine tuning. (At each stage of the process described above, the CMS provides interactive means of making adjustments to the individual device profiles.)

CorelDRAW's CMS Wizard provides help with the calibration process

Scanner calibration

Monitor calibration

Printer calibration

CMS and Kodak Photo CD

One of the most important sources of high quality photographs for use by the graphic designer is the Photo CD, which is based on a process developed by Eastman Kodak. The process converts 35 mm film negative or slides into digital format and stores them, in the Photo CD Master format, on a CD in a range of five different resolutions (the Photo CD Master Pro format has six) ranging from Poster size – 2048 3072 pix els – through Large (1024 1536 pix els), Standard (512 768 pixels), Snapshot (256 384 pix els) to Wallet (128 192 pix els). Using a utility such as Corel's Photo CD Lab, once an image has been loaded into a viewing area, it can be 'pre-processed' by making selections from a menu covering rotation angle, resolution, number of colours and format, e.g. BMP, EPS, PCX or TIF.

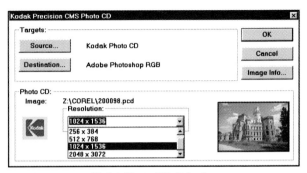

Kodak Photo CD dialog box

Because of the popularity of the format, many applications now include a CD reader which can access Photo CD files directly. In the Picture Publisher reader, for example, a dialog box allows specification of parameters for the image to be opened. The Corel reader provides two alternative colour correction methods – Gamut CD and Kodak – to permit colour correction to a Photo CD ROM image before importing it into PHOTO-PAINT or CorelDRAW. GamutCD uses gamut mapping to enhance the colour fidelity and tonal ranges of the image which ensures that the colours in the image can be reproduced by a printer. Kodak Colour Correction allows adjustment of brightness, contrast, colour tints and colour saturation.

Corel's Photo CD Lab dialog box

Before importing a CD, most readers provide the option of applying colour management to the image to ensure that it will print correctly to the specified output device. Many Photo CDs come with a device profile for the scanning device used to create the bitmap images on the Photo CD. This profile should be specified as the CMS source when importing.

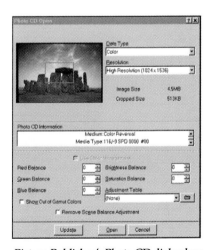

Picture Publisher's Photo CD dialog box

Applying colour

As we have seen, digital designers and artists have at their disposal a vastly greater choice of colours than were available to their traditional counterparts. As the earliest digital applications emerged, the objective of the developers was to provide tools and techniques which allowed application of colour in ways which mimicked the traditional pencil or pen, the only variation possible being the thickness of the stroke. From these early beginnings, the ingenuity of developers – and the healthy competition which exists between them – has extended the range of tools and techniques dramatically in the matter of only a few years, as the following summary shows.

Applying colour in drawing applications

Lines

After using a line tool to create a straight, freehand or Bezier line and setting its width, colour can be selected from any of the spot or process colour matching systems described earlier or indeed from any of the colour models or mixers. Using the HLS model, tints, shades or tones can then be applied. Macromedia Freehand makes the job of selecting tints even easier by providing a convenient tint option within its colour mixer box; the tint required can be applied by simply be dragging and dropping the required tint swatch on to the line to be tinted. As well as providing means for colouring and tinting lines (a specific tinting dialog box is provided for Pantone spot colours), Micrografx Designer also allows the application of vector hatching, gradient, bitmap textures or object line fills to any line.

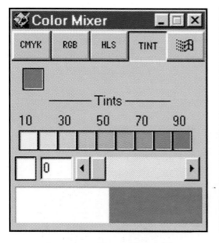

Freehand's Color Mixer

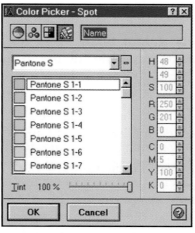

Freehand's Spot Color Picker

Designer's Line Fill dialog box

Fills

As with lines, any closed shape can be filled with solid colour selected from a matching system, model or mixer; tints, shades or tones can be applied if required. In addition,

CorelDRAW provides fill options in the form of two colour bitmap patterns, full colour bitmap patterns, vector patterns, textures, gradients or PostScript fills, but the designer has to be aware that these fills do not rotate with the object filled. Micrografx fills – as described for lines above – do rotate when the object filled is rotated. Freehand provides a selection of patterned, graduated and PostScript fills, but only the graduated fills rotate with the object; additionally, Freehand provides a tiled fill using any object copied to the clipboard as the basis of the tile.

Blends

Colour blends can be created between open or closed paths, using the same fill and stroke type for each path. For example, a path using a graduated fill will not blend with a path using a radial fill. It is important to use a valid colour combination; if two spot colours or a spot colour and a process colour are blended, intermediate colours will print successfully on process colour separations. Choice of the number of steps used in a blend depends on the printer resolution (higher resolution, more steps) and on the colour change between the two selected paths. As well as being useful as a technique for transforming one object into another, blending is a very effective way of creating 'spot' highlights and shadows to give objects depth.

CorelDRAW's Special Fill dialog box

Using Blend to create highlights

Applying colour in painting applications

Lines

Before a line is created in a photoediting or painting application, using any one of a variety of line tools, colour is first selected from any of the spot or process colour matching systems or colour models described earlier. Alternatively, a scratchpad – such as the one provided with Photoshop – can be used for mixing a custom colour before application. Using the HLS model, tints, shades or tones of a hue can be can selected before application. The opacity of a stroke can also be defined by adjusting an opacity slider. Using a pressure sensitive stylus, pressure can be set to control stroke width, colour or transparency, or a combination of these, creating strokes with smoothly changing properties.

Photoshop's Scratchpad

Picture Publisher's Brush Style dialog box

Painter's Brushes

Experimenting with brush looks in Painter

Applications like PHOTO-PAINT and Picture Publisher offer a wider range of stroke types for applying colour than does Photoshop. Picture Publisher, for example, includes styles like *Brushed Oils, Chalk, Colorizer, Crayon, Distort, Dots, Marker, Oil Pastels, Oil Paint, Scatter, Smudgy Marker* and *Watercolour*, but the application offering the graphic artist the widest range of colour application styles is still Fractal Painter. As well as emulating the widest range of drawing and painting tools, Painter makes it possible to apply colour and texture simultaneously to the working surface. A range of variables can be applied to the tools to produce a wide range of different effects. A dialog box contains sliders for control of brush size, opacity and percentage 'graininess' of each stroke. Another Painter dialog box provides the means of creating and saving special brushes. Using Painter's *Nozzles* feature, it is even possible to paint with images!

Adjusting brush parameters in Painter

Painting with images – in this case, the image of a leaf

Fills

A standard *Fill* tool provides the means of flooding a bounded area with any of the range of colours, tints, tones or shades selected, in the same way as for lines. The boundary of the enclosed area can be created with a pencil or brush tool, or defined by a mask. Reducing the opacity

setting before applying a fill to an object allows underlying objects to show through. Gradient fills are also offered by most painting applications. Photoshop provides several options – linear or radial fills from foreground to background colour, with controls to adjust the gradient midpoint (linear fill) or offset (radial fill) as well as clockwise or counterclockwise gradients between two points on the colour wheel.

Adjusting gradient options in Photoshop

More complex gradients can be created in Photoshop, of course, by joining two or more two colour gradients back to back, but some applications, like MetaCreations' *KPT Gradient Designer* or Painter, provide a library of more complex gradients which can be used as they are, or edited, using tools provided. Using an interesting feature provided by Painter, an image can be filled with a gradient in such a way that the image's luminance values are replaced by the gradient's luminance values. Painter also allows the user to create new gradients by capturing colours from an existing image – e.g. a photograph of a sunset – or by using a range of colours produced with Painter's tools and colour sets.

KPT Gradient Designer dialog box

Painter's Gradient fills

Linear sepia gradient applied using image luminance in Painter

Selecting Weaves in Painter

Painter's Patterns

Medical research shows that creative brain activity occurs in the right hemisphere of the brain

In addition to colour fills or gradient fills, some applications provide the facility to fill specified areas with patterns or textures. Preset patterns may be provided via a menu, like that of Painter's *Weaves* or Picture Publisher's *Textures*, but more often the user selects an image or part of an image, using a mask to create a pattern 'tile', and then fills a specified area with tiles.

1. Defining a tile in Photoshop

2. Painting with the tile

Colour combination techniques

The effects which can be produced by the various line and fill tools described so far in this section on applying colour have parallels in the realm of traditional graphic design and are largely intended to allow the digital designer to mimic the traditional style of working. The use of colour combination techniques, on the other hand, represents a crossing of a boundary into the domain of digital manipulation, in which the intrinsic properties of digital colour are exploited to produce effects which would be difficult or even impossible to achieve by traditional methods. While the design process predominantly takes place on the right side of the brain – the creative side – certain aspects of digital design, such as the use of colour combination techniques, requires also the use of the left, or logical, side. Each pixel in a composite RGB colour image is defined by the values assigned to each of its three channels, with these values varying between 0 (black) and 255 (white). It is the ability to alter the values in these channels in a precisely controlled way which opens the door to a range of new possibilities.

By applying mathematical 'operations' to the channels in an image, the way in which the applied colour interacts

with the underlying colour can be controlled. In Picture Publisher, for example, these operations – called Merge Modes – allow the user to combine, or mix, colours using additive or subtractive colour theory. An image can also be changed selectively according to hue, saturation, or lightness, while other modes make modifications to the red, green, or blue channel of an image.

Using the *Additive mode*, the applied colour is mixed with the underlying colour according to the additive colour model. Painting a green image – R(0), G(100), B(0) – with a blue brush – R(0), G(0), B(100) – produces cyan in the image – R(0), G(100), B(100) – as a result of the additive mixing of green and blue.

AN EXAMPLE OF ADDITIVE MIXING USING GREEN AND BLUE			
Green	R(0)	G(100)	B(0)
Blue	R(0)	G(0)	B(100)
Cyan	R(0)	G(100)	B(100)

Using the *Subtractive mode*, painting on a cyan image with a magenta brush produces blue, according to the subtractive colour model.

The *If Lighter mode* is used to edit an image based on the lightness values of the image and the lightness value of the applied colour. Lightness refers to the 'L', or lightness value, in the HSL colour model. If the applied colour has a lightness value equal to or higher than that of the image, the applied colour is transferred to the image. If the lightness value is less than that of the image, no change occurs.

AN EXAMPLE OF SUBTRACTIVE MIXING USING CYAN AND MAGENTA			
Cyan	R(0)	G(100)	B(100)
Magenta	R(100)	G(0)	B(100)
	R(100)	G(100)	B(200)
	-100	-100	-100
Blue	R(0)	G(0)	B(100)

The *If Darker mode* is used to edit an image based on the lightness values of the image and the lightness value of the applied colour. If the applied colour has a lightness value lower than that of the image, the applied colour is transferred to the image. If the lightness value is not lower than the image, no change occurs.

The *Multiply mode* multiplies the value of the image by that of the applied colour. The resulting colour is always darker. The effect is analogous to placing a coloured transparent film over the underlying image.

The *Filter mode* uses a combination of *Additive* and *Multiply* to create a filtered effect.

The *Difference mode* subtracts the value of the applied colour from the value of the underlying colour to produce a new colour.

Multiply mode applied to the right side of the image

Creating texture on the right side of this image using Texturize mode

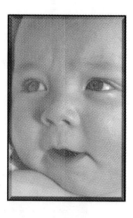

Replacing the saturation value on the right side of this image using magenta as the applied colour in Saturation mode

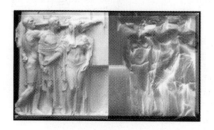

Invert mode has been used to invert the right side of this image

The *Texturize mode* converts the paint colour to greyscale, then multiplies the greyscale value by the image colour.

The *Colour mode* is used to replace the colour of an image with the hue and saturation values of the applied colour, leaving the lightness value unchanged.

The *Hue mode* is used to replace the hue value of an image with the hue value of the applied colour, leaving saturation and lightness values unchanged.

The *Saturation mode* is used to replace the saturation value of an image with the saturation value of the applied colour. Using this mode, painting with white or black (which have zero saturation) alters the underlying colours to their equivalent greyscale values.

The *Luminance mode* is used to replace the lightness value of an image with the lightness value of the applied colour.

The *Red mode* is used to replace the red channel (using the RGB colour model) of an image with the red value of the applied colour. Only the red channel is affected.

The *Green mode* is used to replace the green channel of an image with the green value of the applied colour. Only the green channel is affected.

The *Blue mode* is used to replace the blue channel of an image with the blue value of the applied colour. Only the blue channel is affected.

The *Invert mode* is used to reverse the colours of an image. A black-and-white image reverses to look like a photo negative. A colour image reverses using additive colours.

PHOTO-PAINT provides a set of Merge modes, similar to those of Picture Publisher, while Photoshop provides a set of Mode Options, some of which are similar to Picture Publisher's, while others differ, offering results sometimes difficult to predict, so that experimentation is recommended:

The *Screen mode* multiplies the inverse brightness values of the pixels in both channels. The resulting colour is always a lighter colour.

The *Overlay mode* performs a combination of multiplying and screening. Applied colours are overlaid on the existing pixels but the highlights and shadows are maintained.

The two channel pixels are mixed to reflect the lightness or darkness of the original colour.

The *Soft Light mode* multiplies or screens the pixels in the two channels. It produces the effect of shining a diffused spotlight on the image.

The *Hard Light mode* multiplies or screens the pixels in the two channels. It produces the effect of shining a harsh spotlight on the image.

Any of the above modes can be applied, by means of editing tools such as a paintbrush or fill tool, to modify an underlying image. Alternatively, they can be used when combining two images to produce a third image. This is achieved in Photoshop by selecting *Calculations* from the *Image* menu. The effects produced by Photoshop's *Calculations* can be summarised as follows: When working with composite images, Adobe Photoshop calculates the pixel values in each set of colour channels and then combines them into a single channel in a third, composite, image. The combining process can be applied while using any of the merge modes described above.

Applying Soft Light mode

Image 1

Photoshop's Calculations dialog box

Image 2

The images combined using Photoshop's Hard Light mode

Colour editing

Colour editing techniques are found mainly in bitmap painting applications, as these applications give the user access to individual pixels within an image. The same is not true of vector images, which are defined in terms of lines and shapes; however, thanks to the ingenuity of software developers, even vector applications are beginning to offer colour editing techniques, some of which are described below.

Colour editing in vector drawing applications

Lenses

CorelDRAW provides a number of 'lenses' which can be used to create interesting colour effects.

Applying the *Transparency* lens to an object effectively fills the object with a tint of the colour selected in the Lens dialog box, while at the same time making the object partially transparent (transparency increases with the *Rate* percentage selected in the dialog box).

CorelDRAW's Lens dialog box

When the *Brighten* lens is applied to an object and the object is placed on top of another object or bitmap image, it brightens the underlying object to an extent determined by the *Rate* percentage. Because of the accuracy with which vector objects can be drawn and positioned, this can be an effective method for moderating the brightness of targeted parts of a bitmap.

The *Invert* lens works like the *Brightness* lens, but in this case the colours in the underlying objects are inverted, red becoming cyan, green becoming magenta etc. This lens simulates the effect of a colour filter on a camera.

The *Colour Limit* lens filters out all colours under the lens except black and the colour specified in the *Colour* dialog box. For example, if a blue lens is placed over an object, it filters out all colours except blue and black within the lens area. The strength of the filter is set by the value specified in the *Rate* box. A rate of 100% would only allow blue and black to show through. A lower setting would allow tints of the other colours to show through.

Applying the Invert lens

The *Colour Add* lens mixes the colours of the lens and objects underlying it.

The *Tinted Greyscale* lens causes the colours of objects under the lens to be mapped from the lens colour to an equivalent tonal colour of that lens. For example, a green lens over a light-coloured object creates light green, while the same lens over a dark-coloured object creates dark green.

The *Custom Colour Map* lens maps underlying object colours to colours using a colour range specified in the dialog box. The *Heatmap* lens maps underlying object colours to colours in a pre-defined *Heatmap* palette, creating a (rather garish) heatmap or infrared look.

Applying the Colour Add lens

Freehand's Eyedropper tool

Freehand provides a tool which is very useful when a project requires matching colours from different sources, e.g. matching the colour in line art created in Freehand with colours in an imported bitmap. Using the tool simply involves dragging the required colour from the source to the destination.

Freehand's Xtra Tools

Using the Eyedropper tool to drag a colour from a bitmap into a vector star object

Colour editing in bitmap painting applications

Colour masking

Detailed and sophisticated editing of colour images is made possible by tools which enable the user to select portions of an image based on the colour similarities of adjacent pixels. The *Magic Wand* tool, found in most bitmap applications, provides a simple way of achieving this. Using it simply involves clicking the tool in the toolbox, entering a tolerance value in the *Magic Wand Options* palette (a low

The ubiquitous Magic Wand icon

Setting the Magic Wand tolerance

Photoshop's Color Range dialog box

Picture Publisher's Color Shields

tolerance value to select colours very similar in colour value to the pixel clicked and a higher tolerance value to select a broader range of colours) and clicking the target colour in the image.

Photoshop's *Color Range* command selects a specified colour within a selection or within an entire image. A colour can be chosen from a preset range of colours, or a selection can be built by sampling colours from the image using the eyedropper tool in the dialog box. Alternatively, highlights, midtones or shadows can be selected. An initial selection can be modified by clicking *OK* and then reopening the *Color Range* dialog box. In the central window of the dialog box, *Greyscale* displays the selection as it would appear in a greyscale channel, *Black Matte* displays the selection in colour against a black background, *White Matte* displays the selection in colour against a white background, while *Quick Mask* displays the selection using the current *Quick Mask* settings. The range of colours selected can be adjusted by using the *Fuzziness* slider or by entering a value in the *Fuzziness* text box. Increasing fuzziness increases the range of colours selected. Plus or minus eyedroppers in the *Color Range* dialog box can be used to add or delete colours from the selection.

Picture Publisher's *Color Shield* operates in a similar way to Photoshop's *Color Range*. Clicking the *Color Shield* dialog button opens the dialog box shown, containing eight 'shields', each with its own colour range. Clicking the *Color Select* button alongside the first shield activates it and displays an *Eyedropper* tool which is used to click the first image colour to be shielded. Further colour ranges can be added by sequentially clicking additional shields and selecting additional image colours.

Once a colour range has been selected, it can be colour-edited using a brush tool or fill tool and any of the colour application methods described above.

In any masking operation, a challenge for the designer is to produce changes which appear natural, without sharp edges when the mask is removed. This can be accomplished by feathering the edges of the mask and Picture Publisher's *Chroma Mask* provides the facility to combine colour masking and feathering operations. Using the

Chroma Mask dialog box, areas of an image can be masked as described for the Color Shield, while the *Fade* setting at the bottom of the dialog box determines the smoothness of the edges of the mask, creating a natural blending between the masked object and the background.

Corrective colour editing

The most common corrective editing task is the removal of a colour cast from an image. A colour cast – an imbalance between the red, green and blue components of an image – can result from several causes such as photographing a subject under coloured lights or due to the fading of colours in an old photograph by the effects of sunlight. An alternative cast removal method provided by Photoshop is called *Variations*, which may be selected from the *Image/Adjust* menu. Colour adjustments can be applied sequentially to a thumbnail preview of the image and assessed visually until an acceptable result is obtained. A cast can be removed by selecting the appropriate red, green or blue channel in the *Levels* dialog box and adjusting the gamma setting. If a set of images with similar casts is to be corrected, the dialog box settings can be saved and reapplied to the other images.

Another common colour editing task is the removal of 'red eye' – the red colour which appears in the eyes of a photographed subject, caused by red light from the camera's flash being reflected from the eye back through the camera lens. Usually, the part of the eye that reflects red should be black and can easily be corrected by choosing a high image magnification and using single pixel sized editing brush to paint the appropriate pixels black.

Picture Publisher's Chroma Mask dialog box

Photoshop's Levels dialog box

Using Variations to remove colour casts

Removing red eye

Hue Shift in Picture Publisher

Picture Publisher's Hue Map

Creative colour editing

As well as methods for correcting colour defects in images, bitmap applications provide a range of techniques for more creative colour editing. Picture Publisher's *Hue Shift* command, based on the Hue, Saturation and Lightness (HSL) colour model, allows all the hues in an image to be manipulated. Hue is specified by a angular value ranging between 0° and 360°, corresponding to the colours on the colour wheel. When an angle is specified in the *Hue Shift* dialog box, all hues in the image are rotated by the same amount, effectively changing all the colours in an image. The dialog box also includes sliders for adjustment of the saturation and lightness of the image.

Also using the Hue, Saturation and Lightness (HSL) colour model, Picture Publisher's *Hue Map* command allows selected ranges of hues in an image to be changed. For this purpose, the HSL colour wheel is divided into twelve ranges, each range representing 30 of the 360 hues. A range is shifted by moving its corresponding slider. *Hue Shift* is useful for changing a single colour in an image without affecting other colours. *Hue Map* can also be used to colorise a greyscale image; after converting the greyscale image to RGB mode, the skin area was masked (leaving out the eyes and mouth) and the *Hue Map* was opened. On the top and bottom of the sliders are colour swatches. The lower swatch is the original hue, while the upper swatch is the new hue. Setting the saturation level to +20%, the first hue slider was dragged down until the masked area became flesh coloured. The dialog box's Saturation and Brightness sliders were then used to make fine adjustments.

The *Colorize* option in Photoshop's *Hue/Saturation* dialog box can be used to convert all the colours in the image to the 0° point on the colour wheel (red), with a saturation of

48

Using Hue Map to colorise a greyscale image

100%, while preserving the lightness value of each pixel. Dragging the hue slider then cycles the hue around the colour wheel. For example, if the hue slider is dragged to 120° then the image takes on a green cast since green is the colour located 120° degrees in the clockwise direction from red.

Photoshop's Hue/Saturation dialog box

 Monotones, duotones, tritones and quadtones can be created in Photoshop. Monotones are greyscale images printed with a single, non-black ink, while, duotones, tritones and quadtones are greyscale images printed with two, three and four inks, respectively. In these types of image, different coloured inks are used to reproduce different levels of grey rather than to reproduce different colours.

 A typical offset printing press can reproduce only about 50 levels of grey per ink, therefore duotones are often used to increase the tonal range of a greyscale image, using a black ink for shadow detail and a grey ink for the midtone and highlight areas. Duotones may also be printed using a coloured ink for the highlight colour, producing an image with a slight tint and significantly increased dynamic range. Duotones can be used to extend the range of graphic possibilities for inclusion within a two-colour print job. Tritones and quadtones may be used to introduce even greater tonal range of a greyscale image or to add even more subtle coloured tints. For the designer in a hurry, Photoshop also includes an extensive library of presets which can be applied to any greyscale image.

Colorising an image using the settings shown in the dialog box above

Converting the monotone image on the left to the tritone image on the right using the settings in Photoshop's dialog box shown below

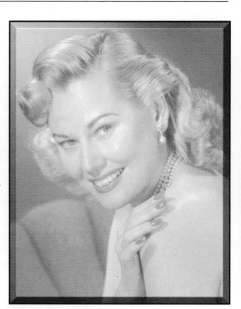

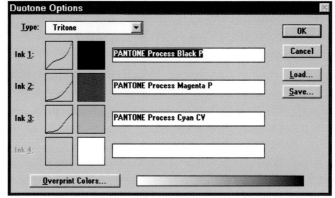

Both Photoshop and Painter provide the means of adding the effect of coloured lighting to a composition. Photoshop provides sixteen different lighting presets, selectable from the *Style* menu at the top of the *Lighting Effects* dialog box. Sliders are provided for adjustment of the light intensity and spread, and clicking on the swatch to the right opens a colour dialog box for selection of a colour for the light. Clicking the *Preview* button (bottom left of the dialog box) shows the effect of the chosen light parameters on the image. An ellipse shows the spread of the light and handles on the ellipse can be dragged to alter the light's spread and position. Using the four lower sliders, the 'properties' of the light can also be adjusted to relate correctly to the nature of the object or scene being illuminated.

The *Gloss property* determines the reflectance of the surface on which the light is shining, varying from *Matte* to *Glossy*.

The *Material property* determines whether the light or the object colour has more reflectance. *Plastic* reflects the colour of the light, while *Metallic* reflects the object colour.

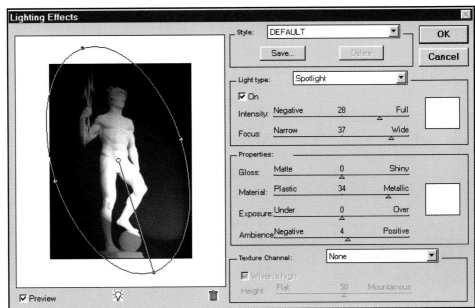

Applying Lighting Effects in Photoshop

The *Exposure property* lightens or darkens the light, positive values adding light, negative values subtracting light.

The *Ambience property* diffuses the light as if it were combined with other light in the room, such as sunlight or fluorescent light. The slider varies the ambience from *Positive* (increasing the effect of the light source) to *Negative* (diminishing the effect of the light source).

The colour of the ambient light appears in the colour swatch and can be altered by clicking on the swatch. An additional light or lights can be added to the scene by dragging the small lightbulb icon at the bottom of the dialog box into the preview area. Once positioned, the parameters of the additional light can be adjusted as required. Quite complex effects can be built up by using a combination of lights and by using masks to control the areas of the image affected.

Painter offers thirteen lighting presets, selectable from its *Apply Lighting* dialog box. Each light is represented in the preview window as a line, indicating the direction of the light, with circles at each end. Dragging the large circle moves the light source; dragging the small circle changes its direction. An additional light can be created by clicking in the preview area. Sliders provide control over

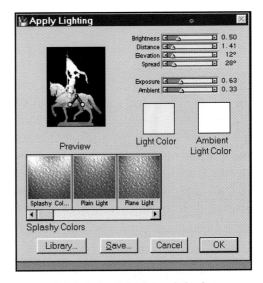

Painter's Apply Lighting dialog box

brightness, distance, elevation, spread and exposure of the selected light. (Photographic principles apply to editing lighting. For example, if light intensity is increased then exposure may need adjustment.) The *Ambient* slider controls the surrounding light in an image. As in Photoshop, light or colours may be changed by clicking on the appropriate colour swatch.

Working with high resolution colour images

A standard feature found in both drawing and painting applications allows the designer to specify the size of the 'page' or 'canvas' before work begins and even to increase the size while work proceeds. A very important difference between the two types of application emerges, however, when such a size increase takes place. The file size of a drawing created at, say, standard A4 remains the same when the drawing is scaled up to a new page size of, say, A2, since the mathematical information needed to describe the components of the drawing are independent of size, and – even more significantly – the resolution or sharpness of the drawing remains the same when it is scaled. By contrast, the file size of a colour A4 painting scaled to A2 size would increase by a factor of four – in proportion to the area increase – as the new size would require four times as many pixels to describe it. Also, when a drawing image prints, it does so at the resolution of the printing device, while the printed resolution of a painted image depends on the resolution at which it is created – the usual rule of thumb being to create the painting at a resolution equal to double the line screen to be used for printing, e.g. at 300 dpi for a line screen of 150 lpi. This difference in behaviour creates a major challenge for the designer working with large colour bitmapped images such as scanned photographs or paintings. Even an A4 sized RGB image scanned at 300 dpi equates to a file size of 29.7 Mb. Manipulating such an image on the screen and applying effects to it – such as filters – is beyond the capabilities of the average desktop system. Fortunately, however, help is at hand!

Even importing a multimegabyte colour image into a painting program is a highly RAM-intensive process. To allow users with limited RAM to open large files, Picture Publisher offers a *Low Resolution* mode which allows the user to open a TIFF image at a lower resolution than it was saved at.

TABLE OF FILE SIZE VS DPI (5 cm 5 cm image)		
	RGB	CMYK
72 dpi	60 k	79 k
150 dpi	255 k	340 k
300 dpi	1 Mb	1.33 Mb
600 dpi	4 Mb	5.32 Mb
1200 dpi	16 Mb	21.3 Mb

Low Resolution Open

File Name:	Model.tif
File Type:	Tagged Image File Format (*.tif)
Data Type:	24-Bit RGB Color
Width:	359 pixels (60.79 mm)
Height:	403 pixels (68.24 mm)
Resolution:	150
Image Size:	425KB

Open Resolution 75 ppi

Open Image Size 106KB

Open Cancel

Opening an image in Picture Publisher in Low Resolution mode

For example, an image to be used only as part of a screen presentation can be opened at the resolution of the monitor screen. Choosing the *Low Resolution* option opens a dialog box for choosing the lower resolution. This dialog box displays the file size for each resolution chosen. Even when the system is powerful enough to work with the full resolution image, a low resolution version of the file can be used to test general changes such as adjustments to hue and saturation. Because the file resolution is low, processing such changes is faster. When the required changes have been established, a macro (a script file containing details of the change) can be recorded and then applied to the larger original file. Low resolution files also speed up the printing of a proof on a low resolution printer, as a printer wastes processing time discarding data above its resolution.

Applications which use the above *Low Resolution* option, in which a 72 dpi file is used to represent the larger, high resolution file, are often described as 'proxy' systems. The disadvantage of working with a proxy is that it is not possible to zoom in and examine effects at pixel level. In addition, it is difficult to carry out precise masking work as the proxy file lacks the detail of the actual file.

An alternative trick offered by Picture Publisher – called *FastBits* mode – displays a preview representation of a TIFF image from which the designer can choose a segment to open for editing. The mouse pointer is first dragged to superimpose a variable size grid on top of a preview of the image displayed in the *FastBits* dialog box. Clicking on a segment of the grid opens just that part of the image corresponding to that segment. When the image is saved, the segment – including any edits – is recombined with the rest of the image. Using this method, a large image can be edited step by step on a system with limited memory. A macro can be used to apply the same edits sequentially to different parts of the image. The *FastBits* technique can also be used as an efficient way to apply different effects to different segments of an image.

While modes like those described above offer a way of working around the problems of manipulating large colour files, recent innovative applications like Live Picture and Macromedia's xRes take a more radical approach to the problem. Macromedia xRes, for example, offers two quite distinct modes of working; in *Direct Mode*, which is used for images up to about 10 Mb in size, operation is similar to that of

Picture Publisher's FastBits dialog box

Using FastBits to apply different effects to different areas of an image

Macromedia's xRes allows the user to work on large images at low resolution and later render the changes at high resolution

conventional bitmap applications like Photoshop; in *xRes Mode*, which is used for images greater than 10 Mb in size, the way in which images are created, modified and saved is quite different, the processing principle used being analogous to that found in 3D applications, in the sense that the time-consuming final rendering of an image is delayed until the design operations have been completed.

To illustrate the principle involved, let us suppose that a *Motion Blur* filter is applied to an image which is 4000 3000 pix els in size. In *Direct Mode*, the filter is applied immediately to all pixels in the 12 million pixel image. In order for the processor to manipulate 12 million pixels, it needs about 100 Mb of RAM. Even with sufficient RAM and a powerful processor, the operation could take many minutes to complete (and in many cases would simply cause the designer's system to crash!). In *xRes Mode*, the filter is only applied to the pixels currently visible on screen at the selected zoom level. For example, if the image is being viewed at the 1:8 zoom level and an area of 400 300 pix els is being viewed, the Motion Blur filter would be applied only to 400 300 pix els, or 120 000 pixels in total – only 1% of the full 12 million pixels in the image. Even with a small amount of RAM, the filter can be applied in just a few seconds. If the image is now exported as, say, a TIFF file, xRes performs the processing it has

delayed in order to produce the final file, applying the filter effect to all pixels (a process described – somewhat misleadingly – as rendering).

In general, operations which would take many minutes to apply in *Direct Mode* take only seconds to apply in *xRes Mode*, as the speed of the operation in *xRes Mode* is not dependent on the size of the file. The selective processing used in *xRes Mode* achieves this rapid speed of operation by requiring the system processor to do only the work necessary at the selected zoom level and processing only the area of the image visible on screen. Use of *xRes Mode* does not involve the compromising of a proxy system, as it is possible to zoom in to the actual pixel data in order to evaluate the result of an applied effect. Editing, painting and masking are all possible at single pixel level.

xRes's LRG document format is designed specifically to address the problems of saving very large files (larger than 10 Mb). The data within an LRG document is stored in a series of tiles, making it easy to access the image data rapidly. When a file is converted into the LRG format, up to seven different zoom levels of document are made at varying resolutions. Each level is composed of several tiles of data.

By way of illustration, imagine a 4000 4000 pix el document converted to the LRG format. The lowest level of the LRG file is 4000 4000 pix els, the same size as the original document and representing the 1:1 zoom level (although it is not an exact copy of the image as it is arranged in rectangular tiles, as opposed to lines of pixel data). The second level in the LRG file is 2000 2000 pix els, representing the 1:2 zoom level. This level is one-quarter of the size of the original document. The third level is 1000 1000 pix els – the 1:4 zoom level – now only one-sixteenth of the size of the original document, and so on up to seven zoom levels ranging from 1:1 to 1:64. Organising data in this manner allows it to be processed selectively. When an operation is performed, it is applied to only one of the seven zoom levels.

In the years ahead, we can expect to see further developments in methods of handling large colour files efficiently. A consortium of companies, including Kodak, Hewlett-Packard, Microsoft and Live Picture are working on a revolutionary technology called FlashPix, which has already been demonstrated at computer shows. FlashPix is a highly optimised way of handling graphics which allows the designer to load several 50 Mb-plus image files into an ordinary Macintosh or Windows PC with standard disk and RAM, and manipulate them rapidly and safely. The technology works by including in the file a number of versions of the image, all at different resolutions, from a full photographic quality version with 16.7 million colours down to a thumbnail used for previewing. The format is said to be capable of handling the staggering number of 2^{32} pixels, managed in tiles of 64 pixels each. The file also accumulates all the edits made since the image was first created, allowing multiple levels of undo and, because the changes made don't affect the original, screen updates can be made quickly, as only a small part of the image needs to be recreated. When imported, only the appropriate part of the file is loaded, so for display on screen only the 72 dpi image will be used, while printing on a standard office laser printer would use the 300 dpi image, with all edits applied.

Summary

As we have seen in this chapter, working with digital colour presents disadvantages, but also offers advantages, when compared with working in traditional media. Some of these are listed below.

Disadvantages

Problems of maintaining consistency of colour from device to device (camera to scanner to monitor to printer or press)

Limited colour gamuts of digital devices

Problems of manipulating large images

Advantages

Precision and consistency in specifying and replicating colours, shades, tints and tones

Range of colours to choose from

Ability to experiment on screen with different colours before committing to a final choice

Range of application methods – stroke types emulating oils, pastels, charcoals etc. and fill types such as gradients, blends and patterns

Ability to combine colour and texture

Special effects such as use of lenses, modes, lighting effects, duotones etc.

Range of editing methods – colour masking, colorising, H/S adjustment etc.

Ease of importing and combining coloured objects and images

Only a few years ago, the hardware and software available to the digital designer could produce only the crudest simulation of work done by traditional techniques, which had been developed and fine-tuned over the centuries. Now, as we have seen, work is going on continuously to find ways of reducing or eliminating the remaining areas of disadvantage, while the advantages multiply as the cost/performance of hardware continues unabated and the ingenuity of software developers not only provides closer and closer emulation of traditional methods, but also offers an increasing range of exciting colour techniques which are purely digital in concept ↗

3

Colour output

A removable Zip cartridge stores up to 100 Mb of data

An overhead transparency projector

A slide projector

nce a digital design has been completed on screen, many output 'routes' are available to the designer. If the design is one of a number of alternatives being prepared for review by a client, then the file containing the design may simply be copied to a recordable medium such as a diskette, a Zip cartridge or a CD and mailed to the client for viewing. Alternatively, the file may be attached to an e-mail message and be sent to the client via the Internet. If the design is to be shown to an audience at another location, the file may be output to an image recorder, creating a 35 mm colour slide which can be viewed using a conventional slide projector or it can be copied to a laptop linked to an LCD overhead projector and projected on to a simple projection screen or a convenient office wall.

By far the most common output method is via one of a number of different types of desktop printer, either to paper or to transparency for use on a conventional overhead projector. Desktop printers come in a wide variety of technologies and prices, producing results ranging from crude to photorealistic.

Desktop printing

As discussed earlier, printers use the subtractive colour model to reproduce colour, mixing the subtractive primaries, cyan, yellow and magenta, to produce other colours. Even when a printer has been carefully calibrated and a colour management system is used to optimise the match between screen colours and printed colours, the results obtained depend on the printer's colour gamut – the range of colours which it can reproduce, as defined in its device profile.

The ideal printing technology would be one able to emulate the traditional mixing of liquid paints in the proportions necessary to produce the desired colour at every point on the paper. Most available technologies are unable to do this. Certainly not the colour dot matrix printer, as the 'ink' is not in a liquid form and is deposited on the paper by firing pins to impress coloured ribbons against the paper. Similarly, colour laser printers, which use dry coloured toners, have no means of mixing the toners. Even inkjet printers, which use real liquid inks, can either expel a minute droplet of ink at each

position on the paper, or not, have no capability of mixing the individual droplets. The same limitation holds true for solid ink and thermal wax technologies, although recent advances have produced a thermal wax printer which will produce over 4000 colours by varying the amount of ink delivered to a given location, hence altering the size of the dot produced. Only dye sublimation can genuinely produce a full spectrum of 'real' colours by applying differing amounts of each ink to the same point on the paper.

Most desktop printer technologies produce colours within their gamuts by interspersing dots of cyan, yellow, magenta and black in one of a variety of dither patterns. An even mix of cyan and magenta dots, for example, will be perceived (if the dots are small enough and the viewing distance is great enough) as the colour blue in the eye of the viewer. Reproducing subtle differences in tone using only a limited number of colours can be achieved by using groups of dots to represent different shades, but the limited number of dots made available by the printer's resolution (dots per inch or dpi) makes this process imperfect. Low resolution results in visible 'banding' as the printer driver switches from one whole number of dots to the next, fractional numbers of dots being impossible to produce.

In conventional colour printing, it is important to understand that, in the process of simulating a particular colour, the final resolution of the printed image is not the nominal resolution of the printer (e.g. 360 360 dpi). This reso-lution must be divided by the size of the dot groups used; even a 3 3 grouping reduces the resolution down to a coarse and ugly looking 120 dpi. Recent developments, however, in this fast-growing market have pushed resolutions up to 1440 720 dpi. When combined with the development of new printer drivers capable of more sophisticated configuration of dot positioning, the result has been a significant increase in quality.

Low resolution printing produces a visible banding effect

Higher resolution produces a smoother result

Printer driver software

Printer driver software is becoming increasingly 'intelligent', as vendors strive to make it easier for users to optimise colour output. Intelligent driver technology is marketed under a variety of names – Xerox's *Intelligent Color,* Hewlett Packard's *ColorSmart,* Tektronix's *TekColor* and QMS's *QColor,* for example. The basic principle behind these technologies is that the contents of a page are analysed by the driver as it is

Epson's printer driver provides the user with a high degree of control over how an image will be printed

being rasterised and the halftoning method and colour mode are customised to the contents of the page. The most advanced solutions can resolve individual text, graphics and bitmap objects within the page and apply different optimised settings to each. For example, a page containing text, a coloured pie chart and a scanned photograph would have the text rendered in solid black, the pie chart using amplitude modulated screening and 'vivid' colour mode, and the photograph using frequency modulated screening and 'photographic' colour mode. Fully featured driver software such as that provided with the Epson Stylus Colour inkjet printer also provides direct access to basic image editing controls and allows selection from different colour management options.

Page description languages

Desktop printers print by depositing dots on paper, but those dots can be configured in different ways within the computer/printer subsystem. This is where page description languages (PDLs) play an important role. The minimal type of printer architecture is a nonintelligent device which simply outputs a bitmap that has been created by the host computer. Such are the so-called GDI (Graphics Device Interface) printers which are designed to work with Windows; the GDI

commands used to display the screen image are directly converted to bitmap form by the host PC, stored in the PC's memory and then sent to the printer for output. GDI printers are relatively cheap, since they do not require processing power or large amounts of internal memory, instead relying on the power and memory of the host PC.

Page description languages (PDLs) such as Hewlett-Packard's PCL and Adobe's PostScript use a completely different printing architecture. These high-level PDLs require special drivers installed on the host PC to convert GDI commands into PCL or PostScript code, which is then sent to the printer, where an on-board processor decodes the data, rasterises it (turns it into a bitmap which the printer can output) and stores it in memory until the print engine is ready to print the dots. This need for processing power and memory makes PCL and PostScript printers more expensive, the trade-off being their ability to render complex pages containing graphics and multiple fonts more efficiently and – in the case of PostScript – have much greater control over how the output device renders pages. As ever, the best choice of printing architecture depends on the kind of output being processed. If output is mainly text and simple charts, then a GDI printer is an acceptable choice, as it shouldn't impose excessive demands on the host PC. For general business documents which contain some graphics, a PCL printer is perfectly adequate, while for complex graphics and desktop publishing work, PostScript is the preferred solution. PCL, the native language of Hewlett Packard's LaserJet family, has become the industry standard for general office printers and is supported by virtually all PC and printer vendors, application vendors and operating system vendors. PostScript is often available as a firmware upgrade to mid-range PCL printers.

The mode of operation of the main desktop printer classes is described below.

Inkjet

An inkjet's printing head holds a central reservoir of liquid ink connected via a tube to a matrix of microscopic nozzles set in a square or rectangular array. These draw ink from the reservoir by capillary action. Each nozzle is equipped with an electric element which is controlled by the printer's central circuitry. When a current passes through the element, it heats up, causing tiny bubbles to form in the surrounding

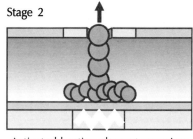

Stage 1 Nozzle

Ink droplets

Heating element

Stage 2

Activated heating element vaporises ink which is expelled through nozzle

Stage 3

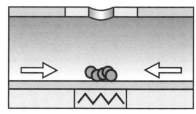

Heating element deactivated

Inkjet printing

liquid. As the bubbles merge, a droplet of ink is expelled on to the paper's surface. Expulsion of the droplet causes the bubble to contract, drawing more ink from the nozzle. Graphics or text characters are constructed by selectively activating the nozzles as the head moves horizontally back and forth across a forward-moving printing surface. Budget colour printers use three such heads for cyan, yellow and magenta, while more expensive products use an extra head for black. The type of paper used makes a significant difference to the quality of inkjet output. If the paper is too absorbent or fibrous, the ink will be absorbed and will spread out. Most manufacturers offer a coated paper which prevents this.

Thermal wax

The two principal components of a thermal printer are its printing head, which stretches the entire width of the page and its paper transport mechanism. Although employing an application technique which is similar in principle to that of a typewriter using a single strike typewriter ribbon, the thermal wax printer is much more expensive; each wax-coated ribbon can be used only once, regardless of how much of each colour is applied. The ribbon, which has an area equal to that of the printed page, is coated with alternate panels of cyan, magenta, yellow and black, running parallel to the paper, and passes from an input to an output cassette. The result is good-quality dithered output, producing vivid, slightly glossy colours.

Thermal wax printing requires a bright white, clay-coated paper to reflect the maximum amount of light back through the translucent dyes. As the paper passes through the printer four times – once for each colour – registration problems can occur over time as the transport mechanism wears. In a thermal wax printer, the printing head, which stretches the entire width of the paper, is made up of hundreds of tiny heating elements. As an element heats up, it melts an identically sized dot of wax from the film backing on to the moving paper below. Wax beneath the unheated elements stays in place, leaving the underlying paper surface clear. Once a page-sized colour layer of, say, cyan pigment dots has been applied, the ribbon moves to the next colour while the paper returns to its starting position ready for the second coloured layer of dots to be added, and so on.

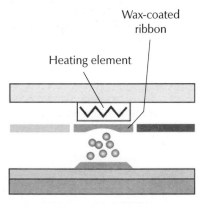

Wax-coated ribbon

Heating element

Thermal wax printing

Wax phase change

Another version of thermal wax technology is used by the 'phase change' printer. Sticks of wax are heated to 140°C and melted wax is fired at the paper from a head scanning across the page, solidifying on contact with the paper, with little spread. This is caused by the wax's abrupt phase change curve, the wax melting sharply above 140°C and solidifying almost instantly below it. Colour density is good as the colour is dye based, rather than a pigment based. Printing takes place in a single pass, minimising registration problems, and running cost is relatively low as only the wax deposited on paper is consumed.

Dye sublimation

Dye sublimation printers can vary the volume of dye transferred to paper in 256 steps as well as the intensity of the individual colour printed. The amount of dye released from the film substrate is temperature dependent. The higher the temperature of the head, the more dye is deposited. With three or more dyes, the result is a true continuous tone image of up to 16.7 million possible colours for each CMYK dot deposited on a photographic paper which contains a quantity of chemical fixer to complete the print process. The near-photographic result is achieved in spite of a relatively low resolution – usually 300 dpi. The down side to the excellent results produced is that the dye sublimation printing process is slow compared with other technologies and is also the most expensive. It also costs the most to run – up to £4 per page.

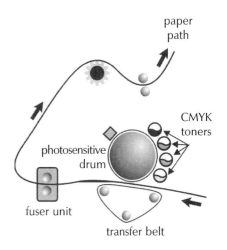

Dye sublimation printing

Colour laser

Laser printing – a form of electrostatic printing – uses the same imaging technology as the original photocopier, although the optics involved in colour work are more complex. Colour laser printing multiplies the original black and white electrostatic process by a factor of four, with different manufacturers using different techniques to implement the imaging process. Canon's photosensitive drum, for example, is imaged four times, while Xerox exposes a long photosensitive belt with all four colours exposed on the belt end to end. The latent images then pass under the corresponding toner hoppers attracting toner on to the paper. Laser printer

Colour laser printing

resolutions are typically 300 or 600 dpi. As the development of toner technology continues, higher resolutions can be expected.

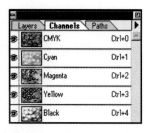

Photoshop's layers show thumbnails of the four CMYK images of which the composite image (below) is composed

Desktop proofing of colour separations

Proofs of colour separations can be printed on a black-and-white desktop printer to verify that objects appear on the correct separations and that colours overprint or knock out as expected (see explanation of overprinting and knock-out later). Colour separations should be proofed on a PostScript printer, as non-PostScript printers cannot accurately show how separations will image on a PostScript output device.

To proof separations from DTP applications such as Pagemaker on a PostScript desktop printer, the PPD for the printer is first selected in the printer dialog box, *Colour/Separations* is clicked and the inks to be used in the final separations are selected. Clicking *Print* causes the printer to output a page for each colour selected.

Commercial printing
Photographic colour separation

As we have seen earlier, the subtractive primaries cyan, yellow and magenta can be combined to recreate all the colours of the spectrum. Therefore, in theory, it should be possible to print a full colour image just using cyan, yellow and magenta inks. To do this, it is first necessary to separate the original image into its cyan, yellow and magenta components. This can be done by photographing the image – e.g. a colour photograph – three times, through filters which are the same colour as the additive primaries – red, green and blue. When the image is photographed through the red filter, green and blue are absorbed and the red passes through, producing a negative with a record of the red. By making a positive of this negative we will obtain a record of everything that is not red, or more specifically, a record of the

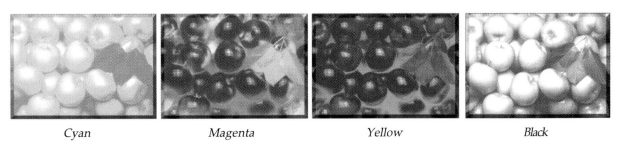

| Cyan | Magenta | Yellow | Black |

The cyan, magenta, yellow and black separations of the apples image (opposite) used to create plates for CMYK printing

green and blue. The green and blue, as we have seen earlier, combine to produce cyan; therefore, we have a record of cyan. The same process is repeated for magenta, using a green filter, and for yellow, using a blue filter. As each filter covers one-third of the spectrum we now have a record, on three sheets of film, of all the colours in the original image. When the sheet of film containing the cyan content of the image is placed in contact with a printing plate and then exposed, it transfers the cyan content of the image to the plate; printing on to paper with the plate, using cyan ink, then produces a print of just the cyan content of the original image. Repeating the process with the yellow and magenta film and printing two further passes using yellow and then magenta inks should, in theory, reproduce the original full colour image. Unfortunately printing inks are not pure, absorbing colours that they would not absorb if they were pure. For this reason, the printed image will appear 'muddy' unless colour corrections are made on the separations to compensate for these ink deficiencies. Another problem with using just the three separations is a lack of density in the shadow areas. To overcome these problems, a fourth, black, separation is made by using a yellow filter or a combination of all three filters. The addition of black improves shadow density and overall contrast.

When the printing plates are made, the four separations are screened at different angles so that the halftone dots for each ink print in a symmetrical rosette pattern. Traditionally, the cyan screen is printed at 105°, the magenta screen at 75°, the yellow screen at 90° and the black screen at 45°. If one or more of the process inks are set to print at different angles, or if the paper rotates slightly as it moves through the press, then the rosette pattern does not

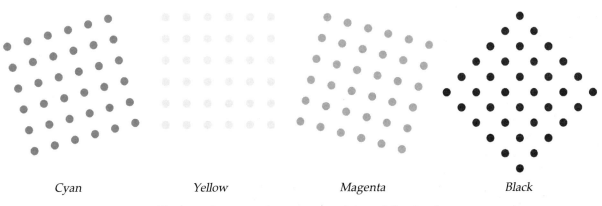

| Cyan | Yellow | Magenta | Black |

The four colour separations are screened at pre-defined angles

Cyan
105° Yellow 90°
Magenta 75°

Conventional printing angles for the four colour screens

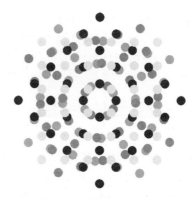

Resulting rosette pattern

print correctly and a moiré pattern appears, disrupting the smoothness of the colour gradation.

When printed, the image is reproduced as thousands of tiny dots laid down in thin layers of colour. The colour perceived by the eye is determined by the size of the dots, the manner in which they overlap, and their relation to one another, i.e. the colours are produced not in the physical mixing of the inks, but in the optical mixing of individual colours by the viewer's eye.

Howtek Scanmaster drum scanner

Most photographic colour separations are now made using high precision colour scanners. The original image, or a positive transparency of it, is placed on a drum, and a laser light beam scans rapidly back and forth over it. The reflected (or, in the case of a transparency, transmitted) light is divided into three separate beams which pass through red, green and blue filters, activating extremely sensitive photocells. Depending on how much light the photocells detect, signals of varying strength are sent to laser light generators, which automatically expose a set of separation negatives by emitting precisely controlled bursts of light.

Digital colour separation

Linotype imagesetter

Many desktop applications now provide facilities for colour separation. Using PageMaker, for example, spot and process colour separations of a publication can be imaged directly to a PostScript imagesetter using paper or film. When *Separations* are selected in the Pagemaker's *Print Colour* printing dialog box, the information found in the PPD file for the optimised screen option, and the angle and frequency fields are displayed. One sheet of paper or film is produced for each spot or process ink to be printed. A commercial printer then

uses these separations to prepare plates for the printing press. Spot colours normally print at the angle specified in the PPD (PostScript Printer Description file) for *Custom Color,* which is usually 45°. Process colours normally print at the same angles as those evolved for the traditional separation process as described above – cyan 105°, magenta 75°, yellow 90° and black 45°.

Due to the fact that imagesetters simulate halftone dots by grouping printer dots together in halftone cells, producing consistent angles at 75° and 105° can pose problems. A number of vendors offer screening solutions to address this problem, notable among them being Agfa's *Balanced Screen Technology* and Linotype-Hell's *HQS Screening* and *Rational Tangent Screening* systems. While these systems offer improved colour results, they are still based on the traditional screen ruling and angle combinations.

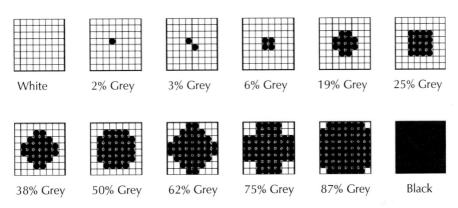

| White | 2% Grey | 3% Grey | 6% Grey | 19% Grey | 25% Grey |
| 38% Grey | 50% Grey | 62% Grey | 75% Grey | 87% Grey | Black |

Creating shades of grey by means of grouping dots in halftone cells

Even better results may be offered by recent developments in the use of frequency modulated (FM) or stochastic screening, also from Agfa and Linotype-Hell. While the traditional halftone screening uses the size of the halftone dots to convey shading, FM screening does not arrange dots into halftone cells, but simulates the different shades of an image by controlling the number of dots in each area – more dots producing a darker shade and fewer dots producing a lighter shade. Because there is no regular dot pattern in FM screening, the problem of Moiré patterns is avoided; also, since FM screening uses smaller dots, more detail and subtle changes in colour may be reproduced.

Printer's marks

Part of the process of preparing separations for printing is ensuring that the prepress bureau and/or print shop are provided with all the information necessary to produce film and plates and to monitor the consistency of print quality during the print run. Many digital applications provide the means of adding information to the individual separations covering the following requirements.

Crop marks – marks indicating where the printed pages will be trimmed

Register marks – normally in the form of cross hairs or star targets. After a file is separated and printed, the print shop uses the register marks which

appear on the negatives to align the separations to create proofs and plates. Star targets are harder to align than cross hair register marks but they are extremely accurate. Each image should have at least four registration marks

Bleed area – area which falls outside the cropping area. Bleed is included in an artwork to compensate for shifts of the image on the printing press, or to allow for a slight margin of error for images which will be stripped into a keyline in a document. A press bleed – one which bleeds off the edge of the printed page – should be at least 18 points

Text labels – specifying, for example, file name, page number, line screen used and screen angle and colour of each plate

Colour calibration bar – used by the print shop to check colour consistency during the print run. There are two types of colour bar, called progressive and black overprint. The progressive colour bar consists of a solid colour square of cyan, magenta and yellow as well as various combinations of these three colours. The black overprint colour bar prints the various combinations of cyan, magenta and yellow with a solid swatch of black over the colour combinations to check for show-through of underlying inks

Gradient tint bar – used to check for consistent tint values in separations. Tints usually range from 10 % to 100 % in 10 % intervals

CorelDRAW's Print Preview dialog box

Offset printing

Still used today to reproduce full colour output, halftone colour printing was introduced in the 1890s, although many years passed before its full potential was realised. Although colour reproduction theory was fairly well understood, the lack of colour film restricted colour work to studios where the necessary separation negatives had to be made directly from the subject, under the most exacting conditions. As reliable colour film became available in the 1930s, colour reproduction became both more common and more accurate. The offset plate is made of a base material – such as aluminium, stainless steel, or, for very short runs, paper – coated with a photoreactive substance. After exposure, the plate is developed and then treated to enhance its ink-attracting or water-repelling properties.

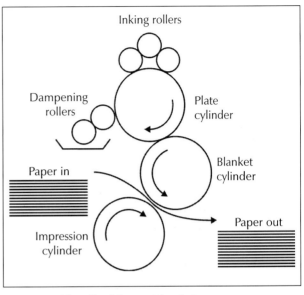

The offset lithographic printing process

For very long print runs, bimetal plates are sometimes used; typically, copper forms the image area, while aluminium or chromium is used for non-image areas. Recent developments which have seen dramatic increases in the light sensitivity of photopolymer coatings offer the possibility of producing plates in future which will no longer require film exposure, but will instead be digitally imaged by a scanning laser.

When printing process colours, two factors must be controlled to ensure the quality of the finished work, namely the number of halftone dots which print per inch (called the screen frequency or screen ruling) measured in lines per inch (lpi) and the angle at which they print (called the screen angle). If these factors are not correctly specified, the process inks may not print correctly in relation to one another, and distracting moiré patterns may appear in the final printed colours. The default screen settings in the selected printer's PPD are based on specifications from the printer manufacturer and are optimised for the printer. A prepress service provider may, however, suggest different settings in some circumstances.

Trapping

When printing overlapping coloured objects in a composition on an offset press, conventionally the top object is printed and the equivalent area of the bottom object is not printed or is 'knocked out' in printing terminology. As mentioned earlier, colour misregistration can occur if the paper rotates slightly as it travels through the press. The same effect can occur if a plate is misaligned or if the plate or paper stretches slightly during printing. Because of the knocking-out convention, such misregistrations can cause unsightly white slivers between adjoining colours. To compensate for this problem in

Effect of misregistration when the bottom object is knocked out

Spread – overlapping object enlarged

Choke – underlying object reduced

CorelDRAW's Trapping dialog box

the traditional separation process, the platemaker used photographic techniques to 'spread' or 'choke' adjoining objects on the separate plates to allow for misregistration, using a process called trapping. Spreading involved enlarging the size of an overlapping object, while choking involves reducing the size of an underlying object.

Using digital separation methods, trapping is applied to a publication, either manually or automatically, before film separations are created. Trapping is required mainly for overlapping objects created in a vector drawing application and printed using distinct spot colours applied from separate plates. Trapping is less important if the objects use process colours which share a sufficient quantity of common inks and normally no trapping is necessary for artwork consisting of continuous tone images, as the colours blend naturally together. Trapping of complex objects such as those involving blends or graduated fills is a skilled and exacting process as the trap colour and shape must change as the colour on the perimeter of the object changes. Assistance is available in the form of software such as Adobe's *Trapwise*, which provides more sophisticated trapping than that found in illustration or page makeup applications.

Trapping in a drawing application

CorelDRAW provides a comprehensive set of trapping options:

Trapping by always overprinting black. Any object containing 95% black or more overprints any underlying objects – a useful option for artwork containing a lot of black text.

Trapping by auto-spreading. Auto-spreading creates colour trapping by assigning an outline to the object that is the same colour as its fill and having it overprint underlying objects. Colour trapping will occur for all objects in the artwork which meet three conditions – (i) they do not already have an outline, (ii) they are filled with a uniform fill, and (iii) they have not already been designated to overprint. The amount of spread assigned to an object depends on the maximum trap value and the object's colour. The lighter the colour, the greater the percentage of the maximum trap value. The darker the colour, the smaller the percentage of the maximum trap value.

Trapping by overprinting selected colour separations. Using Corel's *Advanced Separations Settings*, one or more of the CMYK separations can be set to overprint graphics, text, or both.

To trap by overprinting selected objects. *Overprint Fill* causes the top object to print over the underlying object (instead of the underlying object being knocked out), which makes 'white gaps' impossible. This option is best used when the top colour is much darker than the underlying colour, otherwise an undesirable third colour might result (e.g. red over yellow would result in an orange object). *Overprint Outline* causes the top object's outline to print over the underlying object. The safest choice is to assign the colour of the top object's fill to the outline. When setting the outline thickness, it has to be remembered that the outline straddles the path which defines the object's shape. Therefore, an outline of, for example, 0.20 points actually creates a trap of 0.10 points.

CorelDRAW allows saving of both artwork and colour separation instructions in a .PRN file for sending directly to an output device by a service bureau, where the file will be processed through a Raster Image Processor (RIP) in order to rasterise its PostScript instructions. The rasterised file will then be loaded to an imagesetter to produce the film separations which in turn will be developed in a film processor.

> **Procedure for printing to file**
>
> 1. Click *File, Print.*
> 2. Enable *Print to File.*
> 3. Enable *For Mac* if the print file is being sent to a service bureau with Macintosh equipment.
> 4. Click OK.
> 5. Type a file name and choose a destination. The appropriate extension (.PRN) will be appended to the file name.

Creating a PostScript .PRN file using the Print to file option

Trapping in a painting or photo editing application

Adobe Photoshop traps by spreading, according to the following guidelines:

All colours spread under black

Lighter colours spread under darker colours

Yellow spreads under cyan, magenta and black

Pure cyan and pure magenta spread under each other equally

Generally speaking, four colour images need only be trapped when solid tints are being used in CMYK mode. Excessive trapping may generate a keyline effect (crosshair

> **To create a trap in Photoshop**
>
> 1. Choose *CMYK Color* from the *Mode* menu to convert the image to the CMYK mode.
> 2. Choose *Trap* from the Image menu. The Trap dialog box appears.
> 3. Select a unit of measurement from the *Size Units* menu.
> 4. In the *Width* box, enter the trapping value provided by the print shop.

lines) in the C, M and Y plates. This problem is not visible in the composite channel, showing up only when output is made to film.

The procedure for creating a trap is as follows:

1. The image is first converted to CMYK mode
2. *Trap* is then selected from the *Image* menu, causing the Trap dialog box to appear
3. A unit of measurement is selected from the *Size Units* menu
4. In the *Width* box, the required trapping value, as agreed with printer, is entered

Specifying a trapping value

Trapping in a page makeup application

PageMaker traps text to underlying PageMaker-drawn objects (rectangles, polygons, lines and ellipses), and traps PageMaker-drawn objects to each other, but it ignores imported graphics. Imported graphics must first be trapped in the illustration or image-editing program used to create them. PageMaker applies the correct trapping techniques on different parts of the object even if text or a PageMaker-drawn object overlaps several different background colours. The trapping adjustments are made automatically throughout the publication, although the application allows the user to vary settings from the default in particular situations.

To trap a publication in PageMaker

1. Open the publication.
2. Choose *Utilities/Trapping Options*.
3. Click *Enable Trapping for Publication*.
4. Set the trapping options required.
5. Choose *File/Print*.
6. Complete the *Print* dialog box settings and click *Print*.

PageMaker Trapping Options dialog box

PageMaker decides whether to trap based on ink density values, and places the traps based on the neutral densities (relative lightness or darkness) of adjoining colours, in most cases spreading lighter colours into adjacent darker colours. In all cases, the overprint trapping technique is used – the trap colour prints over the darker of two adjoining colours. The trap colour used depends on the component inks of the two adjoining colours. For adjacent process colours which require a trap, PageMaker creates the trap colour using only the CMYK values in the lighter colour which are higher than those in the adjoining colour. For a

process or spot colour next to a spot colour, the lighter colour is used as the trap colour.

When colours have similar neutral densities, neither colour defines the edge. To trap these colours, PageMaker adjusts the trap position from spreading the lighter colour into the darker one to straddling the centreline between them, creating a more elegant result.

PageMaker traps text characters to underlying PageMaker-drawn graphics. A text character overlapping different background colours traps accurately to all colours it overlaps (this applies only to PostScript or TrueType outline fonts as bitmap fonts do not trap).

The value entered for *Black Limit* in the *Trapping Options* dialog box determines what PageMaker considers a solid black and a rich black (a process colour consisting of solid black with one or more layers of C, M or Y inks). The default value of 100% specifies that only colours containing 100% black will be considered solid or rich blacks by PageMaker. The *Black Limit* setting is useful when it is necessary to compensate for extreme dot gain, e.g. when using low-grade paper stock which could cause black percentages lower than 100% to print as solid areas. By decreasing the *Black Limit* setting from its default of 100%, it is possible to compensate for dot gain and ensure that PageMaker will apply the proper trap width and placement to black-coloured objects.

If the *Fill* and *Line* options are checked in the *Black Attributes* section of the *Trapping Options* dialog box, PageMaker overprints the lines or fills, and does not trap them.

Pagemaker, like CorelDRAW, allows saving of a publication and its colour separation instructions in a .PRN file for sending directly to an output device by a service bureau.

Dot gain

Many variables – from the photomechanical processes used to produce separations, to the paper type and press used – affect the size of printed dots. Typically, dots increase in size as wet ink spreads, under pressure from the offset press rubber blanket, as it is absorbed by the paper. A 50% halftone screen, for example, may show an actual density of 55% on the printed image when read with a densitometer. Dots may also increase in size as negatives from different sources are duplicated to produce the final film, or can result from miscalibration of an imagesetter during the imaging process. If too much dot gain occurs, images plug up and colours print darker than specified.

Some applications, such as Photoshop, provide the means for compensating for dot gain. When a *Dot Gain* value is entered in Photoshop's *Printing Inks Setup* dialog box, the program uses this percentage as the midtone dot gain value to generate a dot gain curve. Changing the dot gain makes the image appear lighter (if a lower percentage is entered) or darker (if a higher percentage is entered) on the screen. It does not affect the actual data in the image until Adobe Photoshop uses the setting to adjust the CMYK percentages for dot gain during the conversion process.

The filling in of shadows in a halftone image is caused by dot gain and can be due to several factors, or a combination of factors – overinking, overabsorbent paper, overexposure of the printing plate or poor film-to-plate contact. Modern imagesetters are capable of producing a wide variety of dot shapes. Elliptical dots (right) are less prone to dot gain than conventional round dots (left)

Compensating for dot gain in greyscale images in Photoshop

There are two ways to compensate for dot gain in greyscale images:

1. Click *Use Dot Gain for Greyscale Images* option in the *Printing Inks Setup* dialog box. This option adjusts the display to reflect the dot gain. If the image appears too dark, the *Curves* or *Levels* dialog box can be used to compensate for the adjustment on an image-by-image basis.

2. The *Transfer Functions* dialog box can be used to compensate for dot gain when the image goes to film. Transfer functions don't permit viewing the results of the adjustment on screen; however, they provide the most precise control over dot gain and permit adjustment of the dot gain to specific values throughout the image.

Compensating for dot gain in colour images

To compensate for dot gain in the proof of a colour image, the *Dot Gain* text box in the *Printing Inks Setup* dialog box may be used. The dot gain estimate in the *Printing Inks Setup* dialog box represents dot gain for the specified paper stock for the midtones (that is, the 50% pixels). Photoshop then uses this value to create a dot gain curve which adjusts for dot gain throughout the image. The default dot gain estimate reflects the expected dot gain between film and final output (the expected dot gain between the colour proof and the final output is usually between 2 and 5%).

Adjusting for dot gain via Photoshop's Prinking Inks dialog box

Adjusting for dot gain via Photoshop's Transfer Functions dialog box

To determine the correct dot gain, a calibration bar may be included with the proof by clicking the *Calibration Bar* option in the *Page Setup* dialog box. A reflective densitometer can then be used to take a reading at the 50% mark of the printed calibration bar, that value being then added to the printer's estimate of the expected dot gain between proof and final output. In the absence of a densitometer, the *Dot Gain* value should be adjusted until the image on-screen looks like the proof, and then the corresponding value should be added to the printer's estimate of the expected dot gain.

A calibration bar will be provided with the proof when this option is checked

Compensating for dot gain using transfer functions

Transfer functions were used traditionally to compensate for dot gain due to a miscalibrated imagesetter. In addition, transfer functions can be used when precise control over the dot gain values throughout an image is required. Unlike the *Dot Gain* value in the *Printing Inks Setup* dialog box, transfer functions allow specification of up to thirteen values along the greyscale to create a customised dot gain curve.

Adjusting transfer function values:

1. A transmissive densitometer is used to record the density values at the appropriate steps in the image on film

2. *Page Setup* is chosen from the *File* menu, causing the *Page Setup* dialog box to appear

3. Clicking the *Transfer* button opens the *Transfer Functions* dialog box

4. The required adjustment is calculated and the values (as percentages) are entered in the *Transfer Functions* dialog box

For example, if a 50% dot has been specified, and the imagesetter prints it at 58%, then clearly there is an 8% dot gain in the midtones. Entering 42% (50% minus 8%) in the 50% text box of the *Transfer Functions* dialog box compensates for this gain. The imagesetter then prints the 50% dot required. When entering transfer function values, the density range of the imagesetter should be kept in mind.

Undercolour removal and addition and grey component replacement

In theory, equal parts of cyan, magenta and yellow combine to subtract all light and create black. As explained earlier, due to impurities present in all printing inks, a mix of these colours instead produces a muddy brown. To compensate for this deficiency in the colour separation process, prepress operators remove equal amounts of cyan, magenta and yellow from the C, M and Y plates in areas where the three colours overlap, and add black ink instead via the K plate. Called undercolour removal or UCR, the process adds depth to shadow areas and to neutral colours, reduces the amount of ink required and helps prevent ink trapping.

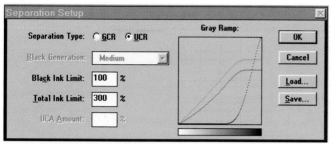

Adjusting UCR via Photoshop's Separation Setup dialog box

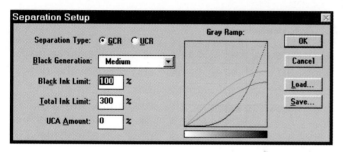

Adjusting GCR via Photoshop's Separation Setup dialog box

Normal CMYK range

Extended range

High fidelity colour extends the gamut of colours which can be printed

UCA or undercolour addition – the converse of UCR – is a way of compensating for the colour thinning which can occur with GCR or UCR, by adding back colour. UCA produces rich, dark shadows in areas that might have appeared flat if they were printed with only black ink. UCA can also prevent the posterisation which can occur if there is a lot of subtle shadow detail.

GCR or grey component replacement is the process of substituting black for the grey component which would have been created in an area of a printed image, where all three colours combine. In GCR, more black ink is used over a wider range of colours. GCR separations tend to reproduce dark, saturated colours better than UCR separations do and GCR separations maintain grey balance better on an offset press.

A number of applications provide the user with the means of manipulating UCR, UCA and GCR values via a *Separations* Dialog Box. The type of separation adjustment required is determined by the paper stock being used and the requirements of the print shop.

High fidelity colour

High fidelity colour printing uses additional process inks to increase the gamut of printed colours by as much as 20%. For example, Pantone Hexachrome colours are reproduced using cyan, magenta, yellow, black, orange and green inks. PageMaker can create separations for up to eight inks, including both process and spot colours, varnishes and high fidelity colours.

Ink and paper

The paper used has a major influence on the quality of the colour printed on it. Because process inks are transparent, it is the light reflected from the paper's surface which supplies the colour to the ink. For example, when light passes

through cyan ink printed on paper, the ink acts like a filter, absorbing the colour it is not (red) and allowing the colour it is (blue and green) to pass through. These two colours then reflect off the paper and back up through the ink. What the viewer sees is a blend of the blue and green colours which constitute cyan. It is the quality and quantity of the reflected light which dictate the quality of the reflected colour. For this reason, the paper must be bright and neutral in colour if it is to reflect maximum light without introducing any colour change. Also, the paper should be smooth and flat as a rough surface will scatter the light and distort the colour.

> White paper reflects all colours.
> Yellow absorbs blue, reflects red and green.
> Magenta absorbs green, reflects red and blue
> Cyan absorbs red, reflects green and blue.
> Black absorbs all colours.
> Rough paper scatters light and distorts colour.

Proofing a publication

Digital proofs

This category of proofs includes those generated from inkjet, laser, thermal wax, phase-change, or dye sublimation printers. Data is imaged directly from the original file on to paper. This method is quick and economical, and is useful to give a first pass representation of how a page will print, but it is not usually accepted by print shops as being a good enough representation of what they are expected to produce, as the proof is not produced from the film which will be used to make the printing plates. In particular, digital proofs cannot reproduce press conditions such as screen frequencies and angles, dot gain, etc.

Off-press proofs

These are made from the film separations which will ultimately be used to make the printing plates. This category includes blueprints, overlay proofs (e.g. Color Key) and laminate proofs (e.g. Cromalin, Matchprint or Agfaproof).

Press proofs

Produced using the very plates, inks and paper which will be used for the final print, press proofs provide the most accurate but also the most expensive proofing method. They are generally reserved for high-end projects ↗

Part 2
Workshop

Defying the paradigms

Virtual architecture and terrain

The portrait

Digital sculpture

The human figure

The bizarre and the macabre

Images from nature and science

Digital art

This Workshop follows on from that in an earlier book by the author – *Digital Graphic Design* – which explained the techniques used to produce over 300 monochrome graphics using leading edge drawing, painting, photoediting and three-dimensional applications. The following workshop explains the techniques used to create an even wider range of graphic effects, many of which employ the additional dimension of colour.

Graphic designs may be classified in many different ways. The method chosen for the purpose of this Workshop is to arrange the chapters by 'theme', showing how designs consistent with each theme can be created using a wide variety of different techniques.

4
Defying
the
paradigms

After Dali's Persistence of Memory

Rendering of Picasso's Guernica

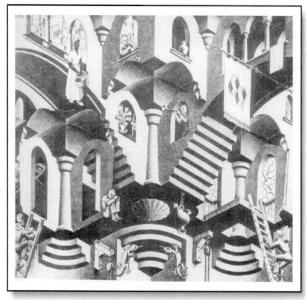

After Escher's Concave and Convex

technique which is finding increasingly common use among graphic designers, particularly in the world of advertising, is one which aims to gain attention by presenting a scene or an image in a way which defies the paradigms with which we expect the world around us to conform. Such a technique is not new, of course, being found in the work of artists like Salvador Dali and Pablo Picasso, to name but two illustrious exponents. Both produced works of almost hypnotic quality, startling the viewer with their unexpectedness and nonconformity with conditioned concepts of structure and order.

More recently, the work of the Dutch graphic artist Maurits Corneille Escher, who died in 1972, has become increasingly popular because of its unique combination of meticulous precision with visual trickery. In 1955 Escher created a visual paradox in the lithograph *Concave and Convex* by combining two separate perspectives into a unified, coherent whole. His work is especially notable for its creation of impossible perspectives and optical illusions – endless staircases and uphill waterfalls – as well as its exploration of the theme of metamorphosis. Even more recently, television advertising has exploited the new technology of morphing to capture viewers' attention by progressively deforming one object – e.g. a car – until it becomes another object such as a galloping stallion.

Analysis of historical examples of this technique show that they fall into a set of categories. Dali's clock appears to have the 'wrong' physical properties, for example; we don't expect clocks to be flexible. Picasso's portraits have the wrong spatial relationships; we expect eyes to be side by side. Many of Escher's works appear to have the wrong

perspective, although their precision attempts to persuade us otherwise. Other categories involve placing objects within the wrong context, giving them the wrong colour or texture, juxtapositioning objects with the wrong relative sizes and so on. In all cases the objective is the same – to startle the viewer and thereby to gain attention.

The historical examples mentioned above were, of course, created by master craftsmen, using traditional techniques to achieve their impact. In this first chapter of the workshop we shall explore ways in which we can also use digital techniques to defy the paradigms.

> **PARADIGM**
>
> An accepted principle, practice or behaviour; what our life experience has taught us to expect.

Magic bricks

This example, which is typical of the work of Maurits Escher, presents a simple brick construction which, at first glance, appears visually convincing. Only a closer look tells us that there is something not quite 'right' about it. The secret about such deceptions is to position components within a composition in such a way that they appear to be physically connected when in fact they are only optically aligned. In this case, the first 'brick' which, in fact, consists only of two sides and a top, is created by skewing a square as shown in Figure 4.1(a). The key in this example is to choose the correct skew angle so that assembly of the bricks as shown in Figure 4.1(b) produces the required alignment.

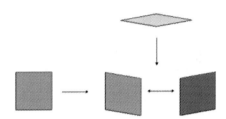

Figure 4.1(a) Constructing the first brick

CONSTRUCTION PROCEDURE – MAGIC BRICKS

1. In CorelDRAW, the basic building block was created, with a 10° skew being applied to the first square

2. The horizontal mirror function was used to create the second face

3. The top face was next created by applying perspective to another duplicate of the first square

4. Shaded fills were applied to the three faces

5. Using the 'snap to points' function the three faces were now brought together to form the first brick and then grouped

6. The duplicate function was used to create the required number of bricks

7. The structure was then assembled brick by brick using the snap to points function to ensure precise alignment

Figure 4.1(b) The final assembly

Weaving

In our normal everyday experience, organic and inorganic objects occupy separate domains (although there are minor exceptions such as the practice of body piercing for the purpose of wearing jewellery). This example overturns that normal experience by presenting the viewer with a hybrid object which seems to have been constructed by weaving together a face and what appears to be some kind of basketwork – Figure 4.2.

CONSTRUCTION PROCEDURE – WEAVING

1. A clipart webbing pattern was opened in CorelDRAW, scaled to size and exported in Adobe Illustrator 3.0 EPS format

2. A new document was opened in Painter and using 'Open EPS as a selection' from the Tools/Selection menu, the webbing EPS file was imported

3. A bitmap image of the girl was opened in Painter in a separate window, and the Freehand Pen tool was used to select the girl's head

4. The selection was feathered by three pixels and the surrounding area was filled with white

5. The head and the webbing pattern were superimposed and then the Masking Brush (with the Mask Out option applied from the menu to protect alternate segments of the weave) was used to paint out alternate segments of the weave

Figure 4.2 Weaving

Scuba diving

One paradigm which alters with age is that of the scale of the objects around us in relation to one another. The baby's perception of scale adjusts as it grows to adulthood – the large teddy bear which terrorised it from the end of its cot now looks like the cuddly toy it seemed to its parents. Once developed, this paradigm of scale is very strong, providing an opportunity for the designer of advertising graphics to gain the attention of the reader by altering the relative scale of objects within a scene so that they no longer fit the viewer's expectations. The scuba diver in a goldfish bowl is an example of this – Figure 4.3.

CONSTRUCTION PROCEDURE – SCUBA DIVER

1. *The shape of the goldfish bowl was first drawn using CorelDRAW's Bezier tool*

2. *The Photo CD image of the scuba diver was then opened in Photoshop where the portion of the image to be used was cropped from the original*

3. *The cropped image was edited with the Levels tool and Dodge tool to improve the visibility of the diver and the fish and then saved as a TIFF file*

4. *The TIFF file was imported into CorelDRAW and selected, then using the PowerClip/Place Inside Container command from the Effects menu the TIFF file was placed inside the 'water' in the goldfish bowl*

5. *To create the impression of curvature of the glass bowl, CorelDRAW's Transparency Lens tool was used to create the reflection on the left (White, 50%) and the darker area to the right (Black, 75%)*

6. *Finally, the Blend tool was used to smooth the edge of the bowl's rim*

Figure 4.3 Scuba diver

The return of King Kong

One of my most vivid childhood memories is that of watching the film *King Kong* in a state of almost paralysed shock. I should explain that I was only about seven at the time and, to this day, I still wonder what the film censors were thinking about when they gave the film a general release certificate. Judging by the looks on the faces around me in the cinema and by the disappearance of heads in front of me as their owners sought refuge under their seats, I suspect the film traumatised many of my generation. Of course the director's objective was to shock and certainly in the matinee performance at my local cinema, he succeeded admirably.

This success was achieved using the technique we just looked at for the scuba diver example – by giving the leading role to a ferocious mountain gorilla one hundred feet tall when most of us in the cinema thought of a gorilla in the form of the docile aging male seen amiably munching leaves on family visits to Glasgow's Calderpark Zoo. The shock effect was further enhanced by removing the gorilla from his normal habitat – i.e. safely behind bars – to *our* habitat which we considered to be definitely a gorilla-free zone.

Figure 4.4 shows a modern day King Kong transported this time from his native Africa not to the height of the Empire State building in New York, but instead to La Grande Arche at La Defense in Paris.

Figure 4.4 King Kong

Figure 4.5 Spook book

CONSTRUCTION PROCEDURE – SPOOK BOOK

1. The bones from a clipart arm and a clipart hand were edited in CorelDRAW and combined to produce just a hand on the end of a wrist

2. The finger bones were node edited to align them as they would be if the hand was gripping a book. The result was exported as an AI Type 3 EPS file

3. The image of the book was sharpened, scaled and rotated in Photoshop

4. The hand was then imported and placed in position on top of the book, and the Smudge tool used to blend the wrist bones into the cover

5. Finally, a suitable title was created in Cloister Black and rotated and skewed to align with the book's perspective

Spook book

This example – Figure 4.5 – achieves impact in several ways. The first is due to the fact that the hand holding the book is skeletal, evoking subconscious associations with dark nights and grisly goings-on; the second way is through the fact that the book is not just any book, but has a dark, slightly sinister appearance, reinforced by the title; the third way is that the rest of the skeleton is missing, the hand appearing to emerge spookily from *inside* the book; finally the image begs the obvious question 'What use would a skeleton have for a book anyway?'

Stonehenge

The megalithic structure of massive vertical stones and horizontal lintels which comprise Stonehenge has become an internationally recognised monument which attracts thousands of visitors to Salisbury in England every year. Dating back to the late Stone Age, its chillingly named *Slaughter Stone* harks back to the practices of our early ancestors who are believed to have used the site for pagan rituals. The positioning of the stones as a means of predicting certain astronomic events also gives the site a very special atmosphere. This example (Figure 4.6) further enhances the already ghostly nature of the site by adding a heavenly face which appears to be looking down on the stones, perhaps recalling with sadness the victims of the many sacrifices witnessed there!

Salisbury

Figure 4.6 Stonehenge

CONSTRUCTION PROCEDURE – STONEHENGE

1. The Photo CD image of Stonehenge was loaded into Photoshop

2. The area behind the stones was selected using first the Magic Wand tool and then Quick Mask and the paint tool at different brush sizes to pick out the detail around the edges of the stones

3. The PhotoCD image of the face was next placed on Photoshop's second layer, scaled and rotated into position

4. Transparency of the second layer was adjusted to allow showthrough of the sky in order to blend the face into the sky

5. Finally, the image of the head was Pasted Inside the selection of the area behind the rocks to create the illusion that the head itself was behind the rocks

Kicking horse

The image of the wild, unbroken stallion is one familiar to lovers of old Western movies. Throwing its would-be riders and kicking down fences were virtually its stock in trade. The horse was also a popular subject for paintings in the centuries before photography, as wealthy owners commissioned artists to immortalise race winners on canvas. This example (Figure 4.7) combines these two threads in an unexpected way. A picture of a horse in a picture frame, or a picture of a horse kicking down a fence would be unremarkable. The sight of a horse within a picture kicking itself out of its picture frame, on the other hand, would be an altogether more unexpected image.

CONSTRUCTION PROCEDURE – KICKING HORSE

1. *Separate clipart images of the horse and the picture frame were opened in CorelDRAW and saved in Adobe Illustrator 3.0 EPS format*

2. *The frame file was imported into Photoshop where the Lasso tool was used to select four segments of the frame which were cut from the original layer and placed on a second layer*

3. *Each fragment was rotated and positioned in turn and then drop shadows were applied to both the segments and the remainder of the original frame*

4. *The horse file was then imported, dragged into position within the frame and scaled to fit*

5. *Finally, a drop shadow was applied to the horse*

Figure 4.7 Kicking horse

The sign painter

Of all the members of the animal kingdom, few command our respect more than the tiger. Perhaps we have inherited such respect from those among our ancestors who managed to avoid becoming a sabre tooth's supper! The image of the tiger used here (Figure 4.8) plays on our subconscious fear of this powerful predator, while the ploy of bringing such an outsized inanimate version to life is the stuff of nightmares. Amusement at the misfortune of others – in this case the hapless sign painter – is probably another instinct we have inherited from our ancient ancestors.

CONSTRUCTION PROCEDURE – SIGN PAINTER

1. Clipart images of the painter, the ladder and the tiger's head were opened in CorelDRAW and saved in Adobe Illustrator 3.0 EPS format

2. The three saved files were then opened in Photoshop, the painter image being placed on a layer above the other two

3. A layer mask was next applied to the painter image and Photoshop's paintbrushes were used to 'paint out' part of the layer mask, allowing the tiger to show through and creating the illusion that the painter's arm and head were now inside the tiger's mouth

4. The resulting image was then flattened and saved as a TIFF file

5. Finally, the TIFF file was opened in CorelDRAW, where the text was added

Figure 4.8 Sign painter

Rodeo

While the classic Western movie may have given way to modern equivalents like *Star Wars* and *Top Gun*, the romance of the Wild West remains an enduring one. A familiar scene within the Western was the rodeo, where cowboys pitted their skills and experience against the strength and wiles of wild mustangs. Inspired by such memories, this example plucks an unsuspecting cowpoke from his passive and clearly aging mount and places him on the back of a rather surprised looking grasshopper whose height to weight jumping ratio would put to shame the wildest of rodeo stallions (Figure 4.9). Like earlier examples, this one uses the incongruity of scale for its effect as well as the unlikely partnership of man and insect.

> **CONSTRUCTION PROCEDURE – RODEO**
>
> 1. Clipart images of a mounted cowboy and a grasshopper were opened in CorelDRAW
>
> 2. Using the Node Editing tool, the cowboy was removed from his horse, scaled and placed in position on top of the grasshopper
>
> 3. The Perspective and Distortion tools were then used to adjust the perspective of the grasshopper to align it with that of the cowboy
>
> 4. Finally, the Drawing tools were used to give the cowboy a right hand and to add and position new reins around the grasshopper's head

Figure 4.9 Rodeo

Chessboard

Providing the arena for perhaps the purest form of one-to-one intellectual competition, the chessboard, with its orderly rows of black and white squares, presents an environment for structured conflict – a virtual battlefield on which the combatants, representing royalty, the church and the army, play out the strategies of small boys and Grand Masters alike. The rules of the game are precisely defined and must be assiduously followed.

In this example, that order and structure is overthrown. Across the set piece runs a human figure, fleeing from some unseen danger, blissfully unaware of her surroundings, even knocking over one of the pawns in her haste (Figure 4.10).

> **CONSTRUCTION PROCEDURE – CHESSBOARD**
>
> 1. The segment of the chessboard was constructed using CorelDRAW's Grid tool
>
> 2. Squares were filled alternately with black and white and then perspective was adjusted using the Perspective tool
>
> 3. Clipart chess pieces were next scaled, positioned and given a fountain fill
>
> 4. The clipart image of the running girl was then added, scaled and positioned using Arrange/Order to place her behind the pawn but in front of the bishop
>
> 5. Finally, one of the pawns was 'knocked over' to help reinforce the illusion that the girl was running across the board

Figure 4.10 Chessboard

Muscles

Few teenage boys have not fantasised about how their lives would be transformed if only they could acquire the physique of an Arnold Schwarzenegger – a fantasy which has been fuelled for reasons of commercial gain since the days of Charles Atlas, with products ranging from lotions and potions, pills and tablets, to ingenious (and usually useless) exercise gadgets and contraptions. Playing on this male vanity, this example (Figure 4.11) offers an alternative solution!

Figure 4.11 Muscles

> ### CONSTRUCTION PROCEDURE – MUSCLES
>
> 1. Two cartoon clipart images were selected – one of Mr Universe and the other of Mr Unendowed
> 2. The Mr Universe figure was saved in Adobe Illustrator 3.0 EPS format and imported into Photoshop for editing
> 3. Photoshop's Eraser and Paintbrush tools were used to delete parts of the original figure and add new parts (two loops passing over a pole)
> 4. The edited torso was then imported back into CorelDRAW and set alongside Mr Unendowed

Schizophrenia

A technique exploited for many years in children's stories and films has been the transformation of a character in the story or film from one form into another – from a frog to a prince, from Clark Kent to Superman, for example. More often, however, particularly in horror films, the transformation is from a benign form to a malign one, the classic examples being *Dr Jekyll and Mr Hyde* and *Portrait of Dorian Grey*. This example (Figure 4.12) employs a similar technique.

Figure 4.12 Schizophrenia

CONSTRUCTION PROCEDURE – SCHIZOPHRENIA

1. *Two Photo CD images were selected and scaled to match in size and resolution*

2. *A blank sheet of paper was torn in two places and the paper adjacent to the tears was folded back on itself*

3. *The torn and folded paper was scanned and scaled to the required size*

4. *All three images were opened in Photoshop where they were sharpened and levels were adjusted*

5. *The images were merged but placed on three separate layers, with the scanned image of the paper in the middle of the sandwich*

6. *The area of the torn section was next selected, smoothed and feathered and then removed using the Eraser tool, revealing part of the classical portrait beneath*

7. *Switching next to the top layer, a selection was made corresponding to the three folded back areas. The selection was inverted, smoothed and feathered and then erased, revealing the paper below*

8. *Finally the paper area was selected and colorised*

La mode

In this example, the viewer's attention is captured by the unexpected scale of the models in relation to the size of the text. The typeface chosen for the text – Bellevue – echoes the elegance associated with high fashion and the positioning of the models, such that their hands appear to be resting on the type characters, helps to integrate them into the composition.

Figure 4.13 La Mode

CONSTRUCTION PROCEDURE – LA MODE

1. The text was created in CorelDRAW, using the typeface Bellevue, scaled to size and kerned to provide the correct character spacing
2. The clipart fashion models were imported, scaled and positioned in relation to the text
3. The elements were grouped and saved in Adobe Illustrator 3.0 EPS format
4. Finally, the composition was imported to Photoshop where a drop shadow was added

The web

Given that a significant proportion of the population suffer, in varying degrees, from arachnaphobia, or fear of spiders, the use of spiders or spiders' webs in any graphic is a sure way to get attention! This example plays on that fear by mutating the spider and web to human size and creating the illusion that a child has strayed on to the web, provoking conflicting reactions of repulsion from the spider and protection for the child (Figure 4.14).

CONSTRUCTION PROCEDURE – THE WEB

1. The clipart spider, web and child were assembled in CorelDRAW, scaled and positioned
2. The web was ungrouped and the elements adjacent to the child were node edited and positioned at appropriate levels to give the impression that the child is gripping the web and that it is distorting under his weight

Figure 4.14 The web

Figure 4.15 The baby

Further examples in brief

Figure 4.15 – The clipart baby was scaled and positioned within a hostile fantasy background, then edited to appear to be crawling down an icy slope towards the cliff edge.

Figure 4.16 – Clipart cartoon arms, legs and musical instruments were grouped, scaled and positioned, then musical notes were added for effect.

Figure 4.17 – A screenshot window was captured and pasted into Painter. Painter's *Distortion Brush* and *Image Warp* (from *Effects/ Surface Control*) were used to distort the image.

Figure 4.18 – The old man's beard was cloned in Photoshop to cover his mouth completely.

Figure 4.19 – Two clipart figures were scaled and one was rotated and then both were placed in position as hands of a clock.

Figure 4.20 – A copy of the bulb's outline shape was edited and then given gradient fill. Corel's *Transparency Lens* was applied to two copies of the fish (50% and 25%) and one copy was positioned behind the filament support.

Figure 4.16 Dancing musical instruments

Figure 4.17 Screenshot

Figure 4.18 Silence is golden

94

Figure 4.19 Clock hands

Figure 4.20 Lightbulb

Figure 4.21 – A clipart clock was rotated and perspective was applied, then it was imported into Painter, where *Surface Effects/Mesh Warp* were used to distort the shape further. Droplet shaped selection made from bottom edge of clock using the *Pen* tool and three droplets were created, scaled and edited. Finally, the clock and droplets were given drop shadows.

Figure 4.22 – A mutation was produced by importing clipart sheep and clipart wolf into CorelDRAW, scaling them to match in size and then node editing both objects to remove their heads from their bodies. The wolf's head was then positioned in relation to the sheep's body, using *Arrange/Order/To Front* to keep it on top ↗

Figure 4.21 Dripping clock

Figure 4.22 The wolfsheep

5
Virtual architecture and terrain

or centuries, the tools and techniques of architectural design have evolved in parallel with those of the artist and the graphic designer. By its nature, of course, architecture depends heavily on the precision of arithmetic, geometry and trigonometry for its success and, ever since the design and construction of the pyramids, has required its designers to undertake complex numerical calculations. Since carrying out complex numerical calculations quickly and effortlessly is one of the things which computers do best, it is no wonder, then, that architectural design, a subset of CAD – Computer Aided Design – was one of the earliest and most successful computer applications. Although the hardware demands of early programs were beyond the capabilities of desktop computers, as those capabilities have increased, many desktop applications have become available and many of the features of these applications have found their way into precision drawing programs like Adobe Illustrator, CorelDRAW, Macromedia Freehand and Micrografx Designer, as well as three-dimensional programs like RayDream Designer, Extreme 3D and MetaTool's Bryce. In this chapter, we shall examine how such features can be used to create a range of structures and terrains for incorporation in design projects requiring such effects.

Architektur ist die erstarrte Musik – Architecture is frozen music

Friedrich von Schelling 1775–1854 German philosopher

Two-dimensional layouts

All the drawing applications mentioned above provide the user with a drawing environment which includes high precision rulers, grids and movable guides. Different elements of a drawing can be stored on a series of electronic layers – useful when drawing, for example, office layouts, as separate layers can be used for furniture, IT equipment, electrical wiring etc. Features such as snapping of objects to the background grid or guidelines, duplicating, scaling, rotating and mirroring of objects make possible the production of quite complex layouts.

Drawing primitives start with straight lines of variable stroke and style as well as tangents and parallel, perpendicular and dimensioned lines. Freehand and Bézier curved variants include splines, parabolas and spirals. Closed shapes include squares, rectangles, cir-

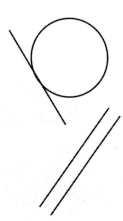

cles, ellipses, grids, stars and polygons.

While the above set of primitives can be used to create the wide range of common objects normally featured in residential or commercial layouts, time can be saved by the use of ready-made architectural clipart in both plan and elevation formats. The plan views in Figures 5.1 and 5.2 and the city ele-vation in Figure 5.3 were constructed from a range of separate clipart items.

A combination of the basic drawing tools plus features like *Duplicate, Scale, Rotate* and *Mirror* can be used to produce more complex structures like the church in Figure 5.4.

A common requirement in architectural drawing is the addition to a drawing of de-scriptive labels. CorelDRAW provides useful tools for this purpose. A variant of the line tool – Figure 5.5(a) – allows easy placement of an arrow pointing at the feature to be highlighted and the automatic placing of the text cursor for typing an appropriate annotation. The *Magnify* lens, used in *Frozen* mode, can also be used to enlarge detail within an object.

Simple layouts and structures can also be enhanced by adding vector or bitmap fills like *Bricks* or *Stucco* to facades; the simple ele-vation example in Figure 5.6(a) was created by first drawing the outline shape of the building, filling it with black and then draw-ing, duplicating and filling it with white shapes for the roof tiles, windows, doors etc. The finished result was imported into Painter, where Painter's *Ivy* and *Poppies* image hoses – Figures 5.6(b) and 5.6(c) – were scaled and used to add detail – Figure 5.5(d).

Figure 5.1 Two-dimensional room layout

Figure 5.2 Simple plan view

Figure 5.3 Cityscape

Figure 5.4 Church frontal elevation

(a)

(b)

(c)

(d)

Figure 5.6 Enhancing an elevation

Annotation

(b)

(a)

Figure 5.5 Annotating and highlighting

100

Pseudo 3D effects

By utilising the same tools and drawing features used for producing two-dimensional layouts and by observing the three rules of perspective – convergence, diminution and foreshortening – drawing applications can be used to construct quite complex pseudo three-dimensional structures. By applying these rules as well as other visual cues, such as the use of shading and simulated aerial effects, the graphic designer can trick the viewer's eye into perceiving two-dimensional drawings as having a third dimension. Two point perspective has been applied to the line drawing of the frontal elevation of the Arche de Triomphe in Figure 5.7 by grouping the completed drawing and using the *Perspective* tool. The drawing and skewing of the right hand side of the arch and the shaded inside of the arched opening, using the same lines of perspective, complete the illusion.

The use of simple two point perspective and a view point close to ground level was enhanced by a simple shaded fill on the end of the building to produce the result in Figure 5.8. As Figures 5.9 and 5.10 show, similar techniques can be used to create quite convincing representations of famous landmarks.

Figure 5.7 The use of perspective and shade

Figure 5.8 Two point perspective

Figure 5.9 The splines and parabolas of Sydney Opera House

Figure 5.10 Duplication and non-proportional scaling featured heavily in creating this representation of Berlin's Brandenburg Gate

Figure 5.11 Achieving a sense of depth through convergence, foreshortening and diminution

Country scenes or terrains can also be given the illusion of three dimensions by applying the same rules of perspective. Figure 5.11 shows a simple example of a drawing of a country road scene which applies the rule of convergence (as the parallel sides of the road appear to converge in the distance), foreshortening (as the equally spaced white marker lines appear to come closer together, at a constant rate as they recede into the distance) and diminution (as the equally sized marker lines become progressively smaller in the distance).

In Figure 5.12 the more distant trees diminish in size compared with those in the foreground. The feeling of depth is further enhanced by the shading of the ground from dark (foreground) to light (background) and the layering of the drawn objects to place the river and mountains behind the trees.

Figure 5.13 uses a combination of aerial effects and gradient fills to create the illusion of a series of wooded foothills receding towards a distant mountain range. Figure 5.14 just uses shading to achieve an aerial effect but also introduces a sharp change in apparent altitude to provide additional interest.

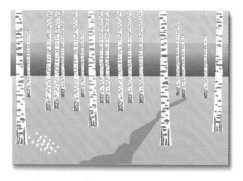

Figure 5.12
Use of diminution, shading and layering

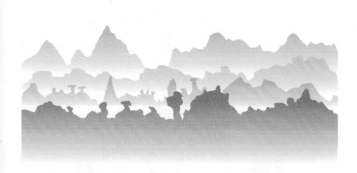

Figure 5.13 Use of aerial effects to convey distance

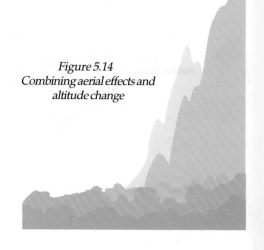

Figure 5.14
Combining aerial effects and
altitude change

Combining several of the techniques from the above examples, the simple landscape shown in Figure 5.15 adds the powerful visual effect of a shadow of the tree in the foreground to create an illusion of distance.

Using a similar technique – a simulated reflection in water – Figure 5.16 shows how a combination of shading with the use of reflection can create a surprisingly effective seascape.

Figure 5.17 uses a more novel technique. A Painter nozzle consisting of a series of whitewashed pueblo-style buildings was used to 'spray' layers of the buildings on to a flat canvas, producing the result shown. Benefiting, perhaps, from the absence of planning permission, the result is reminiscent of many a Mediterranean hillside village.

The final example in this section – Figure 5.18 – shows a more stylised example which achieves visual impact through layering a series of high-rise buildings in a jumbled, impossible perspective relationship.

Figure 5.15 Landscape using a combination of perspective effects

Figure 5.16 The use of reflection and shading

Figure 5.17 Spray your own village, using one of Painter's nozzles

Figure 5.18 High-rise hiatus

103

3D modelling

While a skilled designer can produce quite convincing three-dimensional illusions within a drawing application, using a combination of ingenuity and the techniques illustrated in the previous section, the results are limited to the plane in which the drawing has been created. To produce scenes which are truly three dimensional, i.e. which, once created, can be freely rotated around cartesian axes and viewed from any angle, the designer has to move on to applications which are capable of producing genuine three-dimensional representations.

Until recently the processing power needed to handle the complex calculations involved in manipulating 3D objects and scenes, especially when a composition required the rendering of textures, reflections and shadows, was prohibitively expensive and was restricted mainly to high end

Figure 5.19 AutoCAD's modelling window

workstations used for CAD solid modelling work – Figures 5.19 and 5.20. Such was the complexity of the software that, even for the CAD professional, the application learning curve was daunting. All of that is happily now changing rapidly, with the advent of faster and cheaper processors and graphic cards and the trend in the design of applications like RayDream Studio (Figure 5.21), Extreme 3D or MetaTool's Bryce towards user friendliness, bringing true 3D modelling within the reach of the desktop user.

While the desktop drawing application 'metaphor' is already starting to mature, with a growing commonality of commands, tools and features being offered by different vendors, the more complex 3D application metaphor is still at an early stage, as developers test the market with different approaches. Instead of the drawing area and line and shape tools of the drawing application, the 3D application offers 3D 'views' and solid primitives like spheres,

Figure 5.20 The early application of 3D modelling was in the field of engineering design

Figure 5.21 RayDream Studio's modelling environment

Figure 5.22 The same object viewed from different camera angles

105

Figure 5.23 3D palm tree set against 2D background

Figure 5.24
Bitmap image mapped
to the surface of a sphere

Figure 5.25
Bumpmapped texture
applied to the surface
of a sphere

cubes and cones. As well as these primitives, freehand organic shapes can be created using the processes of lathing, extruding, skinning and sweeping and the resulting forms can be grouped or combined to create subassemblies which, in turn, can be grouped to produce higher assemblies.

Results can be viewed through various camera lenses from a variety of positions (Figure 5.22) and lighting can be manipulated to create different effects. A wide variety of materials including bumpmaps and reflection maps can be applied to objects and, when composition is complete, sophisticated rendering processes create shadows, reflections, refraction and even environmental effects like fog and haze.

As well as making it possible for the designer to create quite detailed architectural structures, applications like Extreme 3D can be used to produce hybrid results like the seascape in Figure 5.23, which combines the palm tree created in the foreground as a 3D object with an imported 2D backdrop. Such applications also provide image mapping and bumpmapping techniques which can be used to produce results like the mapping of a 2D map of the Earth on to the surface of a sphere (Figure 5.24) and the bumpmapping of the textured surface of another sphere to produce the lunar-like landscape in Figure 5.25.

While Extreme 3D can be also be used to produce terrains – by dragging up nodes from a flat ground plane and then applying a suitable texture to its surface – the application which excels in this domain is MetaCreation's *Bryce*. Although capable of producing more conventional 3D models from a comprehensive set of primitives, it is in the creation of realistically stunning terrestrial or lunar landscapes that Bryce excels. Although the rather quirky interface (Figure 5.26) takes a little time to master, the return on the time invested pays back handsomely.

The small window at the top left of the modelling screen shows a miniature rendering of the current scene as it proceeds. To the right of that (displayed when the *Create* menu is highlighted) is a set of selectable primitives which include, as well as the usual spheres, cubes etc., a number of 'geographic' primitives – water, skies, ground planes, relief surfaces and rocks. Primitives selected from the *Create* menu appear in the modelling area as shown in Figure 5.26 where they can be manipulated using tools from the *Edit* menu (Figure 5.27). In addition to the single default light which illuminates each new scene, additional lights can be added from the group of four types at the right hand end of the display of primitives. A third menu, *Sky & Fog* (Figure 5.28) is used to edit the sky parameters and to add haze or fog to scenes. Down the left hand side of the modelling area are various tools for adjusting the camera view of a scene and for controlling the rendering process. A dazzling range of preset procedural textures is

Figure 5.26 Bryce's modelling environment

Figure 5.27 Bryce's object editing tools

Figure 5.28 Tools for editing sky, haze and fog

available for application to objects (Figure 5.29), while the *Materials Composer* (Figure 5.30) can be used either to edit presets or create new materials using a wide range of controls. A *Terrain Editor* (Figure 5.31) provides a means of manipulating the topography of individual terrain or rock objects within a scene.

Figure 5.29 Bryce's Materials presets

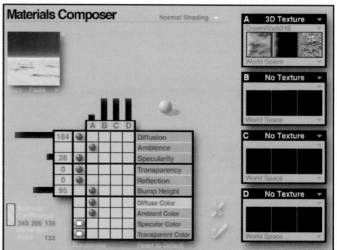

Figure 5.30 Bryce's Materials Composer

Figure 5.31
Bryce's Terrain editor

The few examples which follow can only scratch the surface of what this extraordinary application is capable of, once the initial learning curve is overcome. With its high quality raytracing renderer, it can produce landscapes, seascapes, cityscapes and extraterrestrial terrains of breathtaking beauty, pointing the way to the future of architectural virtual reality development, as additional animation capability is added to the application's features.

Figure 5.32 Mountain high. Before rendering (above) and after (below)

Figure 5.33 Sandstone rocks. Before rendering (above) and after (below)

CONSTRUCTION PROCEDURE – MOUNTAIN HIGH

1. A terrain object was scaled and moved forward to fill the foreground

2. The terrain was given a fractal rocky texture from the Rocks and Terrains preset menu. The chosen texture included the brownish deposit seen on the rocky surface

3. The ground plane which stretches away behind the mountain was given a sand and rocks texture from the Materials menu

4. An afternoon sky was selected, with distant haze added to blend the ground plane into the sky at the horizon

CONSTRUCTION PROCEDURE – SANDSTONE ROCKS

1. Three terrain objects were placed and scaled

2. All three were eroded in the Terrain Editor and given a sandstone texture from the Materials preset menu

3. A water plane was added and a reflective water texture was applied

4. A sphere primitive 'moon' was placed in the sky, scaled, positioned and given a texture from the Rock and Terrains presets menu

5. An evening sky was selected from the Sky & Fog presets menu

6. The direction of the default light was adjusted to enhance the shadows cast on the rocks

Figure 5.34 Shallow water

CONSTRUCTION PROCEDURE – SHALLOW WATER

1. The ground plane was selected and given a coarse, stony texture

2. A water plane was then added and given a high transparency texture to allow the underlying rocks to 'show through'

3. A small terrain was added, dragged to the right and lowered so that it appeared to rise out of the water. A coarse sandstone texture was applied to the terrain

4. A cloudy afternoon texture was applied to the sky

Figure 5.35 City lights

CONSTRUCTION PROCEDURE – CITY LIGHTS

1. A terrain was placed, scaled and positioned and then edited as described in the caption to Figure 5.36, to create the blocky appearance of a high-rise city block

2. A special materials texture was then selected from the Materials presets menu and applied to the terrain to simulate office block lighting

3. A water plane was next added and a reflective water texture was applied to its surface

4. Finally, a night sky was selected from the Sky & Fog presets menu to backlight the buildings and to reflect in the surface of the water

Figure 5.36
Bryce's Terrain Editor dialog box. A greyscale checkerboard was first created in CorelDRAW and saved as a TIFF file. The file was then opened in the Terrain Editor by selecting Elevation/Picture. The resulting terrain consists of high-rise blocks, with height varying according to grey level (white highest, black lowest and intermediate heights corresponding to intermediate shades of grey)

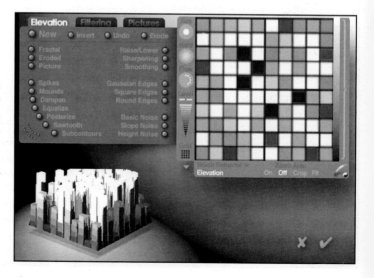

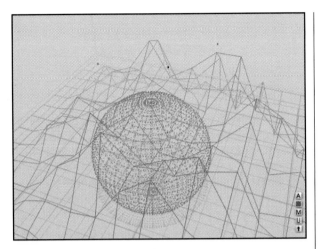

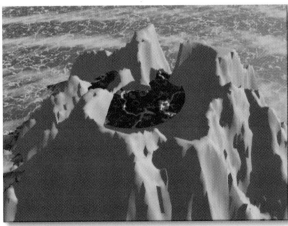

Figure 5.37 Volcanic island before rendering (top) and after rendering (above)

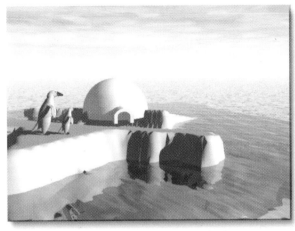

Figure 5.38 Bryce's dialog box for setting Boolean object attributes

Figure 5.39 Polar scene

Figure 5.40
Bryce's dialog box for smoothing imported polyhedron objects

CONSTRUCTION PROCEDURE – VOLCANIC ISLAND

1. A new terrain object was placed on a ground plane and the camera angle was adjusted to create an aerial view of the scene

2. With the terrain still selected, the Positive attribute was checked in the Object Attributes dialog box (Figure 5.38)

3. A sphere was imported into the scene and given a negative object attribute so that, when it was grouped with the terrain object, it carved out a deep hemispherical depression to create the volcanic crater

4. A flattened disc object was placed in the crater and given a texture which simulated molten lava

5. The ground plane was given a 'frothy sea' texture and the terrain was given a grey texture to simulate lava

CONSTRUCTION PROCEDURE – POLAR SCENE

1. A new terrain object was placed and edited in the Terrain Editor to produce a flattened 'iceberg'

2. The igloo and penguin were imported as DXF files, scaled and placed in position on the iceberg. The penguin was duplicated and the copy was reduced in size. The penguins were smoothed using the Polyhedron dialog box (Figure 5.40)

3. A water plane was added and given a texture allowing both reflection (note the reflection of the penguins in the water) and transmission, to allow the part of the iceberg under water to show through

4. The iceberg and igloo were given a grainy white texture to simulate snow

5. Finally a cool sky texture was selected from the presets menu

Figure 5.41 Return from space

**CONSTRUCTION PROCEDURE –
RETURN FROM SPACE**

1. *Two spheres were placed, scaled and positioned to create the planet and moon*
2. *The planet was given a 'cloud cover' texture and the moon was given a grey bumpmapped texture*
3. *To create the gaseous ring around the moon a toroid was selected, flattened and placed in position and then given a cloudy texture with the 'Fuzzy' shading option selected in the Materials Composer dialog box*
4. *Finally a DXF file of the shuttle model was imported, scaled and placed in position*

Figure 5.42 Satellite

CONSTRUCTION PROCEDURE – SATELLITE

1. *The ground planes was selected and given a scattered clouds texture*
2. *To create the moon, a sphere was placed, scaled and given a luminous blue, bumpmapped texture*
3. *A DXF file of the satellite was imported, rotated, scaled and positioned in the foreground. Smoothing was not applied as the polygonal surfaces gave the satellite a more realistic appearance*

Terrains can also be built from DEM (Digital Elevation Module) files. DEM is the file format used by the US Geographical Society for cataloguing topographical information. DEM files can be converted to greyscale image maps using a Shareware program called *DEM View* which is available for download from the Internet. Figure 5.38 shows such an image map of an area west of Salt Lake City in Utah. Once created, the

Figure 5.43 DEM data file converted to an image map of an area near Salt Lake City (1:250 000)

image file can be imported into Bryce's *Terrain Editor* where it can be used to recreate its topography on a terrain object within the Bryce working window. There, the terrain can be edited and manipulated like any other terrain object. Figures 5.44 and 5.45 show two different views of the Salt Lake City area topography created in this way ↗

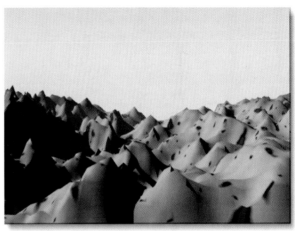

Figure 5.44 An aerial view of Salt Lake City area created from the image map in Figure 5.43

Figure 5.45 A second view of the Salt Lake City area using a different camera angle and a late evening sky

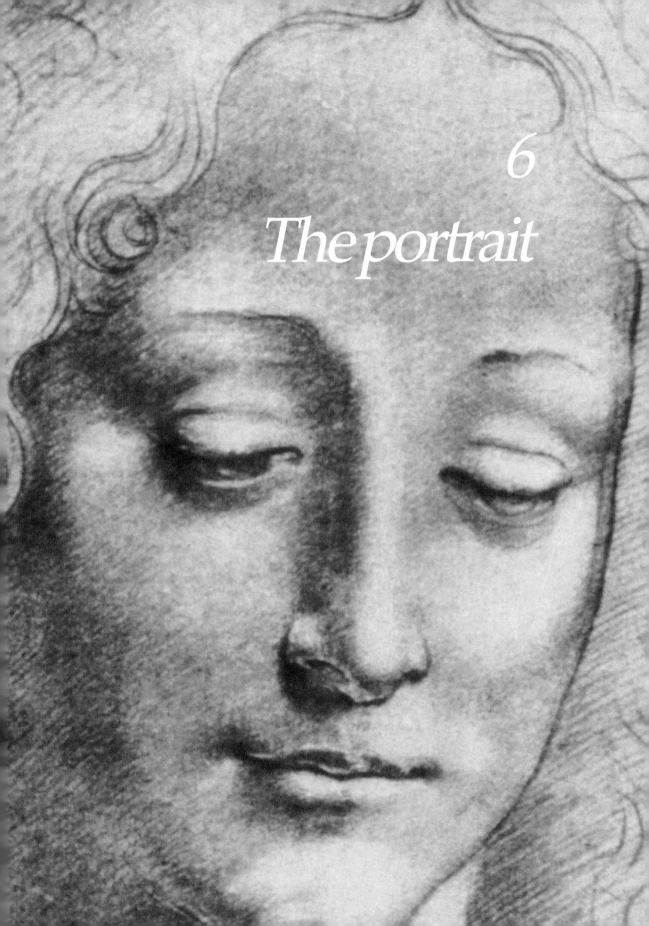

The portrait

Figure 6.1 Although relatively crude in execution, these earliest of portraits have powerful visual impact, with imaginative use of the limited colours then available

ince the earliest beginnings of art, the portrait has been one of its most popular forms. The oldest surviving examples, dating from early Egyptian, through Greek and Roman times and into the first millennium, often feature deities or idealised heroic subjects. Although the ravages of time and climate have left their mark, the examples which survive bear testimony to the skills of the earliest portrait painters.

While the religious influence remained strong into the Middle Ages, the range of subjects broadened to include noblemen and wealthy merchants, members of their families or other chosen subjects. The reason for this is twofold; firstly because over the centuries very few gifted artists were financially independent and they were therefore obliged to seek financial sponsorship from wealthy patrons; secondly because, in exchange for their patronage, these noblemen and merchants would often require the artist to paint their portraits in order to satisfy their own vanity.

Portrait painting over the centuries has, of course, evolved and developed like other forms of art, reflecting the changing moods of the centuries in which they were created, the different styles of the artists and the use of different materials and techniques as these evolved. As well as creating a fascinating visual record of our early ancestors, these portraits form a priceless archive of the anthropological development of the various ethnic lines traced by man's rapid evolution during the last few thousand years.

Figure 6.2
Many early works convey religious themes. These were often commissioned for display in churches and cathedrals

Figure 6.3 As the portrait developed as an art form, so did the skill of the portrait artist in rendering the subtleties of bone structure, skin tone and shade

Figure 6.4 Many early portraits were commissioned by wealthy merchants, noblemen or church dignitaries

In the realm of portrait painting, the digital artist has a wide range of possibilities, starting from the most basic line art construction (Figure 6.5) created within a drawing application, using a combination of line, curve and shape tools. Closed vector shapes can be given simple colour fills (Figure 6.6) or more exotic gradient, texture or pattern fills. Quite powerful results can be achieved with the use of such basic tools to produce shaded or hand rendered effects (Figure 6.7).

Drawing application blend tools also provide the possibility of more subtle effects, as shown in the example in Figure 6.8; here, the blend tool has been used to create a smooth shading to the cheeks and to the eyelids of the face, producing much more impact to the finished result than could be achieved with simple flat fills.

Some drawing applications, such as Macromedia Freehand, also offer the option of using a stylus and tablet to use drawing tools in a pressure sensitive mode, so that lines of variable stroke can be drawn as the designer varies the pressure of the stylus.

Portraits created in a drawing application have the advantage that individual lines and shapes can be easily selected for editing. Such drawings are fully scalable without loss of definition and they print well even on relatively low resolution printers. Although simple in construction, they can have strong visual impact and make excellent posters.

Another approach is to exploit the editability of a drawing application to create the basic features of the portrait and then to import the result into a painting application, where it becomes transformed into a bitmap for further enhancement.

*Figure 6.5
Basic line drawing*

*Figure 6.6
Colour enhancement using a
vector fill tool*

Figure 6.7 Vector drawn portraits can be given depth through the use of fills, hand rendered effects or shading

(a) (b) (c) (d)

Figure 6.8
Enhancement of a vector portrait using blends. The final result (a) is shown broken down into its shape elements (b) and (c). (d) shows how the shading of the cheeks and the eyelids was achieved by using two 10 step blends between shapes filled with solid colour

120

Using a combination of the precision drawing tools offered by applications like Freehand, Illustrator, CorelDRAW or Designer, together with the glittering array of brush styles and painting techniques offered by the leading bitmap painting application Fractal Painter, there are few traditional portrait styles which cannot be emulated by the skilled digital designer or artist. However, while reproducing such styles represents an interesting technical challenge, the exciting thing about the digital medium is that it offers the opportunity to create unique and striking effects which would be difficult if not impossible using traditional methods. The aim of this chapter is to explore just a few of these effects in the examples which follow.

Tonal control effects

Interesting results can be obtained by using the tonal controls available in Photoshop or Painter. Figure 6.9 shows, for example, the use of Photoshop's *Hue/Saturation/Colorize* controls to create a sepia image and the effect of changing the mode of a cutout of the image to *Black and White* and applying the *Diffusion Dither* option.

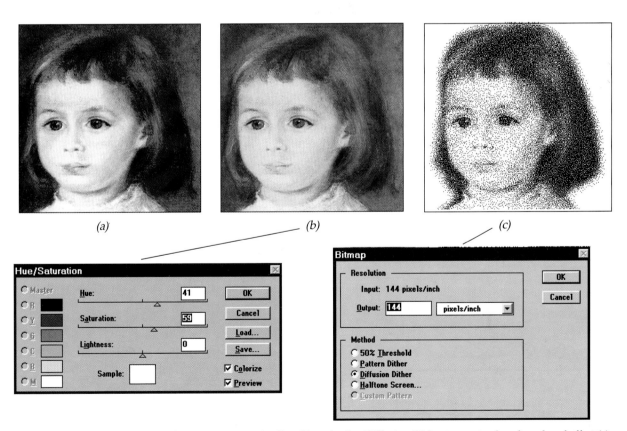

Figure 6.9 Colorising an original (a) to create a sepia effect (b) and using Diffusion Dither to create a hand rendered effect (c)

Other tonal controls which can produce dramatic changes in the appearance of an image are *Threshold* and *Curves*. After placing the image (a) in Figure 6.10 in Photoshop, *Image/Map/Threshold* was selected, opening the dialog box in (d). The effect of *Threshold*, as the name implies, is to convert all the pixels in an image either to black or to white, depending on which side of a greyscale threshold they fall. By adjusting the slider in the dialog box, the threshold setting giving the optimum contrast effect can be chosen (b). To produce the variant shown in (c), image (a) was duplicated and *Image/Adjust/Curves* was selected, opening the dialog box in (e). The x-axis of the graph represents the brightness values of the pixels in the original image; the y-axis represents the new brightness values. The default diagonal line shows the starting relationship between the input and output values, with no pixels mapped to new values. Manipulating the shape of the curve in the dialog box causes selective changes in brightness, producing the solarised result shown in (c).

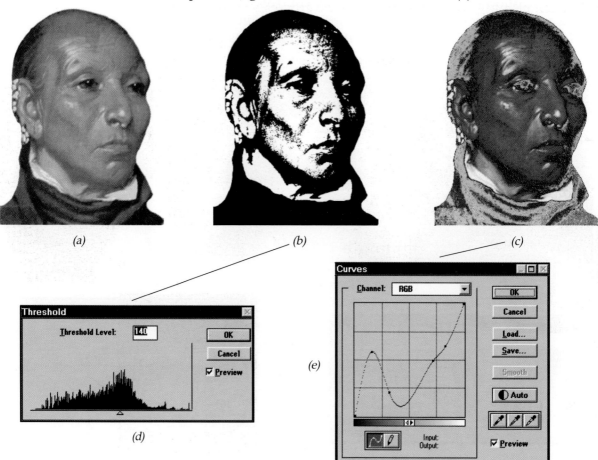

Figure 6.10 Applying Threshold to an original image (a) to create a bold, black and white contrast (b) and using Curves to create a dramatic solarised effect (c)

The posterisation technique – so-called because it produces an image using very few colours, or tints of the same colour, in the style of early silk-screened publicity posters – can produce some interesting portrait effects. The *Posterise* command in painting applications allows the user to specify the number of tonal levels (or brightness values) for an image and then maps pixels to the level that is the closest match. In the example shown below (Figure 6.11), a 3 level posterisation was applied to the image in (a) in Photoshop to produce the result in (b), a 3 level posterisation offering a maximum of ten colours, compared with the millions of colours in the RGB original. To simplify the result even further, Photoshop's *Dust & Scratches* filter was applied to image (b) to produce image (c). Although the normal purpose of this filter is to remove defects from scanned photographic images, it was used in this case to remove the graininess of the posterised image. Such an image can easily be traced in a drawing application, where it can be scaled, without loss of resolution, for silkscreen printing. The same applies to the greyscale example in (d).

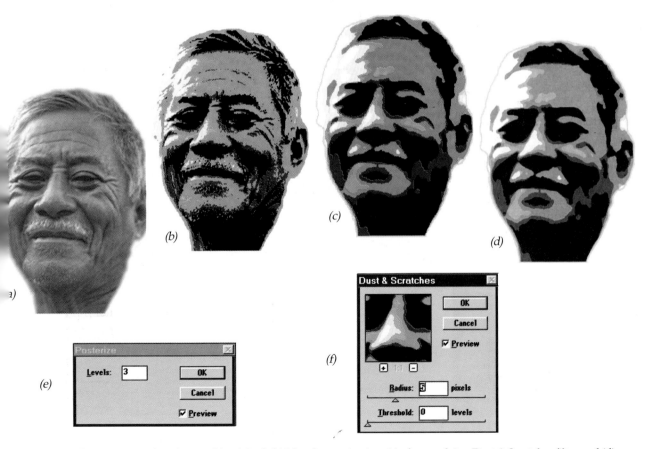

Figure 6.11 Posterising a colour image: (a) original, (b) 3 level posterisation, (c) after applying Dust & Scratches filter and (d) after conversion to greyscale; (e) and (f) show the Posterize and Dust & Scratches dialog boxes respectively

Painting styles

Starting with a photograph or original portrait painting, Fractal Painter offers a wide range of editing possibilities. The original portrait can either be reproduced, via Painter's cloning feature, using cloning brushes which emulate the style of, for example, the Impressionists or can be recreated using any of Painter's wide range of drawing and painting tools. The original painting in Figure 6.12(a) was cloned three times; painting in the cloned images, using Painter's *Artist* clone brushes produced the results in (b) using the *Impressionist* style, (c) using the *Seurat* style and (d) using the *Van Gogh* style.

The results in Figure 6.13 were obtained using four of Painter's other specific cloning tools: (a) used the *Melt Cloner,* in *Soft Cover* mode; (b) used the *Driving Rain Cloner* in *Soft Cover* mode; (c) used the *Chalk Cloner* in *Grainy Hard Cover* mode and (d) used the *Felt Pen Cloner* in *Grainy Hard Cover* mode.

As stated above, any of Painter's range of brushes can be used in clone mode either individually or in combination. Figure 6.14 shows the effect of cloning an original (a) using one of Painter's special effects brushes *F/X Fire* (b), while the result in (c) was obtained using a combination of the *Spirex* brush in *Comb* mode to paint in the flowing lines of the hair and then the *Airbrush* in *Clone* mode to add the soft focus image of the face. When the objective is to clone a specific portion of the original image, then a 'ghost' of the original can be displayed in the clone window for guidance as shown in (d). For further guidance the optional non-printing grid shown can be switched on.

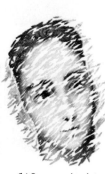
(b) Impressionist

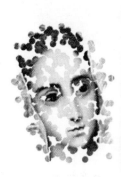
(c) Seurat

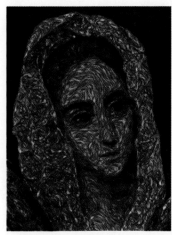

(a) Original

(d) Van Gogh

Figure 6.12 Using Painter's Artist cloning brushes to recreate an original painting (a) in a number of alternative styles – (b) Impressionist, (c) Seurat and (d) Van Gogh

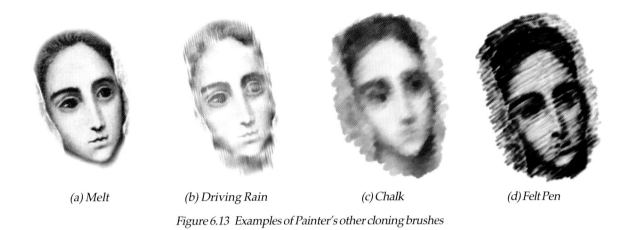

(a) Melt (b) Driving Rain (c) Chalk (d) Felt Pen

Figure 6.13 Examples of Painter's other cloning brushes

(a) Original

Figure 6.14
Using Painter's tracing facility

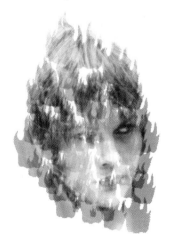

(c) Mixed cloning

(b) Painting with F/X Fire

(d) Tracing window

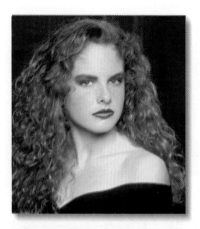

(a) Original

(b) Using image luminance

(c) Using surface texture

Figure 6.15
Surface control in Painter

Applying surface control

As well as applying a variety of different brush effects using cloning brushes, Painter provides the means of editing the appearance of all or a selected part of a portrait using what it calls surface controls. Figure 6.15 shows two examples. Placing the image (a) in Painter and then selecting *Effects/Surface control/Apply surface texture* opens the dialog box in Figure 6.16. The dialog box offers the user a number of ways in which to edit the image (or preselected portion of the image). The *Using* dialog offers a number of options, including *Using Image Luminance.*

Image luminance uses the portrait's luminance to determine where to add surface texture, creating an embossed effect at the edges of the imagery as shown in (b). The *Softness* slider controls the transitions in texture, increasing softness creating more intermediate steps and a smoother distortion. *Picture* controls the amount of colour in the image – at 100%, the full colour of the picture shines through. *Amount* controls how much surface texture is applied to the image. *Shine* controls the highlights. *Reflection* can be used to map a clone source on to the surface at a variable percentage.

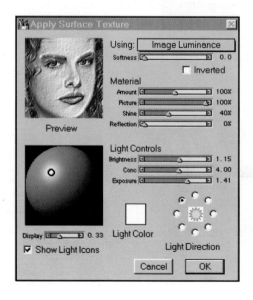

Figure 6.16
Painter's Surface Control dialog box

Creating a mosaic

Some of the oldest surviving portraits from Greek and Roman times were created with the use of mosaics – a medium more enduring than most others in use at the time. Painter provides a twentieth century means of producing mosaic patterns. Figure 6.17 shows three simple examples. The method can also be applied to a scanned photograph or painted portrait by simply applying tiles to the image or selected parts of the image. After selecting the target image in Figure 6.18(a), the style of tile was selected from the *Using* dropdown menu in the *Custom Tile* dialog box (b), which was opened by clicking *Effects/Esoterica*. Sliders and a colour swatch provide the means of manipulating the tile characteristics and the colour of the 'grout' between the tiles. The result is shown in (c).

More sophisticated techniques – in which the tiles can be made to conform to the colour and shading of the underlying image – called *Make Mosaic* and *Make Tesselation* allow users to design imagery in the style of historic tile mosaics starting with a blank canvas or working from an existing painting or cloned photograph. Tiles can either be 'painted' directly on to the canvas, where they remain selectable and editable as the design proceeds, or painted over an underlying image. The *Make Tesselation* tool creates tile inlay patterns which can be made to conform to the shape and colour of a cloned underlying image.

After a mosaic has been created, it can be given a three-dimensional appearance and/or further edited using Painter's other brush tools. Figure 6.19 shows an example in which the same Photo CD image shown in Figure 6.18 was first cloned and then *Make Tesselation* was selected from the *Canvas* menu. After choosing the *Pieces* option from the *Display* dropdown menu (a), 500 points were added

Figure 6.17
Simple tile examples

(a)

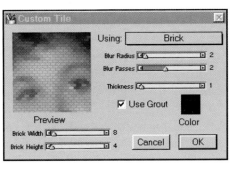
(b)

(c)

Figure 6.18 Applying Painter's Custom Tiles to an image

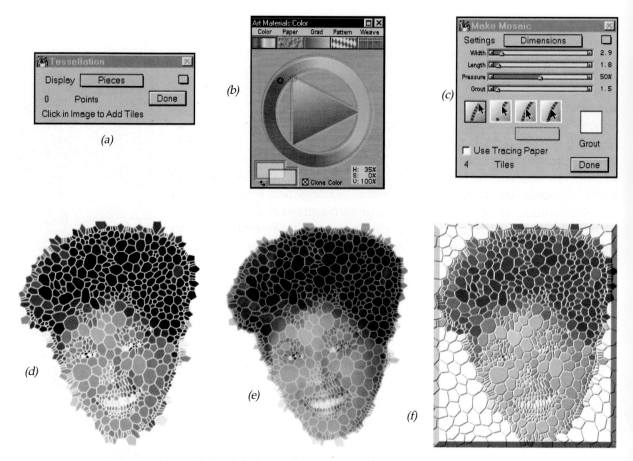

Figure 6.19 Using Painter's Make Tesselation and Make Mosaic options to tile an image

automatically to the cloned image, distributed according to the luminance of the clone source, lighter regions receiving a greater density of points, and so smaller polygons. Setting the check box in the colour palette (b) to use *Clone Color*, meant that the colour of the tiles was picked up from the colours in the original image. Additional tiles were added by hand in the areas of greater detail and, using the options in the *Make Mosaic* dialog box (c), final editing was carried out. The resulting mosaic is shown in (d). The result in (e) was obtained by overlaying the original image on top of the mosaic, with an opacity of 50%. The result in (f), giving the tiles a three-dimensional look, was obtained by rendering the tiles into a mask, using a command available from the *Make Mosaic* dialog box and then applying surface texture, choosing *Mosaic Mask* from the *Using* menu.

Applying filters

With each new release of painting and photoediting applications like Photoshop and Painter, the number of plug-in filters increases, offering effects ranging from the sublime to the truly bizarre. Many of them are unsuitable for use in the editing of portraits, but a few of those which can produce interesting results are shown in Figure 6.20. In all cases the *Magic Wand* tool was used to select just the face in the original (a) and then the filter was applied. The *Notepaper* filter (b) produces a textured greyscale effect. The *Crystallize* filter (c) produces an interesting Pointillist effect. The *Mezzotint* filter offers a range of mezzotint styles – (d) uses short horizontal lines. The *Emboss* filter dialog provides control over the depth of embossing and light direction (e), while *Difference Clouds* (f) produces an interesting solarised result ↗

(a) Original

(c) Crystallize

(b) Gallery Effects Notepaper

(d) Mezzotint

(e) Emboss

(f) Difference Clouds

Figure 6.20 Using filters to create special effects

7 Digital sculpture

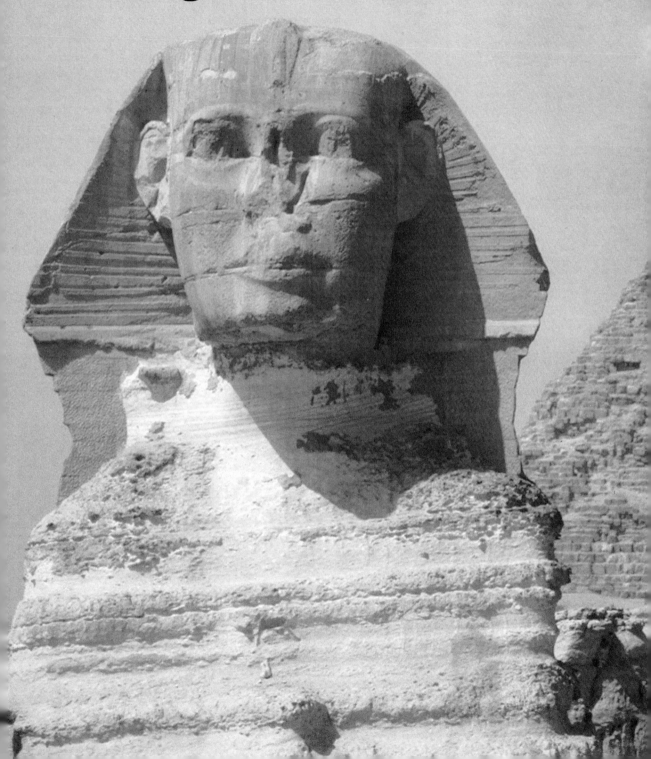

Figure 7.1
Flintknapping

Figure 7.2
Limestone figurine

he word sculpture derives from the Latin *sculpere,* to carve – a skill which can be traced back two million years to the Paleolithic period, when early humanoids first chipped pebbles and stones to form primitive tools and weapons. During the Mesolithic and Neolithic periods the skill of carving developed, as the special properties of flint were discovered and exploited for the production of hand axes and knives (Figure 7.1). In turn, these tools were used for the carving of bone implements.

The earliest objects sculpted from ivory, horn, bone, or stone for artistic, as opposed to practical, purposes date back about 30 000 years, like a small ivory horse found in a cave in Germany and small female figurines like the Venus of Willendorf, carved out of limestone. Such figurines, which are characterised by an exaggerated female anatomy (Figure 7.2), are thought to represent fertility goddesses.

Among the oldest surviving Egyptian sculptures, dating from about 3000 BC, is a piece of slate carved in low relief, known as the Palette of King Narmer, portraying kings, soldiers and various animals. On a grander scale, the pyramids (Figure 7.3) and sphinxes of Egypt date from a similar period. Like much early sculpture, the sphinxes symbolised deities, combining the body of a lion and the head of some other animal, or the likeness of a king.

Aegean art developed the use of terracotta and ivory for the sculpting of statuettes of goddesses, while the Greeks raised the technique of stone carving (Figure 7.4) to a new plane, creating some of the greatest sculpture of the human form in the last few centuries BC.

Figure 7.3
Sphinx and Middle Pyramid of King Khepren

Figure 7.4
A finely carved stone mask depicting the God Zeus
(Museum of Olympia, Greece)

In modern terms, sculpture can be defined as three-dimensional art concerned with the organisation of masses and volumes, subdividing into the two principal categories of freestanding sculpture in the round and relief sculpture, which itself is an extension of the collage technique in painting (Pablo Picasso used paper and other foreign materials pasted on to canvas and also made three-dimensional objects such as musical instruments from paper and scraps of diverse materials).

Sculpture can be made from almost any organic or inorganic substance including marble, bronze, clay, wood, glass and epoxy-resin using the processes of carving, modelling and casting. While carving is a subtractive process in which the artist subtracts, or cuts away, superfluous material until the desired form is reached, modelling is an additive process in which the artist uses soft and malleable material to build up form. Casting, using a material like bronze (Figure 7.5), provides the most durable result. In casting, an impression or negative mould is formed from the original (usually clay) model and then a positive reproduction is made of the original work from the negative impression.

Figure 7.5 Bronze casting

Since the Industrial Revolution, the field of sculpture has been broadened by new techniques like welding and extrusion and materials as diverse as neon tubing and even used car parts.

As in other artistic domains, there were those quick to recognise and exploit sculpture's commercial possibilities. While the mag-

nificent cathedrals of the Middle Ages contained works by the great sculptors of the time, it was the combined skills of the stonemason and the architect which were responsible for the structures themselves.

In a sense, the reverse has been true in the digital world. The development of hardware and software needed to create and manipulate objects in three-dimensional space has been driven by the world of commerce. In many industries, for example in the design and manufacture of aircraft or motor cars, the ability to create and refine digital models in three dimensions offers huge savings in money and time over conventional clay modelling techniques – savings which are multiplied when the design software is used to drive numerically controlled machine tools to produce parts and control assembly. Now it is the turn of the digital sculptor to seize the initiative and to adapt the commercial hardware and software for more artistic purposes.

Figure 7.6 Early solid modelling investment was driven by engineering design opportunities

Earlier, we looked at how drawing and painting applications could be used to create digital architecture and terrains. In this chapter we shall explore what other possibilities are opening up for the budding digital sculptor.

While three-dimensional applications like RayDream Studio, Extreme 3D and Bryce offer the greatest opportunities, drawing and painting applications do offer some possibilities, as shown in Figures 7.7 and 7.8, which show how the use of simple shading and blends can produce powerful sculpted effects. Even without shading (Figure 7.9), a skilled designer can produce a 'carved' effect from only a line drawing.

*Figure 7.8
Using blends to create a
carved effect*

Figure 7.7 Sculpting a surface with solid fills

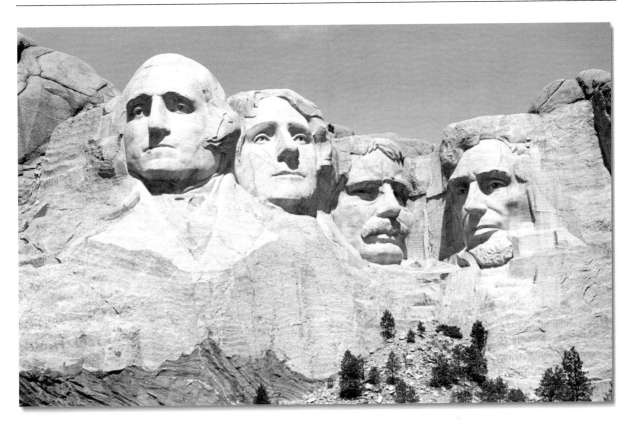

Figure 7.9
A line drawing (below) of Mount Rushmore (above)

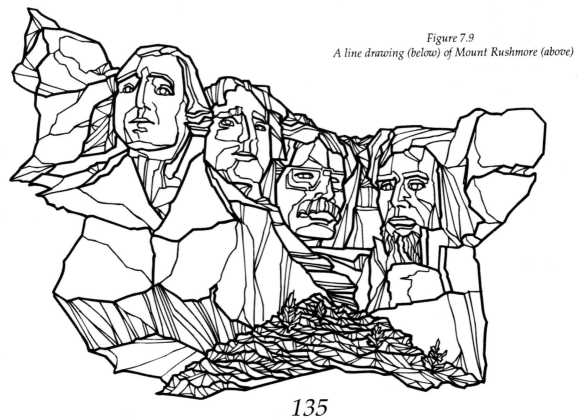

135

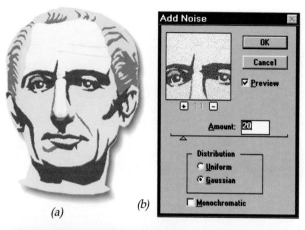

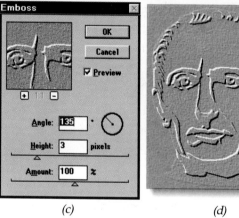

(a)

(b)

(c)

(d)

Figure 7.10 Embossing in Photoshop

In Photoshop or Painter, filters can be used to create simple embossed effects. In the example shown in Figure 7.10, a suitably patrician clipart head (a) was imported via the clipboard to Photoshop, where the *Noise* filter (b) was applied (*Gaussian Distribution, Amount 20*) to give it some texture. The *Emboss* filter (c) was then applied using a height of 3 pixels and an angle of incidence of 135°, giving the result shown in (d).

A more convincing result can be obtained using Photoshop's *Render/Lighting Effects* filter. Starting again with the imported clipart image in Figure 7.10(a), a copy of the image was made and pasted into a new image channel. The copy in the channel was given a *Gaussian Blur* of 2 pixels – Figure 7.11(a) – and then noise was applied to the channel, using the same parameters as in Figure 7.10(b). Returning to the RGB channel, the *Render/Lighting* effects filter was selected, opening the *Lighting Effects* dialog box in Figure 7.11(b). The channel containing the modified copy of the image – Channel #4 – was selected from the *Texture Channel* dropdown menu and an *Omnilight* was chosen from the *Light type* menu, producing the result shown in Figure 7.11(c).

(a)

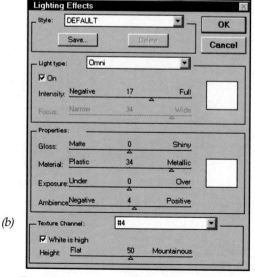

(b)

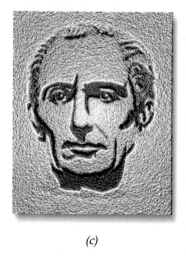

(c)

Figure 7.11 Applying Lighting Effects in Photoshop

Although dropped from later releases, Micrografx Designer 4.0 includes a simple feature for producing and manipulating three-dimensional primitives. These can be rendered with either a smooth finish or as faceted wireframes. Figure 7.12(a) shows examples of faceted rendering. Figure 7.12(b) shows a library of shapes available and the buttons provided to adjust object rotation, shading, precision and lighting controls. Simple forms can be stretched, scaled, skewed or distorted, after conversion to curves, using Designer's drawing tools. They can also be assembled and grouped as in Figure 7.13. More organic shapes can be created by importing Designer's objects into Painter and applying warp effects to them as in Figure 7.14.

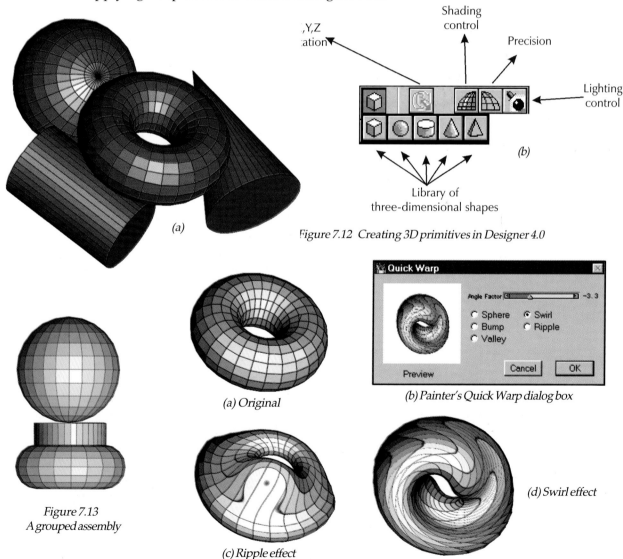

Figure 7.12 Creating 3D primitives in Designer 4.0

Figure 7.13
A grouped assembly

(a) Original

(b) Painter's Quick Warp dialog box

(c) Ripple effect

(d) Swirl effect

Figure 7.14 Warping a 3D object in Painter

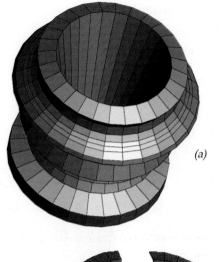

(a)

(b)

Figure 7.15
Lathing (a) and disassembling (b) an object in Designer 4.0

Figure 7.16 *Bryce's Objects palette*

Figure 7.17 *Setting Object Attributes*

Designer 4.0 also provides the means of 'lathing' objects, i.e. creating objects as if turned on a lathe. To produce a lathed object, a path is first created using any, or a combination, of Designer's drawing tools. Applying Designer's *Lathe* tool then turns the path 360^0 around a specified axis. Once created, a lathed object can be coloured, rotated and lit using the tools in Figure 7.12(b). Figure 7.15(a) shows an example of such an object. Because it is object oriented, it can also be ungrouped and disassembled into three-dimensional subcomponents as in Figure 7.15(b).

To produce more complex objects, to which realistic surface effects can be applied, we have to move on to applications designed specifically for three-dimensional work. As we saw in Chapter 5, MetaCreations' Bryce, as well as providing its main function of creating terrains, offers the use of Boolean algebraic operations of *Addition*, *Subtraction* and *Difference* to combine standard primitives like spheres and cubes, to provide new compound shapes. Figure 7.16 shows the Bryce palette of primitives, ranging from the rock on the left through spheres, toroids, cylinders, pyramids etc. Any object or group of objects can become a negative, intersecting, or union object when grouped with any other. For objects to interact in this way, they have to be assigned Boolean object attributes from the dialog box shown in Figure 7.17. Grouping two objects with positive attributes unites them into a single object. Grouping a negative object with a *positive* one simulates the flintknapping process, with the negative object acting as a tool to carve material out of the positive one. By altering the size and shape of the 'cutting' object, precise control of the carving process can be achieved.

If *Intersect* is selected as an object's Boolean attribute, the space that is common to both objects will be the only material visible when the objects render.

Quite complex objects can be con-

structed with compound Booleans. For example, a hollow cylinder can be made out of a grouped positive and negative cylinder; a Boolean property can then be assigned to that group, such as negative, and that shape used to cut a circle through a cube and so on. Figures 7.18 to 7.21 show some examples of Boolean objects created in this way.

Figure 7.18 shows the result of aligning a sphere within a cube in Bryce space and then giving the cube a positive attribute and the

Figure 7.18
Boolean subtraction – cutting a sphere from a cube

CONSTRUCTION PROCEDURE – Figure 7.18

1. The ground plane was selected and given a flat grey texture
2. The sphere on the left was positioned so that its centre coincided with that of the cube
3. The cube was given a positive attribute and then a wood texture was applied to it
4. The sphere was given a negative attribute
5. The two items were grouped, so that the negative sphere was cut out of the positive cube, giving the result on the right

Figure 7.19
Boolean subtraction – cutting a cube from a sphere

CONSTRUCTION PROCEDURE – Figure 7.19

1. The ground plane was selected and given a flat pink texture
2. The sphere on the left was given a positive attribute, a marble texture and aligned with the cube as before
3. The cube was given an negative attribute
4. The two items were grouped, so that the negative cube was cut out of the positive sphere, giving the result on the right

Figure 7.20
Boolean intersection (left) and compound effect (right)

CONSTRUCTION PROCEDURE – Figure 7.20

1. The result on the left was obtained by giving the cube an intersection attribute and the sphere a positive attribute and a marble texture, so that, when grouped, only the common space occupied by both objects was rendered
2. To obtain the result on the right, three identical negative cylinders, lying along the x-, y- and z-axes, were aligned with an untextured copy of the object on the left and then grouped

sphere a negative attribute. Figure 7.19 shows the result of reversing the attributes of the sphere and the cube, while Figure 7.20 shows, on the left, how use of the *Intersect* attribute leaves only the material occupied in common by the two intersecting objects. The example on the right of the figure is a compound Boolean object created by subtracting three negative cylinders from an untextured copy of the Boolean group on the left. In turn, further operations could now be applied to this new group to produce even more complex objects.

Figure 7.21 shows how more dramatic compositions can be created by the application of more exotic materials to Boolean groups which can then be set against sky or other backgrounds. The object on the left was created by grouping a positive cylinder and negative torus. The more complex object on the right involved three construction steps. First, a hemisphere was created by grouping a negative cylinder with a sphere of same radius, then the hemisphere was grouped with an inverted cone; finally, that result was grouped with a negative torus.

Figure 7.21 Setting off Boolean groups against a Bryce Sky background

As we saw in Chapter 5, Bryce can also import three-dimensional objects which have been saved in DXF format. Figures 7.22 and 7.23 show two such examples. In the first, a Buckminster Fuller-like geodesic sphere was imported and transformed into a many faceted crystal ball, by applying a glass texture. Adding a sky background and an ocean ground plane, together with a highlight position allows a complex interplay of reflection and refraction to produce an almost surreal result.

Imported objects can be duplicated, scaled and positioned to form three-dimensional groups. Figure 7.23 shows such an example using a model of a tiger. The polygonal surface was left unsmoothed to give the tigers a chiselled look. Different textures were applied to each tiger and a reflective ground plane was added for effect.

Figure 7.22
Using an imported object to create a scene

CONSTRUCTION PROCEDURE – Figure 7.22

1. A geodesic sphere saved in DXF format was imported into Bryce, scaled and positioned above a ground plane

2. A glass texture was applied to the sphere to give it the appearance of a large crystal ball

3. An ocean texture was applied to the ground plane and a sky was added to provide a background

4. A light was positioned high and to the right of the scene

Figure 7.23
Creating a group with imported objects

CONSTRUCTION PROCEDURE – Figure 7.23

1. A model of a tiger in DXF format was imported, scaled and positioned in the centre of the scene

2. The model was duplicated twice and the duplicates were scaled and positioned to form the group

3. A low camera angle was selected

4. The ground plane was given a reflective watery texture

5. The background was left as default blue to make the group stand out clearly

Available three-dimensional models include human figures which can be posed and then imported to Bryce. Figure 7.24 shows a figure imported from Extreme 3D. Like other polygonal objects, figures can be smoothed or left in faceted form and, within Bryce, can be scaled and rotated to any position. Ground planes can be textured and skies can be added to provide a range of background effects.

Figures can also be created, posed and imported from Fractal's Poser application which is specifically designed to position human figures with great precision and anatomical accuracy. The Poser model in Figure 7.25 strikes a pose reminiscent of Michelangelo's *David* (Accademia, Florence, Italy) although the silver finish applied in Bryce is more akin to an Oscar trophy without hair!

Figure 7.24
Smoothed and unsmoothed imported figures

Figure 7.25
Figure imported from Fractal Poser

CONSTRUCTION PROCEDURE – Figure 7.24

1. A male figure saved in DXF format was imported from Extreme 3D into Bryce, scaled and positioned above a matt grey ground plane
2. The figure was duplicated and the duplicate (on the left) was rotated and smoothed
3. The two figures were given contrasting material finishes

CONSTRUCTION PROCEDURE – Figure 7.25

1. A posed male figure was imported from Fractal Poser, scaled and positioned
2. A Bryce cube primitive was scaled and positioned to form a plinth for the figure to stand on
3. Textures were applied to the plinth and the figure and a textured ground plane and sky were added to complete the scene

142

As well as placing complete three-dimensional models within a Bryce scene, DXF models can be ungrouped and individual elements can be used in compositions. Figure 7.26 achieves a dramatic effect by partially submerging an imported head below the surface of a terrain. The use of similar textures for the head and terrain, and the addition of a warm golden sky, unites the elements, while the retention of the polyhedron form of the head gives it a carved, sculptured appearance.

Figure 7.27 illustrates another powerful feature of Bryce – the use of bitmapped images within a three-dimensional scene. To produce this result, a copy of the Mount Rushmore image in Figure 7.9

Figure 7.26
Blending objects into a background

CONSTRUCTION PROCEDURE – Figure 7.26

1. The model of a head was imported into Bryce, scaled and positioned above a ground plane
2. A terrain was added and edited so that the head appeared to be partly submerged
3. The head was left unsmoothed and head and terrain were given two different variants of the same gold texture
4. A late evening warm sky background was added to complement the colouring of the head and terrain

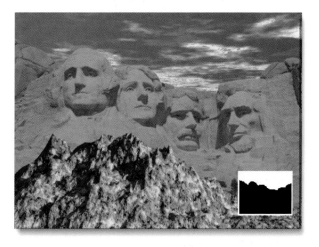

Figure 7.27
Using a bitmap within a 3D setting

was imported into a new file via the Picture dialog box shown alongside the figure (see top left thumbnail in Figure 7.27). A copy of the image's alpha channel, which isolated the blue sky area of the image, was also imported (see inset and second thumbnail) and the two images were combined (see third thumbnail) before placing in the scene. The purpose of the mask is to allow the selected Bryce sky to replace just the sky area in the original image and to prevent it showing through the rest of the image. After selecting a dark sky, a new terrain was positioned in front of the bitmap image to enhance the illusion of depth and given a stony texture.

Unlike some other three-dimensional applications, Bryce does not provide the means of creating text characters, but these can be imported as DXF files and then manipulated within a scene. An example of this is shown in Figure 7.28; the text was prepared in RayDream Studio (see dialog box below right) and saved as a single object in DXF format. A new terrain was placed in Bryce where it was scaled and textured. The ground plane which appears behind the mountain was given a texture which simulates a low-rise city backdrop and a sky was added with high clouds and a haze on the horizon. The text object from RayDream Studio was next imported, scaled, placed in position on the mountainside and given a reflective grey-white texture.

Imported text objects can also be used to create convincing stone engraving effects by making the text object negative and cutting the text out of a flat positive Boolean surface, or embossed effects by making the text object positive and then giving it, say, a marble or metal texture and then grouping it with a positive Boolean surface to which the same marble or metal texture has been applied.

We have seen how primitive objects in Bryce can be 'sculpted' by means of Boolean

Figure 7.28
Welcome to Hollywood

operations and how objects created in other applications can be imported and used in constructing scenes. To find the means of creating three-dimensional forms of a more complex nature, however, we have to look beyond Bryce at, for example, RayDream Studio or Extreme 3D. Such applications offer the user processes like extrusion, lathing, skinning and pipelining to create solid or hollow objects or flowing, three-dimensional surfaces. Shapes modelled using these techniques can be edited down to the level of nodes on individual outlines, providing the designer with virtual 'digital clay' which can be manipulated with a precise level of control.

The few examples which follow are intended only to give a briefest glimpse into the possibilities offered by such techniques. In the first (Figure 7.29), a profile was first drawn in Illustrator (a) and imported into RayDream Studio, where a *Symmetrical* extrusion window was chosen from the *Geometry* box and the profile was extruded (b); a node point was then added to the extrusion profile (blue lines on drawing plane in the *Perspective* box) and dragged to give the extrusion a fishtail appearance. A metallic surface finish was then applied to the extrusion and the result was rendered (c).

In the second example (Figure 7.30), Studio's lathing feature was used to lathe a path created on the drawing plane (the blue line in (a). Applying a marble texture and rendering the object produced the result in (b). Re-rendering after rotation and after the application of a wood texture produced the result in (c).

Figure 7.31 shows an example of the kind of result which can be obtained using the skinning process. Using the *Create Multiple* com-

EXTRUDING

Applying a three-dimensional appearance to a selected object by adding surfaces to it.

LATHING

A technique for creating a three-dimensional object with axial symmetry by first creating a two-dimensional outline and then rotating the outline around a specified axis.

SKINNING

A three-dimensional modelling technique which simulates the stretching of a flexible skin over a series of cross-sectional shapes or formers.

PIPELINING

In the pipelining process – sometimes called a sweeping process – a single cross-section is extruded along a path.

(a)

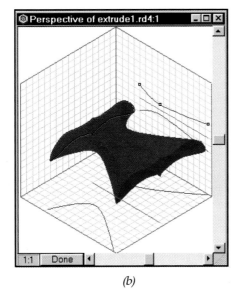

(b)

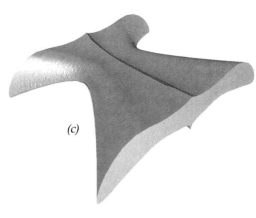

(c)

Figure 7.29 Extruding in RayDream Studio

mand from Studio's *Sections* menu a number of cross-sections can be placed along the length of an extrusion. Each cross-section can be selected and its shape can be edited. Its positions on the extrusion path can also be adjusted by dragging the corresponding point along the extrusion profile. Cross-sections can be filled or unfilled; in the latter case, the result looks as if a surface or skin has been stretched over a series of cross-sectional formers, hence the name skinning. Figure 7.31(a) shows an extrusion with four cross-sections. (b) and (c) show two rotated and rendered copies of the result.

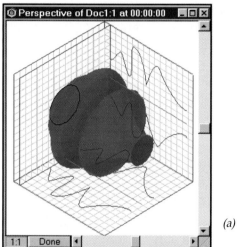

(a)

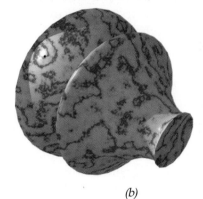

(b)

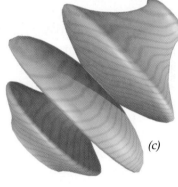

(c)

Figure 7.30 A lathed object

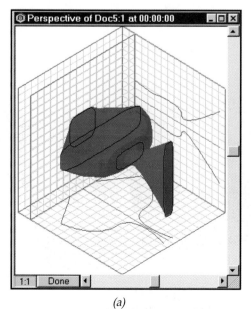

(a)

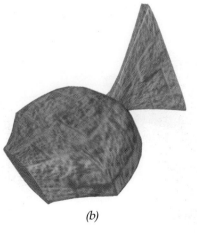

(b)

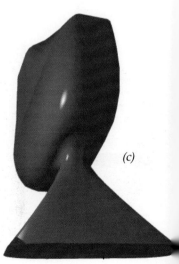

(c)

Figure 7.31 Skinning

In the pipelining process – sometimes called a sweeping pro-
cess – a single cross-section is extruded along a path. In Figure 7.32(a),
after selecting *Extrusion Method/Pipeline* from Studio's *Geometry* menu,
a hexagonal cross-section has been extruded along the profile path
shown on the right hand plane of the *Perspective* box. The shape of
the profile path can be edited using the *Selection* and *Node-editing*
tools to refine the result. (b) and (c) show two rotated and rendered
versions of the result.

More complex results can be obtained by creating compound
objects (Figure 7.33) or using preset functions (Figure 7.34). Figure
7.33 shows the result of creating a profile consisting of two overlap-
ping squares made into a compound object using Studio's *Arrange/*

(a)

(b)

(c)

Figure 7.32 Pipelining

Figure 7.33
A compound Studio object

Figure 7.34
Using the Spiral preset

Combine as Compound command and then extruding the compound using *Geometry/Extrusion Preset/Torus*. Figure 7.34 shows the effect of using *Extrusion Preset/Spiral* with eight turns to transform a simple circle into a three-dimensional spiral. Studio's modelling tools can also be used to produce hollowed-out objects (Figure 7.35) and three-dimensional surfaces like the example in Figure 7.36.

Using a combination of the tools and techniques described above, quite complex sculptured forms can be created. Figure 7.37(a) shows such an example – a likeness of Pegasus, the mythical winged horse. Deformers such as *Stretch, Shatter, Bend* and *Twist* constitute a powerful class of three-dimensional manipulation tools to modify and twist objects and groups of objects. Figure 7.37 shows, for example, how the *Twist* deformer, using the settings in dialog box (b), has been used to select and turn the head of the horse towards the viewer.

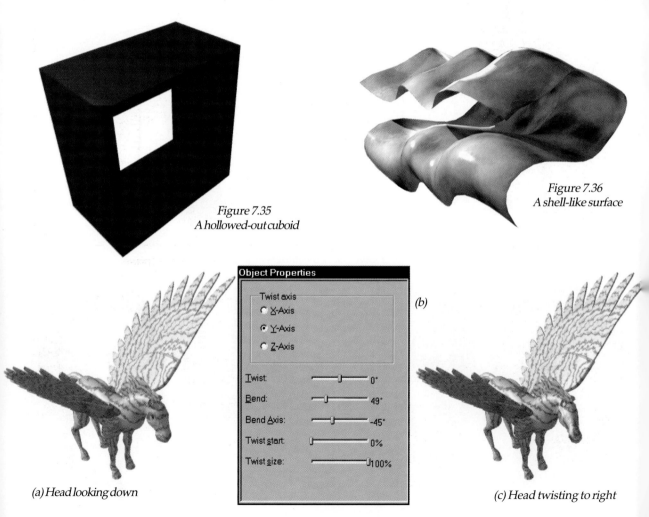

Figure 7.35
A hollowed-out cuboid

Figure 7.36
A shell-like surface

(b)

(a) Head looking down

(c) Head twisting to right

Figure 7.37 Using the Twist deformer to turn the horse's head

148

Extreme 3D offers the same processes of extrusion, lathing, skinning and pipelining as RayDream Studio, but provides even more detailed control over surface modelling by displaying the surface of an object as a matrix of spline-based control points, which can be manipulated by the designer. Figure 7.38 shows the effect of selecting and dragging several of the nodes on a faceted spherical surface. The object in Figure 7.39 started life as a flat plane. The red dots correspond to the surface nodes, some of which were dragged up to create a terrain effect. Figure 7.40 shows the use of the same technique on a modelled head. (a) shows the underlying polygonal structure and (b) shows the node points corresponding to the polygon boundaries; selecting the group of nodes at the bottom of the chin

Figure 7.38 A node-edited sphere

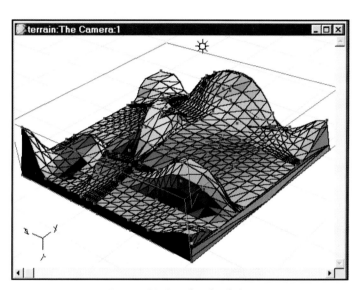

Figure 7.39 A node-edited plane

(a)　　　　　(b)　　　　　(c)　　　　　(d)

Figure 7.40 Node editing the model of a head

and dragging down produced the elongation shown in (c). The elongation applied to all the nodes of the chin, not just those in a single plane, as shown when the head is rotated in (d).

By its nature, the manipulation of digital three-dimensional shapes places extra demands on the imagination of the designer, who, unlike his traditional counterpart, is unable to walk around the piece under construction, and on the hardware being used, which must cope with the complex computational demands of a third dimension. Compared with drawing, painting and photoediting applications, which in a few short years have advanced rapidly, desktop three-dimensional applications are still at an early stage of refinement and an intuitive sculpting metaphor is still some way off. Already, however, the pace of development is picking up and the continuing rapid advances in hardware development are pushing outwards the integration of visualising, modelling and rendering to open up exciting new opportunities for the future ✗

8
The human figure

omo sapiens is identified, for purposes of anthropological classification, as an animal with a backbone and segmented spinal cord which is equipped with five-digited extremities, a collarbone, and a single pair of mammary glands on the chest, with eyes at the front of the head and a proportionately large brain.

Belonging to the family Hominidae, the details of skeletal structure distinguishing *Homo sapiens* from the nearest primate relatives – the gorilla, chimpanzee and orang-utan – stem largely from early adaptation to a completely erect posture and a two-footed striding walk. The S-shaped spinal column places the centre of gravity of the human body directly over the area of support provided by the feet, giving stability and balance in the upright position. Other mechanical modifications for bipedalism include a broad pelvis, a locking knee joint, an elongated heel bone, and a lengthened and aligned big toe.

The large brain of *Homo sapiens* is approximately double that of early human tool-makers, an increase which took two million years to achieve. Unlike the early human adult skull, with its sloping forehead and prominent jaw, the modern human skull exhibits a high-rounded dome, straight-planed face and reduced jaw size.

The discovery of the remains of Java Man in the 1890s gave impressive evidence of an extremely long process of human evolution (Figure 8.1), supported by the Leakey's discovery, during the 1960s, of a series of hominid fossils in Olduvai Gorge in East Africa. Fossil remains unearthed in the late 1970s and 1980s have provided further

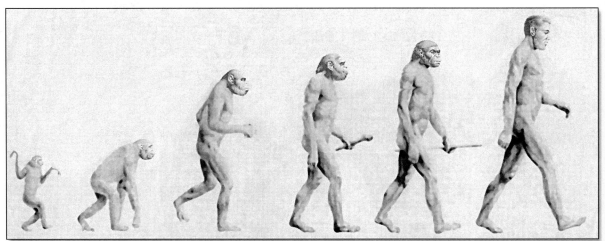

Figure 8.1 Evolution

evidence that, as long as three million years ago, the genus Homo co-existed in East Africa with other advanced man-ape forms known as Australopithecines.

The weight of fossil evidence suggests that Africa is the probable centre of earliest human evolution, which spread later to Europe and Asia. All humans living today are *Homo (sapiens) sapiens* and are descended from the same ancestors. Genetic features such as height and skin colour vary geographically, but the categorisation of people by 'race', into oriental, black, hispanic or white, is more a social than an anthropological statement.

While the cave paintings of our prehistoric ancestors, discovered at 150 sites in western Europe left us a fascinating, if crude, record of the animals which roamed the Earth at that time, there are, sadly, few records of the cave dwellers themselves, although one painting at Lascaux in France depicts a dying hunter lying alongside a wounded bison. It is only from Ancient Egyptian times that pictorial records really begin, most notably in the form of amazingly well preserved murals discovered in the sterile conditions deep inside the burial chambers of the Pharaohs and on the walls of great temples (Figure 8.2). Although simple in execution, these murals provide a rich archive of information about the physique and posture of some of our most ancient ancestors. Male figures in particular were given a strong, stylistic, geometric emphasis, with the shoulders and chest plane resembling an inverted triangle.

In the centuries which followed, as we saw in the last chapter, the human figure has appeared in art of antiquity in many forms. The famous *Winged Victory* figure, now in the Louvre in Paris, dating from about 190 BC, is one of the most famous Greek sculptures from the Hellenistic period. *Aphrodite of Melos*, named by the French the

Figure 8.2 Ancient Egyptian murals

Venus de Milo (see chapter title page) also dates from this Hellenistic period. The sculptor of this graceful and evocative work is unknown.

The Greeks' mastery of stone carving and bronze casting created some of man's greatest statuary, with figures well proportioned and shown in movement. Gods and athletes were favourite subjects of this period (Figure 8.3).

Though less creative than the Greeks, the Romans and, in particular, the Etruscans, admired their work and mimicked their style, producing life-size figures of the Gods in terracotta and bronze. Through the eleventh and twelfth centuries and into the Gothic period, the skills of the sculptor spread across much of Europe, the majority of figures being produced to complement and enhance church architecture.

The fifteenth and sixteenth centuries saw the emergence of two of the giants of creative art – Michelangelo and Leonardo da Vinci. As both sculptor and painter, Michelangelo was still only in his twenties when he created one of the greatest works in the history of art – the heroic figure of David (Figure 8.4). In 1505, Michelangelo was recalled to Rome by Pope Julius II to work on Vatican frescoes such as *The Group of Blessed* (Figure 8.5). Working high above the floor of the building, he created truly awesome images which demonstrate a masterly understanding of human anatomy and fluidity of movement unsurpassed to this day.

Figure 8.3
Greek sculpture featured Gods and athletes

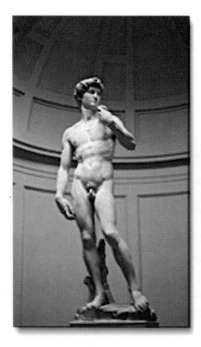

Figure 8.4 Michelangelo's David

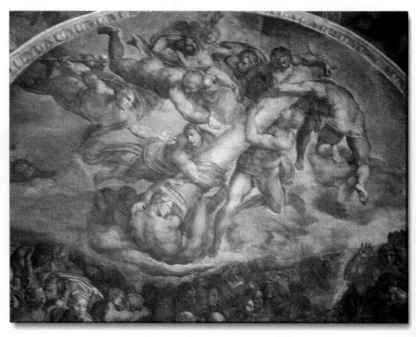

Figure 8.5 Michelangelo's The Group of Blessed

The scientific studies of Leonardo da Vinci in the field of anatomy anticipated many of the developments of modern science. One of his best known works – *Proportions of Man* – illustrates his study of the biological proportions of the male figure. Although much of his work has been destroyed, Leonardo's many extant drawings reveal an extraordinary draftsmanship and mastery of the anatomy of both humans and animals.

Figure 8.7 shows three paintings which exemplify this growing understanding of human biology. When combined with supreme artistic skill of the artists, such knowledge produced works of timeless beauty.

In the centuries which followed, as tools, materials and techniques evolved, artists strove to produce studies of the human figure which were ever more accurate in their representation and more outspoken in their content, such as the painting of the *Naked Maja* in 1786 by the innovative Spanish painter Francisco de Goya (Figure 8.8). Goya preserved the impression of natural light by the elimination of minor shadows and the representation of areas of light rather than details of form. Much of the art of the great nineteenth-century French masters like Edouard Manet and the twentieth-century genius Pablo Picasso was taken from Goya.

In more recent work, like that of the French Impressionist Pierre-Auguste Renoir (1841–1919) and Postimpressionist painter Paul Gauguin (1848–1903), the pendulum has swung away from accuracy of representation. Gauguin's figures in particular display flat, brightly coloured, two-dimensional forms in a style which formed the basis of what we now call modern art.

Figure 8.6 Leonardo da Vinci's Proportions of Man

Figure 8.7 Mastery of line and light
Michelangelo's Studio di Nudo (left and centre) and Andrea Mantegna's Man Laying on a Stone Slab (right)

Figure 8.8
Goya's Naked Maja (left), Renoir's Young Girl Bathing (centre) and Gauguin's Two Figures on a Tahitian Beach (right)

As well as studying and learning from the works of the Masters, the digital designer would do well to emulate Leonardo da Vinci by studying the human form; understanding its natural dimensions and especially the muscular and bone structures which constrain the body's movements.

Figure 8.9 shows, on the left, simple line drawings of front and side views of *Homo sapiens*. In the centre we can see how the muscle system within the body is configured, while, on the right, we can see the underlying bone structure. More detail, of course, can be found in medical treatises.

In a sense, digital figure drawing began a little bit like cave drawing – with crude drawing tools capable of producing only the most rudimentary of results, like the simple 'line and fill' graphics shown in Figure 8.10. Perhaps we should protect this early digital heritage against a future nuclear holocaust by painting facsimiles on the walls of some of our deeper potholes!

As digital tools improved and the developing technology began to attract the attention of more skilful designers, the range and quality of results which could be obtained broadened considerably.

Figure 8.9 Muscle and bone structure

Figure 8.10 shows a range of figures created using contrasting techniques which, although visually simple, convey a surprising fluidity of motion, while the figures in Figure 8.11 show how well-drawn and filled silhouettes can achieve a high impact.

Figure 8.12 (top row) shows a nice example of how the same basic line drawn figure can be posed in different styles, using a combination of Bézier drawing tools and node editing. The use of shading adds a simple posterised effect. The figures in the lower row illustrate how the skilled designer can introduce graceful movement into a simple line drawing.

Figure 8.13 shows a range of stylised examples from svelte mannequin to sumo wrestler.

Figure 8.14 shows how reversal or even the limited use of shading can add to the impact of a simple drawing.

Finally, Figure 8.15 shows the transformation which occurs with the use of colour to produce, in this case, a series of easily recognised national figures.

Figure 8.10 Basic silhouettes and outlines

Figure 8.11 A little more style

Figure 8.12 Movement and grace

Figure 8.13 A variety of styles

Figure 8.14 Using fills

Figure 8.15 Figures from around the world

As we saw in the last chapter, it is possible to create figures within three-dimensional applications like RayDream Designer, but until later releases offer more intuitive sculpting tools, such as digital chisels, drills and rasps, an easier way is to use Fractal's Poser – an application designed exclusively for posing three-dimensional figures.

Poser offers three basic anatomies – an adult male, an adult female and a child (Figure 8.16). Any one or any combination of these can be displayed and saved in a choice of seven modes – *Silhouette, Outline, Wireframe, Hidden Line, Lit Wireframe, Flat Shaded or Rendered*. A classic mannequin is also available. Figure 8.17 shows some examples. A *Tools* palette (Figure 8.18) provides a range of tools which are used to manipulate whole figures or body parts and to adjust camera and lighting settings.

A Poser figure has nineteen separately adjustable body parts. In *Pose mode* individual body parts can be selected and manipulated to alter their position or size, to bend an arm or turn a head or twist a hand. Poser uses *Inverse Kinematics* – a technique which creates hidden links between the body parts so that if one part, e.g. a hand, is moved, then the forearm and upper arm move with it in a natural way.

Body mode freezes the posture and allows control of the model so that it can be moved or scaled as a single object.

Figure 8.16 Lit Wireframe examples of adult female, child and adult male figures

Figure 8.17 Lit Wireframe (left) and rendered (right) examples of Poser adult male figure displayed as (from left to right) Stick Figure, Mannequin, Skeleton and Normal

Camera mode permits adjustment of the view in the main window (Figure 8.19). The *Main Camera* provides a perspective view while the *Front, Top* and *Side* cameras provide orthographic views. The *Focal Length* tool changes the 'lens' of the *Main Camera* to adjust the sense of perspective. Figure 8.20 shows other camera adjustments.

Light mode is used to colour and aim lights to illuminate the figures. Poser provides three distant light sources which can be edited independently of each other. Figure 8.21 shows the lighting adjustment panel.

Bumpmaps and textures can be applied to body surfaces (Figure 8.22) to create 'clothes' or just to apply interesting effects. As well as specifying whether bumpmaps and textures should be used when rendering, the *Render* dialog box (Figure 8.23) allows choice of background colour and specification of whether shadows should be rendered.

Figure 8.18
Poser's Tools palette

Figure 8.19 Poser's main figure editing window

Figure 8.20
Camera adjustments

Figure 8.21 Lighting panel

Figure 8.22 Setting bumpmaps and surface textures

Figure 8.23 Specifying settings for rendering

160

Poser provides libraries of preset poses, lighting configurations and camera positions. Figure 8.24 shows an example of one of the preset poses. In this example, the ground plane has been made visible, allowing the rendered shadow of the figure to be seen. A greyscale bumpmap (*Mmekanik.tif*) and texture map (*Mmekanik.tif*) have been applied to the figure to give it a surface topography and texture.

A figure or group of figures can be posed against an imported background image or saved in bitmapped format and then opened in Photoshop or Painter for editing. Such editing is facilitated by the fact that Poser creates and exports an alpha channel mask corresponding to the silhouette of the figure, so that it can be easily separated from its background. Figures can also be exported in DXF or another three-dimensional format and then incorporated into Bryce for construction of a three-dimensional scene, as we saw in Chapter 7 (Figure 7.25).

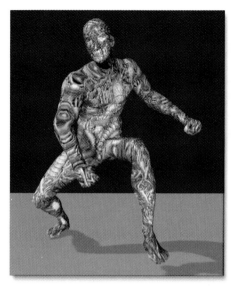

Figure 8.24
Bumpmap and texture applied to figure

Figure 8.25 shows an example of a posed figure saved in TIFF format in *Lit Wireframe* mode. After importing the file into Photoshop, the imported alpha mask was used to select the background behind the figure and above the ground plane. Using Photoshop's *Gradient* tool, shading from 50% black to the same shade of green as the ground plane (picked up with the *Eyedropper* tool), a radial gradient was applied, adding drama to the scene.

Figure 8.26 shows, on the left, an adult female figure created in Poser, to which a bumpmap (*Fcompmek.bum*) and surface texture (*Fcompmek.tif*) have been applied. After saving the scene as a TIFF file, it was imported into Photoshop for editing. A Photo CD file of a Yosemite scene was opened in a separate window, a new layer was created, and the size and resolution of the image were adjusted to match those of the Poser scene. Next, using the Poser alpha channel, the figure of the girl was selected and dragged across into the

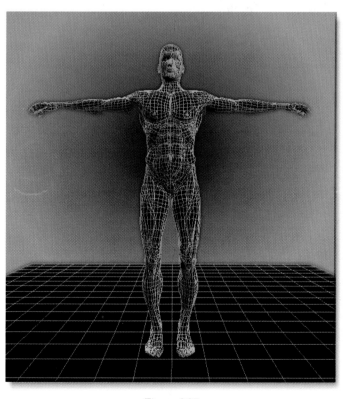

Figure 8.25
Adding a background in Photoshop

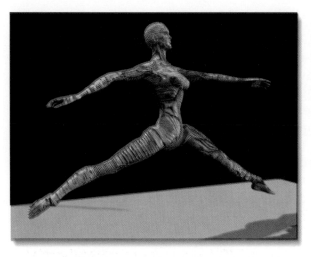
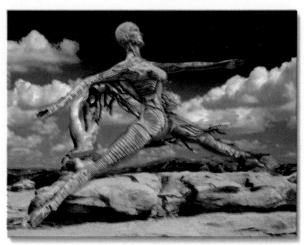

Figure 8.26 Bumpmap and texture applied to figure on left. Copy of figure on the right merged with a Photo CD image

(a)

(b)

Figure 8.27
Bumpmap and texture applied to figure

Yosemite scene where it floated above the new layer. While it was still floating, *Adjust/Hue/Saturation* was selected from Photoshop's *Image* menu and the *Colorize* controls were used to adjust the colours of the figure, chameleon-like, to match its new background.

More natural effects can be achieved by combining the features of both Poser and Bryce applications. Figure 8.27 shows such an example. The kneeling male figure – shown in wirenet form (a) – was exported from Poser and saved in DXF format. It was then imported to Bryce as an object, where it was scaled, rotated and positioned in front of a setting sun background. The ground plane was given a water texture and its height was raised so that the figure appeared to be kneeling in the water. The figure was then selected and given a metallic bronze texture so that it reflected the light from the water as well as reflecting in the water.

Poser figures placed in Bryce can also be manipulated and placed in a three-dimensional relationship to other objects within the Bryce scene. In Figure 8.28, for example, the diving male figure has been scaled, rotated and placed so that it appears to be diving off the rock on the left. The scene was composed

using Bryce's different camera views (top, left, right etc.) to ensure the correct placement of figure and rock. The reflection of one arm can be seen on the surface of the rock. A glass texture was applied to the figure which resulted in interesting reflection and refraction of light from the background.

When the relative position of figures and objects is more critical, detailed alignment can first be carried out within Poser and then the objects can be imported and manipulated in Bryce. Figure 8.29 shows an example. The model of the buffalo was first imported into Poser as a DXF file and the *Mannequin* was selected as the Poser figure type (a). Using Poser's rotate, twist and translation tools, the mannequin was placed on the buffalo's back and the arms and legs were

Figure 8.28 Placing a figure in relation to another object

(a)

(b)

Figure 8.29 Posing objects in Poser and then importing them to Bryce

adjusted into natural looking positions. The mannequin was then saved as a DXF and both it and the buffalo were then imported into Bryce and positioned as they had been in Poser. The buffalo model was converted into a polyhedron, smoothed to remove the model's surface facets and given a dark, glassy texture. A wood texture was applied to the mannequin, a desert-like texture was applied to the ground plane and a sombre sky was added to give the scene an overall surrealistic effect.

More complex figure groups can be constructed by posing figures in Bryce, saving them individually in DXF format and then importing them for deployment in Bryce. Figure 8.30 shows such a group, looking vaguely reminiscent of our friends in Figure 8.1.

Figure 8.30 Evolution, Poser-Bryce style

As well as posing solitary still figures and groups, Poser can create animations, which can be saved in standard Quicktime or AVI format or as a sequential image file. Such files can be imported into Photoshop or Painter for the addition of special effects, before importing into, for example, Adobe Premiere for merging with other video clips.

Poser's *Animation Control* dialog box is shown in Figure 8.31. Creating an animation uses the same figure positional techniques as those used for still images. In the simplest case, a figure is first posed as it is required to appear in the first frame of the animation and this pose is saved to Keyframe 1 of the animation. The figure pose is then adjusted to a new position, e.g. by moving an arm or leg, and this

second pose is saved as, say, Keyframe 5 of the animation. When the animation is played back, Poser 'interpolates' Frames 2, 3 and 4 so that the figure pose 1 translates smoothly to the figure pose 5. Additional key frames can now be added at intervals to extend the motion of the figure. Lights, cameras and imported props can also be animated ↗

Figure 8.31 Poser's Animation Control dialog box

9

*The bizarre
and
the macabre*

 n its struggle to survive and evolve on this restless planet, the human race has faced, over the centuries, the natural terrors of volcanoes, earthquakes, floods, hurricanes and famine, with sudden death or mutilation a fact of everyday life. Attributing these events to the anger of vengeful Gods, early civilisations would offer animal or even human sacrifices by way of atonement. To provide a focal point for these sacrifices, idols representing the Gods would be painted or carved from wood or stone, their faces and bodies often taking on frightening forms to symbolise the fears provoked by their anger (Figures 9.1 and 9.2).

For many, life was a fragile existence, fraught with the dread of such natural disasters and further compounded by the self-inflicted horrors of war between local tribes and even between whole nations. It is perhaps not surprising, therefore, that refuge from these fears was sought, but it remains a curious aspect of the human psyche that this refuge was often found at the expense of others. The Romans, for example, as they sat, socialising in the security of the stands of the Coliseum, apparently relished the spectacle of Christians and sundry other enemies of the Empire being crushed or torn apart by bulls, bears or lions. In later centuries, large crowds gathered to watch public executions, where victims were hung from gallows or beheaded with an axe or guillotine, the severed head often being impaled on a spike and put on display, or to attend so-called 'freak shows' which exploited poor creatures suffering from gross physical deformities.

Echoes from these bloodthirsty events can still be heard today at bullfights and heavyweight boxing matches, and how many secondary traffic accidents are the result of drivers slowing and taking their eyes off the vehicles ahead as they gawp at the poor victims of

Figure 9.1
Early civilisations gave substance to their Gods by creating idols

Figure 9.2
Egyptian friezes like this one included supernatural images – note the arm emerging from the eye

a pile-up on a motorway? Why is it that, in Christian countries, we still celebrate the pagan festival of Halloween (Figure 9.3), with its dark images of witches and warlocks? Somehow, it seems, we take comfort from the misfortunes of others, or by flirting with dark forces, as a means somehow of expurgating the fears from our own nightmares.

Whatever the correct psychological explanation, we humans clearly love to be scared, whether it is in the safety of our armchairs, securely strapped into fairground rides or clinging to the arms of our cinema seats, as evidenced by the runaway success of early films like *Dracula* and *Frankenstein* and their modern day equivalents like *Jaws* and the *Alien* series.

Figure 9.3 The stars of Halloween and early horror films

Figure 9.4
Who's for swimming?

Images of a bizarre or macabre nature appear not only in films but also, increasingly in the advertising of products like music CDs and even life insurance – one advertisement featured a surprisingly animated Grim Reaper lookalike. In this chapter, we shall look at images related to this curious aspect of human nature and at the techniques we can now use to create and embellish them.

Perhaps foremost among the images guaranteed to bring a tingle to the spine are those most obviously associated with the hereafter, i.e. skeletal remains. Featured defiantly on the Jolly Roger (Figure 9.5) – the flag of the pirate sailing ships of the Caribbean – the skull and crossbones struck fear into the heart of many merchantmen, while, more recently, an image of a human skull has appeared on bottles containing poisons, or signs warning of minefields or other hazards (Figure 9.6). Four, more detailed, representations are shown in Figure 9.7; rendering in black gives the images a suitably sombre, funereal, cast. A more complex form – showing a skull leering from within the hood of a monk-like robe – is the familiar Grim Reaper, shown in two different poses in Figure 9.8.

Figure 9.5
The Jolly Roger

Figure 9.6 Achtung! Achtung!

Another graphic device for conveying a sense of mystery or malevolence is the mask, an artefact which has provided a primary artistic outlet for many cultures over the centuries. Dating back to Paleolithic times, masks were often constructed to represent spirits, deities or ancestors and, in early civilisations, it was believed that the wearing of such masks bestowed magical powers on the wearer. Grotesque war masks were worn in battle in ancient Greece and Rome.

The practice of creating death masks – so called because they were made from wax impressions of the features of the dead – originated in Egypt and Rome. The impressions were used as models for sculpted portraits, a practice which continued into the early twentieth century.

In some tribal rituals, the wearer was believed to be possessed by the spirit of the mask. Made from a range of materials including wood, leather, bark and even animal or human skulls, they varied widely in their style and degree of ornamentation, ranging upwards in size to the six metre totem masks of Papua, New Guinea.

Masks were central to many types of ritual ceremony, from initiation of children to ensuring rainfall and success of the harvest to successful hunting. Some were believed to enhance the curative skills of their wearers while others were worn to protect against disease. Burial masks were placed on the face of a corpse to protect the deceased from evil spirits.

The ritual mask still survives in modern Western culture in various folk pageants and customs and in Halloween and carnival masquerading, and occasionally in other instances. Figure 9.9 shows some examples.

In Europe, it became the practice for public executioners to wear a hooded mask which bestowed on its wearer an almost bestial appearance and thus enhanced the

Figure 9.9 Changing faces

171

Figure 9.10 Headhunter

Figure 9.11 The masquerade

theatrical spectacle of the event (Figure 9.10). In fact, in medieval Europe, masks were widely used in the theatre, in mystery and miracle plays to represent a variety of characters, including monsters, God and the devil. During the Renaissance period, the full face mask gave way to half masks which covered only the eyes and nose and these in turn gave way to a mask covering only the eyes. Masks were also worn by the aristocracy at Renaissance courtly events such as masquerade balls (Figure 9.11) and the ballet de cour, while a simple variant found favour with Dick Turpin and other highwaymen (Figure 9.12).

Since the days of the original Greek theatre, theatrical masks have fallen generally into two categories – tragic and comic – with many variations on both themes, giving rise to the now familiar theatrical logo (Figure 9.13).

Outside the theatre, most masks found today are worn for protective purposes, such as the industrial welder's mask or the mask worn by the ice hockey goalkeeper (Figure 9.14) which bears more than a passing resemblance to the faceplate of a suit of medieval European armour, while the balaclava – a simple woollen full-head mask which leaves only the eyes and mouth visible – is favoured both by clandestine terrorist organisations and by the skiing community. The painted face mask of the clown (Figure 9.15) dates back to the first modern circus which was staged in London in 1768.

Figure 9.13
Make them laugh, make them cry

Figure 9.12 The highwayman's
adaptation of the courtier's mask

Figure 9.14
Twentieth century armour

Figure 9.15
The roar of the greasepaint

Astrology, which first appeared as early as 3000 BC, is a quasi-science which possesses its own special group of mystic signs or symbols. Astrology was practised by many early civilisations in China, India, Greece and South America, who observed the correlation between planetary movement and the terrestrial seasons. Mystical signs, which became known as the twelve signs of the Zodiac, were ascribed to the apparent path of the Sun among the stars, which was divided into twelve sections of 30° each.

Astrology has been practised in Europe since the Middle Ages, in spite of condemnation by Christian leaders and progressive undermining by the discoveries of the science of astronomy, and there are still many avid readers of astrological charts who remain convinced that the movements of the planets govern their lives.

The zodiacal signs are Aries, the Ram; Taurus, the Bull; Gemini, the Twins; Cancer, the Crab; Leo, the Lion; Virgo, the Virgin; Libra, the Balance; Scorpio, the Scorpion; Sagittarius, the Archer; Capricornus, the Goat; Aquarius, the Water Bearer; and Pisces, the Fishes.

One of the simplest and most effective

Capricorn

Cancer

Aquarius

Leo

Pisces

Virgo

Aries

Libra

Taurus

Scorpio

Gemini

Sagittarius

Figure 9.16
Signs of the Zodiac

Figure 9.17
Modigliani's La Tête Rouge

ways of creating bizarre or macabre images is to edit or even interchange features between familiar objects. The viewer, at first reassured by what appears to be a scene conforming to normal visual rules, is startled to discover that something is not quite right. Such a technique was widely employed by artists like Modigliani (Figure 9.17), whose portraits are characterised by the oval faces and elongated features often conveying to the viewer a strong sense of pathos.

In the example shown in Figure 8.18, the appearance of the girl has been altered by replacement of her eyes – the most important feature of the face – with the eyes of the tiger. A Photo CD image of the girl was opened in Photoshop and then, using the *Paths* tool, a path was drawn around the girl's right eye and converted to a selection, with a feather of two pixels. A Photo CD image of the tiger was then opened and the tiger's right eye was selected with the *Marquee* tool. The selection was copied to the clipboard and then, using Photoshop's *Paste Inside* command, the tiger's eye was pasted inside the selection of the girl's eye on a new layer. The opacity of the tiger eye was reduced to 75% to allow some show-through. Using a small brush size, the *Smudge* tool was used to blend the edges of the tiger eye into the face. The same procedure was then used to replace the other eye.

Another variation of this procedure is shown in Figure 9.19. In this case, a ceramic mask purchased on a vacation trip to Spain was placed on the platen of a flatbed scanner and scanned at 150 dpi in 24-bit colour using Photoshop's *Acquire* function (a). A copy of the

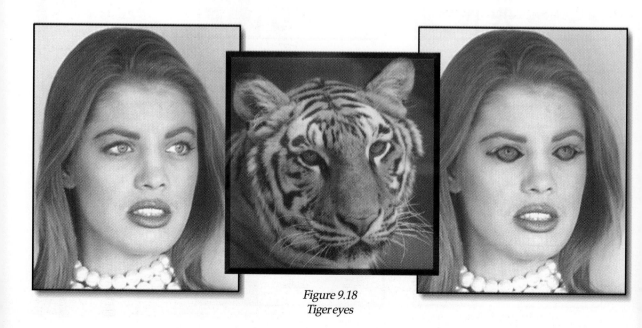

Figure 9.18
Tiger eyes

174

image was made and a similar procedure to that described for Figure 9.18 was used to select the eyes from a Photo CD image and paste them into the empty eye orbits of the mask (b). What helps to give this result visual impact is the convincing three-dimensional look of the mask, shadowed against its background so that the viewer is satisfied that the object is both inanimate and inorganic. The appearance of what are quite clearly human eyes in the sockets of the mask, which in all other respects remains the same, creates a disturbing visual conflict – a technique widely exploited by the 'fantasy and horror' film industry.

Figure 9.20 shows an image reminiscent of an Egyptian sarcophagus, in which a human figure appears to be 'embedded' within a block of stone. This was created by importing a DXF model of the male figure into Bryce, where it was rotated into a horizontal position. A Bryce cuboid primitive was added, scaled and positioned so that the figure lay partially below its surface. Textures with complementary colours were then applied to the figure and plinth and a grey sky was added to give the scene atmosphere.

(a)

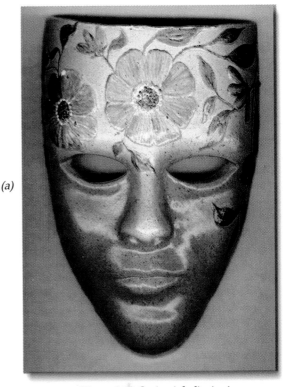

Figure 9.19 Seeing is believing!

(b)

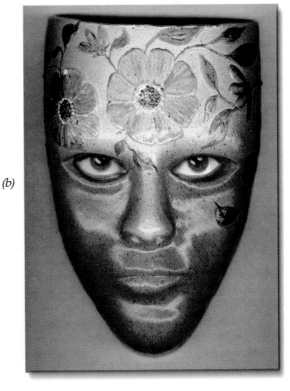

Figure 9.20 Peace at last

Figure 9.21 Drowning in a virtual sea

Figure 9.22 Fraying at the edges

To produce the 'drowning man' image in Figure 9.21, the male figure was first created in Poser with the head tilted back and the arms outstretched. The image was saved in DXF format and imported to Bryce, where it was scaled and rotated into position. In Bryce, a new water plane was created and the relative positions of the figure and the water plane were adjusted so that most of the figure appeared to be below the surface. Textures were then added to the figure and the water plane. Finally a daytime sky with high cloud cover was added to complete the effect.

A more complex technique was used to produce the result in Figure 9.22. The figure was first created and positioned in Poser and *Lit Wireframe* was selected from the *Display* menu to display the figure in wireframe format. This wireframe version was saved as a TIFF file. The figure was then rendered, using the *Nude Male* surface texture provided with Poser and this rendered version was saved as a separate TIFF file. Next, both files were opened in Photoshop and a new layer was added above the rendered version of the image. The wirenet image of the figure was next selected, using Photoshop's *Magic Wand* tool and copied on to the new layer above the rendered version. A *Layer Mask* was added to this upper layer and then the *Airbrush*, using a large brush size, was used to paint out the mask covering the lower part of the figure, revealing the rendered version on the background layer. Using a pressure sensitive stylus and tablet to apply the airbrushed effect, the pressure was reduced in the solar plexus area and on the upper arms to create the impression that the wirenet was 'showing through' the skin. The rest of the figure was left untouched to leave the resulting hybrid effect.

The same technique can be applied to just part of a figure, as shown in Figure 9.23. In this case, the figure was first posed and

then scaled up until only the head and shoulders were visible. The *Lit Wireframe* display was selected and the resulting wireframe image was saved as a TIFF file. The image was then rendered and saved as a second TIFF file. The same technique as described above was used to create the hybrid shown in (b).

When a Poser figure is saved as a DXF file, the option is provided of saving the figure as one object or as a group of separate body parts which can be ungrouped in some other applications (Figure 9.24). Figure 9.25 shows such an example, in which the DXF file was imported into Bryce, ungrouped and the body parts were redistributed as if the figure had been pulled apart.

(a)

Figure 9.24 Poser DXF Export dialog box

(b)

Figure 9.23 That netted feeling

Figure 9.25 Ripped asunder

Figure groups can also be created within Bryce. The figures can either be created and exported separately from Poser, or posed together, saved together as a single DXF file and then imported to Bryce as a single file, so that their spatial relationship is maintained. Once inside Bryce, they can be separated by using the *Ungroup* command and then manipulated separately if, for example, different textures are to be used.

Figure 9.26 shows an unusual dance ensemble created in this way. The figures were created using the *Female Nude* and *Male Skeleton* options and then the figures were posed, scaled and positioned with respect to each other. The pair were then saved as a single DXF file and imported to Bryce. After separating the figures, different textures were applied to them. A ground plane texture was chosen to create a shimmering effect in the distance and to reflect the colour of the sky.

Figure 9.26 Danse macabre

Figure 9.27 uses the technique of disturbing the symmetry of an image (the eyes in the face, in this case) as well as mixing an inorganic object (the monitor) with an organic one (the face). To create this effect, a Photo CD image of the face was first opened in Photoshop and a new layer was added. The clipart monitor was copied to the clipboard from CorelDRAW and pasted on to the new layer, where the white background was selected with the *Magic Wand* tool and erased, leaving the monitor floating over the face. The *Paths* tool was then used to draw the shape of the monitor screen and the path was converted to a selection and saved. Switching to the background layer, the selection was loaded and dragged into position so that it framed the right eye. The selection contents were copied to the clipboard and the *Paste Inside* command was used to place the copy on the screen which was then rotated as shown.

Figure 9.27 Transposition

CorelDRAW's *PowerClip* feature was used to produce the result in Figure 9.28. A 30 30 grid was first placed over the clipart skull (a) and the skull was powerclipped into

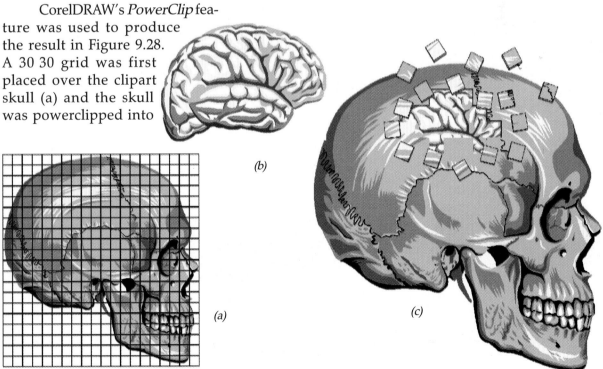

(a)

(b)

(c)

Figure 9.28 Using CorelDRAW's PowerClip feature

the grid. Next, the outline colour of the grid was changed to *None* and the grid was ungrouped, so that the skull was now divided up into 30 30 individual elements. A number of these elements were selected, moved and rotated as shown in (c). They were then extruded, using CorelDRAW's *Extrude* feature and a *Solid* edge fill, to give them an appearance of depth. Finally a clipart brain (b) was imported, scaled and placed in position over the skull and then, using *Arrange/Order/To Back*, was placed beneath the skull so that it now appeared that the brain was being revealed through the opening in the skull.

Finally Figure 9.29 shows how an existing painted image such as the face in the Dutch master on the left can be edited to produce the result on the right which is more reminiscent of the grotesque images painted by Francis Bacon. To produce this result, the original Photo CD image was opened in Photoshop and duplicated. The *Lasso* tool was used to cut out the face and neck and the rest of the image was filled with black. The result was then saved and opened in Painter, where the *Hairy Bristle* brush was used to add red and white to selected areas of the image. A combination of the *Wet Drip Distortion* brush and the *Add Water* brush were then used to paint the added colours into the image and to modify and smooth the features as shown ➚

Figure 9.29 Rubens' Head of a Negro (left) edited in Painter (right)

10

Images from

nature

and science

ince the days of Pythagoras, Plato, Aristotle and Archimedes, man has sought to investigate and explore the wonders of nature which surround him, giving birth to the sciences of astronomy, physics, chemistry, botany, geology, biology and zoology, together with many subdivisions of these, like metallurgy, crystallography and meteorology. Since digital graphic design is only possible through the application of scientific and mathematical principles to the design and manufacture of computer hardware and software, it is only fitting that a chapter of this book should be devoted to images derived, directly or indirectly, from these disciplines.

Instruments developed and used for scientific study, including the camera, microscope and telescope, have allowed us to view and capture images of breathtaking beauty and diversity – images conceived by Mother Nature, the greatest of all designers. The brilliant plumage of a parrot (Figure 10.1) or the beautiful colouring and texture of a simple shell on the ocean bed (Figure 10.2), the delicate tracery of winter frost on a window pane (Figure 10.3) or stalactites formed by hundreds of years of chemical reaction (Figure 10.4), are just a few examples of thousands of such images now available to the designer.

Throughout the history of Man, art and science have been closely intertwined. As well as discovering and applying the principles of mechanics to the building of the Pyramids, it was the Egyptians who arrived at correct rules for finding areas of triangles, rectangles and trapezoids, and for finding volumes of figures such as bricks, cylinders and, of course, pyramids.

Nature is the art of God

Sir Thomas Browne 1605–82
English writer and physician

Figure 10.1
The richly coloured plumage of a parrot

Figure 10.2
The ocean's harvest

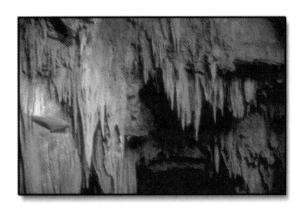

Figure 10.3 Frost patterns

Figure 10.4 Stalactite formations

Artists over the centuries have found inspiration in the beauty of a sunset, the sensuous flowing contours of sand dunes, in fresh winter snow shimmering on fir trees on a mountainside, water droplets glistening on the gossamer strands of a spider's web, in the spectacle of forked lightning illuminating a night sky or the symmetry of a fern – all of them masterpieces of nature. Indeed, the very materials used by artists to paint a landscape (Figure 10.5) or fashion a sculpture in marble (Figure 10.6) are provided by nature's generous bounty. From the earliest cave painter's charcoal to natural chalks like calcium carbonate and the rust colour of iron oxide, artists searched and found pigments which could be made from mineral ores mined from the Earth's crust, including blue azurite, green malachite, yellow orpiment, red cinnabar, blue frit and white lead.

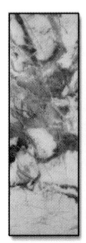

Figure 10.5 A classical landscape

Figure 10.6 Marble textures

The sculptor may also find inspiration in nature's carving of a rockface (Figure 10.7) or even of a whole landscape (Figures 10.8), created by the action of the elements as they combine to reshape the topography of the Earth's surface.

Figure 10.7 Erosion of a coastal rock face by the sea

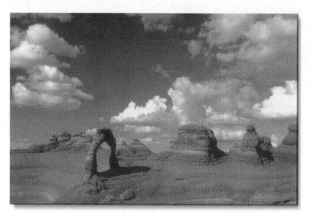

Figure 10.8 Erosion by wind-borne sand

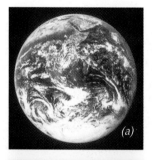

(a)

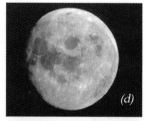

(d)

(e)

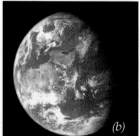

(b)

(c)

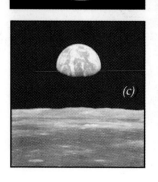

(f)

Advances in science have also allowed man to reach beyond the Earth, to break free from its gravitational force and to see and record breathtaking images of the Earth and the Moon set against the inky darkness of space (Figure 10.9).

At the same time, the boundaries of 'inner space' have been pushed back, with advances in the resolution of optical microscopes and development of the scanning electron microscope which achieves a level of resolution capable of approaching atomic dimensions.

Figures 10.10 to 10.12 show just a few examples of the astonishing variety of colours and textures displayed by sections of crystalline materials when viewed with polarised light under a high powered optical microscope. Such images, available in Photo CD format, are of such high resolution that even small areas can be selected and successfully blown up for use as elements of a graphic composition.

Figure 10.9 (a) and (b) Planet Earth photographed from Apollo space missions; (c) Earthrise, seen from the surface of the moon; (d), (e) and (f) Approaching the moon

(a)

(b)

Figure 10.10 Naphthol (a) and Thiosulphate (b)

(a)

(b)

Figure 10.11 Diphenyloxazole (a) and Agarose (b)

(a)

(b)

Figure 10.12 Salt crystallograph (a) and mixture of sugar and salt crystals (b)

Figure 10.13 Hitachi S-900 Scanning Electron Microscope

The most powerful optical microscopes can magnify an object by around 2000 times. To penetrate further into nature's inner space, we have to turn to microscopes which employ electron beams, rather than light, to explore even finer detail. A transmission electron microscope, which fires a beam of electrons through a thin sample of the target object on to a photographic plate or fluorescent screen, is capable of magnification up to a million times. A scanning electron microscope (SEM) scans the surface of the target object with an electron beam and electrons which are scattered by the target are detected by an electronic counter. The resulting signal is displayed on a TV monitor, building up a 3D picture of the target object as the electron beam scans over the entire sample. An SEM can magnify objects 100 000 times.

Superb examples of these can be found at the Web site http://surf/eng/iastste.edu, where the images are provided courtesy of *Microscopy Today*. Original photos were created by David Scharf using his patented 'SEM Wideband Multi-Detector Color Synthesizer' and computer digital recording. David Scharf is a scientist and photographer whose SEM images have earned him critical acclaim for their artistic and technical perfection. His images have been featured in many publications including *Life, Time, National Geographic, Scientific American, Discover* and many others. Images were acquired with Gatan's DigiScan, DigitalMicrograph and the SEM Wideband Multi-Detector Color Synthesizer. In addition, his images have been shown in numerous exhibitions in science and art museums and are included in many collections.

Images from scientific research

The fresh new sources of graphic images which have resulted from space exploration and electron microscopy are direct spinoffs from fundamental scientific research, which continues unabated, notably in the United States and in Europe. Figures 10.14 to 10.16 show some other examples, courtesy of IBM's Communications Department at its UK Hursley Laboratory, near Winchester.

Figure 10.14 pictures the letters I–B–M written by a new data storage method that has the potential for storing many times more information than current optical data storage techniques. The tech-

nique uses an atomic force microscope and a laser to make tiny pits in a flat, clear plastic surface. The letters I–B–M were written as some 42 marks within a single 2 micron wide data track of a plastic optical disk. The spacing between the pits, which look like peaks in the image, is about 0.2 microns (© IBM Corporation, Research Division, Almaden Research Center).

Figure 10.15 shows a face mask created using a radar scanning technique, while Figure 10.16 shows two images created using advanced computer 3D modelling techniques developed at IBM's UK Scientific Centre, Hursley (© IBM's UK Scientific Centre, Hursley).

As well the categories of photographic images described above, today's digital designer has access to other exciting sources of imagery as described below.

Figure 10.14 Precision laser indentation

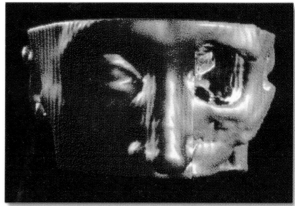

Figure 10.15 Three-dimensional scanning

Figure 10.16 Images created using a three-dimensional modelling technique

Fractals

The origins of fractal geometry can be traced back to the late nineteenth century, when mathematicians started to create shapes – sets of points – that seemed to have no counterpart in nature. The mathematics which evolved from that work has now turned out to be more appropriate than any other for describing many shapes and processes found in nature – shapes which seemed to fall between the usual categories of one-dimensional lines, two-dimensional planes or three-dimensional volumes and processes like the flooding of the Nile, price series in economics or the jiggling of molecules in Brownian motion in fluids.

It was Benoit Mandelbrot, working at IBM in the 1950s, who was first to realise what all these phenomena had in common and it was he who pulled the threads together into a new discipline called fractal geometry with which he sought to explain these shapes and processes. As computers gained more graphic capabilities, the skills of his mind's eye were reinforced by visualisation on display screens and plotters. Again and again, fractal models produced results – for the growth of a fern or the delicate formation of a snowflake – which closely emulated their creation in nature.

The power of the desktop computer now allows us to give vibrant graphic expression to these otherwise remote mathematical formulae, adding an exciting new dimension of expression to our graphic design toolkit. Fractal applications suitable for use by the non-technical designer include Fractint (a remarkable shareware program) and KPT Fractal Designer.

Fractint (Figure 10.17) is a remarkable Shareware application which has been developed and evolved by a group of dedicated 'fractophiles'. It allows the designer to display and explore a wide range of fractal types. Each type can be redrawn with infinite variations, by simple adjustment of parameters within the mathematical expressions describing the fractal and without the need for any mathematical knowledge. Each example can be zoomed and rotated and its colour palette can be changed.

Fractal Grafics, by Cedar Software (Figure 10.18), uses a quite different approach. The user is provided with a menu of simple fractal templates and tools to colour and

FRACTINT Version 16.0				
Select a Fractal Type				
barnsleyj1	barnsleyj2	barnsleyj3	barnsleym1	barnsleym2
barnsleym3	bif+sinpi	bif=sinpi	biflambda	bifurcation
cmplxmarksjul	cmplxmarksmand	complexbasin	complexnewton	diffusion
fn(z)+fn(pix)	fn(z*z)	fn*fn	fn*z+z	fn+fn
formula	gingerbreadman	henon	ifs	julfn+exp
julfn+zsqrd	julia	julia4	julibrot	julzpower
julzzpwr	kamtorus	kamtorus3d	lambda	lambdafn
lorenz	lorenz3d	lsystem	magnet1j	magnet1m
magnet2j	magnet2m	mandel	mandel4	mandelfn
mandellambda	manfn+exp	manfn+zsqrd	manowar	manowarj
manzpower	manzzpwr	marksjulia	marksmandel	marksmandelpwr
newtbasin	newton	pickover	plasma	popcorn
popcornjul	rossler3d	sierpinski	pider	sqr(1/fn)
sqr(fn)	test	tetrate	tim's_error	unity

Figure 10.17 Fractint screen for selecting fractal types

manipulate these templates before drawing or painting with them. Astonishingly beautiful results can be achieved with a little patience and exploration. The fern example shown was created using the simple fractal template in the bottom corner of the screen

KPT Fractal Designer is a Photoshop plug-in which can be used from within Photoshop (or any other application which can access Photoshop plug-ins) to apply fractal fills to masked areas of an image or to a complete image layer (Figure 10.19).

Figures 10.20 and 10.21 show examples of the kind of fractal images which can be created, with a little practice, using these applications.

Figure 10.18 The Fractal Grafics editing window

Figure 10.19 KPT Fractal Explorer

Figure 10.20 Fractal patterns

189

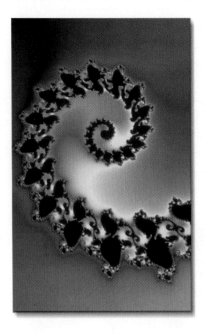

Figure 10.21 Fractal patterns

Procedural textures

The examples of marble textures which were included in Figure 10.6 are typical of a growing range of high quality scanned images of natural materials like wood, rock samples, metal and glass etc. which are available as Photo CD images. Excellent as such images are, they can only be used 'as is', i.e. they are not editable. To overcome this limitation, the same principles used to develop applications which can produce the kind of fractal images shown above have been adapted to provide the designer with the means of creating a much wider range of textures which closely resemble natural materials and which are also fully editable. Such textures, which are created by means of mathematical algorithms, are called 'procedural' textures.

We already saw examples of such procedural textures in Chapters 5 and 7, where they were used within the Bryce application to create terrain materials. Bryce offers both preset options from its *Materials* dialog box and also the ability to edit materials within its *Materials Composer*, but the purpose of this is to provide a wider choice within the application. Corel TEXTURE, on the other hand (Figure 10.22), provides a sophisticated means of creating and rendering procedural textures which are easily saved as bitmap files for use in any application.

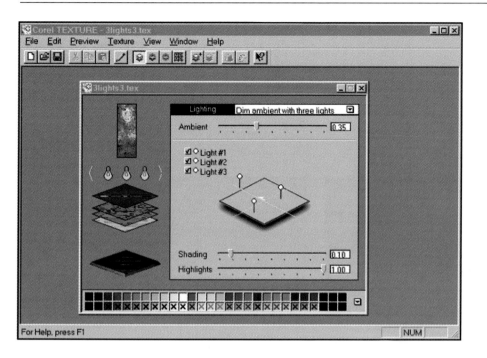

Figure 10.22
Corel TEXTURE's
editing screen

Fractal techniques are used as the mathematical basis for Corel TEXTURE, which means that, instead of the quality degrading as the image is enlarged, finer details simply appear, as if zooming into a fractal, and the resolution and image quality are maintained. Textures are created by combining four properties:

(i) **Lighting** of the surface, using up to three lights

(ii) **Shader Layers**, which may carry *Material* (such as wood, marble, or granite); *Colour*, which acts like the colour filter on a camera lens; and *Blend*, which specifies the way layers interact to form the final texture

(iii) **Topography**, which is used to define the surface contour of a texture

(iv) **Edge**, which provides a round, bevelled, or flat border for a texture

Each of these four properties can be controlled independently to adjust specific aspects of a texture. As well as simulation of solid materials like wood or rock, the generator can mimic the textures of clouds and waves. Corel TEXTURE's editing screen (Figure 10.22) shows a preview of the texture which is in process in the top left

Figure 10.23
Texture in the making

hand corner. Below the preview are the three light icons which can be selected individually for editing and below the lights are the layers of which the texture is composed; any of these can be selected for editing independently of the others. Figure 10.24 shows some examples of the kind of results which can be produced. Textures can be rendered at a reso-

lution appropriate to their planned use, e.g. 72 dpi for screen use or 300 dpi if the texture is to be used in a project to.be printed at high resolution.

Other procedural renderers are provided within Kai's Power Tools suite of Photoshop plug-ins. Texture Explorer (Figure 10.25) provides the user with a wide range of

| Wood grain | Terracotta | Evening sky | Waves |

| Fabric | Marble | Japanese lacquer | Jungle |

Figure 10.24 Procedural textures created in Corel TEXTURE

Figure 10.25 KPT's Texture Explorer dialog box

Figure 10.26 KPT's Spheroid Designer dialog box

presets and controls for mutating new variants from these. Spheroid Designer (Figure 10.26) wraps textures around a sphere and also provides a wide range of tools for editing the many presets provided, offering the designer a simple way of introducing shaded and textured spherical objects into a composition. Figure 10.27 shows an example, in which a spheroid has been added to the scene on the left in order to produce the result on the right. First a Photo CD image of the cave scene was opened in Photoshop and a selection was made using Photoshop's circular selection tool and feathered by one pixel. The selection was positioned so that it overlapped the horizon and then, with *Quick Mask* selected, the lower part of the selection was 'painted out' using the brush tool, with black as the foreground colour. *KPT Spheroid Designer* was opened via the *Filters* menu and a suitable spheroid was selected from the preset list. Clicking on *Accept*

Figure 10.27 Using Spheroid Designer to edit a scene

closed the dialog box and applied the spheroid to the selection, with the result shown.

Figure 10.28 shows a more dramatic way of creating such a scene using Bryce. In this case a sphere primitive was added to a scene containing a terrain object and both terrain and sphere were scaled and positioned so that the sphere was partially obscured by the terrain. Bryce's procedural textures were applied to the sphere, the terrain and the ground plane (the terrain's vertical position was adjusted so that it disappeared below the ground plane in the foreground). A deep blue

Figure 10.28 Creating a mysterious planet in Bryce

sky texture was added, together with a distance-sensitive blue haze, so that the 'planet' appeared to be seen through the haze.

Spheroids can also be used to edit features of either existing vector or bitmap images. Figure 10.29 shows an example in which spheroid 'eyes' have been added to a clipart face to make the face look even more surprised!

Figure 10.29 Using spheroids to edit clipart

As we have seen in this chapter, applied science is opening up a rich treasure chest of new raw material for use in design projects. High powered optical cameras developed to work in the hostile conditions of space or even strapped to the back of an eagle or a great white shark are providing unprecedented images of nature, while the scanning electron microscope has penetrated a hitherto inaccessible world of near-atomic proportions.

Fractal geometry and the development of procedural generators are creating virtually infinite new possibilities for exploring new combinations of colour and texture.

With the advent of high quality, high resolution libraries of royalty-free images available on CD ROM, the emergence of affordable digital still and video cameras and the growing ease of trading images via the Internet, the digital designer now has unprecedented access to the wonders of nature and science ➚

11
Digital art

More than 10 000 years ago, as the first Paleolithic painter picked up a stick or reed and reached out to smear coloured earth on to a cave wall in southern Europe (Figure 11.1), little could he or she have realised that these first tentative strokes laid the foundation for Man's most creative pursuit.

The thousands of years which followed have witnessed continuous evolution in both the materials and the techniques used for painting and the creation of works of enduring and universally acknowledged beauty as well as works which have provoked bitter controversy (see sidebar below).

This process of evolution has continued apace during the twentieth century, as new artists have emerged and new materials and techniques have become available, many of them derivatives of innovative industrial processes and techniques. Notable among the latter has been the rapid development of the digital medium, driven mainly by commercial interests, but now attracting growing interest within the artistic community.

While the early emphasis of desktop drawing and photoediting applications was mainly on providing tools and techniques for graphic designers, users with a more artistic leaning were quick to see the potential for using the applications for purely aesthetic purposes. Responding to this interest, a number of developers now offer products which are actually tailored for the artist, rather than the designer and, in recent years, a whole new genre of computer art has begun to evolve. Artistic styles are almost as varied as the artists themselves, ranging from emulation of the techniques of the traditional schools of painting, to styles which are unique to the digital environment.

To describe the facilities available to today's digital artist is to try to hit a moving target, as every few months brings forth a further application upgrade offering new features and opening up new and unforeseen possibilities. This chapter, therefore, should be seen as just a set of snapshots of the techniques presently on offer from state-of-the-art drawing and painting applications.

Figure 11.1 Cave painting of buffalos found in southern Europe

Drawing versus painting applications

In their earliest form, drawing applications offered little more than the ability to draw simple, straight or freehand lines and basic geometric shapes, using a palette of sixteen colours. Today's applications, by contrast, offer a dazzling range of tools, techniques and special effects, a palette of 16.7 million colours and even the ability to control the stroke width of lines, using stylus pressure sensitivity, and the transparency of objects within a scene.

As Figure 11.2 shows, the use of transparency can dramatically alter the effect of a simple scene. This scene was created in CorelDRAW using three copies of a clipart elephant. The *Interactive Transparency* tool was applied to each in the vertical direction, to differing degrees and the copies were then scaled and positioned so that the group appeared to be emerging from a mist.

The drawing application has traditionally offered the artist a greater degree of precision through the use of rulers, movable guides, node editing and multiple layers for the separation of elements within a composition. This distinction, however, is becoming increasingly blurred, as developers seek to port many of these features to photoediting and painting applications like Photoshop, Painter and PHOTO-PAINT. The ability to move elements of a composition or even a partially completed composition between applications for editing purposes is also improving rapidly, for example through the exporting of paths or alpha channels or by file conversion using increasingly sophisticated import/export filters. The need for a creative artist to work spontaneously and intuitively has also been recognised by the developers who are now offering deferred rendering features which relieve the problem of slow response time, when working with large colour files, by allowing the artist to work with a screen resolution image and later to render changes to the higher resolution required for printing.

By working with a combination of applications, therefore, the artist can now combine the precision of a drawing application with the virtuosity of a painting application and the lighting and atmospheric effects of a three-dimensional application.

Figure 11.2 Elephants in the mist

197

Examples

Figure 11.3 shows the result obtained by using Photoshop's *Paths* tool to select the left side of a bitmap image which was then traced in Corel Trace. When tracing was complete, the fill was set to *None* and the outline to black. The result was then reimported to Photoshop where it was 'spliced' back on to the right half of the original. Figure 11.4 shows an alternative effect which was created in Painter by using the *Distortion* brush to break up the sharp boundary between the two halves of the image, giving the impression that one half is bleeding into the other.

Tracing was also used to produce the result in Figure 11.5. Adobe Streamline was used to trace a photograph of my wife Julia, using two different threshold settings. The copies were opened in Illustrator, where the vector elements of each image were combined before radial gradient fills were applied. After importing the images to Photoshop and placing them side by side, a ten pixel stroke was applied to a rectangular selection to form a frame, using a colour selected from one of the images with the *Eyedropper* tool. Finally, a drop shadow, using the same colour, was applied to the frame.

Figure 11.6 – a self-portrait of my younger son, Simon – again used a combination of drawing and painting applications. After propping up a mirror alongside the computer monitor, he first sketched his image in CorelDRAW using a stylus and tablet. Fills were applied and then the image was saved and imported into Photoshop where shading was added, using the *Airbrush* tool.

Figure 11.3
Using Tracing to create a compound image

Figure 11.4
Softening the boundary with Painter's Distortion tool

Figure 11.5 Portrait study

Figure 11.6 Simon Pender – a self-portrait

Continuing with the family theme, Figure 11.7 is based on a family snapshot of my younger daughter, Claire, imported and edited in Painter. A clone was first made from a scan of the snapshot, using Painter's *File/Clone* command, and the image was erased from the clone window.

Clicking the icon in the vertical scroll bar of the clone window produced a 50% ghost of the original source image, providing a guide for the editing process.

To create the 'ice crystals' effect for the hair, a *Chalk* brush variant was chosen, using the *Cloning* method and *Grainy Hard Cover* subcategory (the brush grain control was set to 100% to maximise the effect); using these settings, the hair and tinsel tiara were painted back in, using a large brush size and bold strokes. The brush subcategory was then changed to *Soft Cover* and, again using a large brush size, the face and neck were painted back in.

Figure 11.7 Ice maiden

Figure 11.8 Ghostly apparition

Creating the effect in Figure 11.8 involved the use of two Photo CD images. The first image – of a hooded figure in a monastery – was opened in Photoshop and the *Lasso* tool was used to select just the hood and gown, leaving the face and background unselected. The selection was feathered to one pixel and saved as an alpha channel. The second image – of a woodland against a sky backdrop – was opened in Photoshop, where it was cropped to the same size as the first image, with the same resolution. The whole scene was selected and copied to the clipboard.

The mask in the first image was reselected and inverted, protecting the mask and gown and *Paste Inside* was used, from the *Edit* menu, to paste the woodland scene 'behind' the hooded figure, so that it appeared to show through where the face had originally been. Finally the area of the face was selected and a *Lens Flare* filter was applied.

Figure 11.9 also involved the use of two Photo CD images, this time to create a 'hybrid' being in which the eyes and nose of the monkey replaced those of the man. To achieve

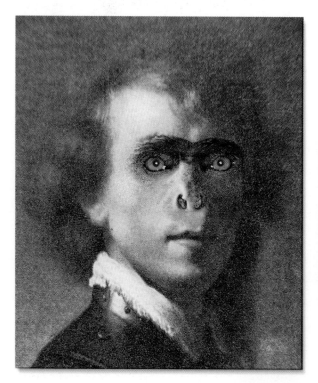

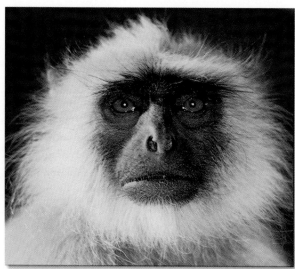

Figure 11.9 The beast within

this result, a selection of the eyes and nose of the image on the left was selected, feathered and saved and the eyes and nose of the monkey were pasted inside, as in the previous example. To make the result more dramatic, while the monkey eyes and nose were still floating, Photoshop's *Hue/Saturation* dialog was used to adjust the colouring. The floating image was then dropped and the *Smudge* tool was used to blend the pasted image more smoothly into the face. As smudging tends to obliterate texture, the areas which had been smudged were selected and the *Gaussian Noise* filter was used to restore the lost texture. Finally, using the *Eyedropper* tool to match the colours, a fine brush was used to touch in any blemishes at the boundary between the two images.

Painter's distortion brushes were used to create the multi-coloured eagle's head in Figure 11.10. With the original image of the head set against a black background, a *Penetration* brush variant was used to add a range of colours to the head feathers from one of Painter's *Custom Sets*. The *Distortion/Hard Grainy Drip* variant of the *Liquid* brush was then used to blend the new colours into the original, taking care to follow the original direction of the feathers. The same brush variant was used to edit the eye and beak to give them a more evil-looking aspect.

Figure 11.11 was created by first scanning a simple carved wooden figure which my daughter had purchased on a trip to Poland. The figure was simply laid flat on the bed of the scanner and the lid was closed as far as possible on top of it. The resulting scan, which was surrounded by shadow, was cleaned up in Photoshop and saved, with an alpha channel which defined the figure's outline, as a TIFF file. The file was then imported into Bryce, where it was rotated, scaled and positioned and a duplicate was made and offset to the right. Loading the alpha channel

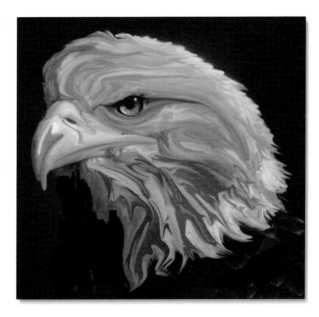

Figure 11.10 Feathered venom

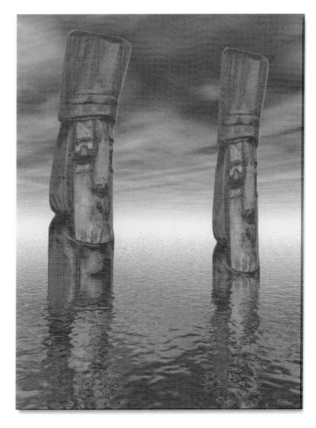

Figure 11.11 Silent sentinels

Figure 11.12 Killing fields

mask saved with the file has the effect of 'cutting out' the white background of the bitmap, leaving just the figure visible. A water plane was added to the composition and its level was adjusted so that the two figures appeared to rise out of the water. Finally, a suitable sky background was added and the lighting adjusted to produce the final effect.

Figure 11.12 was also produced in Bryce, using a feature not mentioned earlier. The bitmap of the skull fragment was first saved, as a TIFF file, with an alpha channel mask as in the previous example. The file and its mask were then loaded into Bryce and rotated, scaled and placed in position, so that the skull appeared to be floating in the air. A ground plane was added and the same TIFF image was used as a texture map for the ground plane, so that the same skull image was echoed in the ground plane, with perspective matching that of the ground plane. Finally a suitably sombre sky background was added and the position of the lighting was adjusted so that the floating skull cast a shadow on the ground below.

To produce the illusion of footprints in the sand in Figure 11.13, a clipart left footprint symbol was first opened in CorelDRAW

Figure 11.13 Man Friday

and then a copy was flipped to make a right footprint. Further copies of both feet were made and positioned to create a trail of prints. The result was copied and pasted into Photoshop, where a mask of the footprints was saved as an alpha channel. The *Blur* filter was used to blur the mask slightly. The *Background* layer was then given a sand-coloured fill and the *Gaussian Noise* filter was applied to add texture. Next, *Render/Lighting Effects* was selected from the *Filter* dropdown menu. In the *Lighting Effects* dialog box, the mask of the footprints was chosen as the *Texture Channel* and a spotlight was configured to add a lighting effect. *Gaussian Noise* was added to the result, to add texture to the 'sand' and then the whole image was selected and perspective was applied by choosing *Effects/Perspective* from the *Image* menu and dragging the corner handles.

Another result created in Photoshop is shown in Figure 11.14. The flower vase was sketched using the *Freehand* tool, filled and then given the appearance of depth by shading it with the *Airbrush* tool. A simple flower shape with petals was then drawn in CorelDRAW, saved in Illustrator format and imported into Photoshop as a selection. Duplicates were made and the KPT *Texture Explorer* and *Spheroid Designer* plugins were used to apply a range of textures to the petals and spheroid effects to the flower centres. Finally the stems were drawn in and coloured.

To produce the result shown in Figure 11.15, the girl's head was first removed from its background, saved as a TIFF file and then opened in Painter. The image was cloned using the *File/Clone* command and then the copy of the head was deleted from the cloned image. From the *Brushes* palette, the *Scratchboard* variant of the *Pen* tool was selected and the *Subcategory* was set to *Soft Cover Cloning*. The default brush size was increased to 22% and a sweeping brush motion was used to paint

Figure 11.14 Digital still life

Figure 11.15 Disintegration

Figure 11.16 Impasto

Figure 11.17 Impasto Options dialog box

in the clone window, causing just that part of the original image to reappear which corresponded to the brushstokes. Using the *Magic Wand* tool, the new image was selected and floated and a soft shadow was applied via the *Effects/Objects* menu.

Painter was also used to create the next example in Figure 11.16. Once again, a Photo CD image was separated from its background, cloned and the copy was deleted from the clone window. The *Grainy Hard Cover* subcategory of the *Scratchboard* pen variant was selected from the *Brushes* palette and the size was set to 5% in the *Brush Controls* palette. Next, the *Impasto Floater* was selected from the *Objects* palette and *Apply* was activated to open the *Impasto Options* dialog box (Figure 11.17). Using the settings shown in the dialog box, sweeping brushstrokes were applied to the clone window, recreating parts of the original image beneath the brushstrokes, which simulated the appearance of richly applied oil paint. Finally, a light colour – which affects both the painted area and the background – was chosen to complement the colours in the cloned image.

One of Painter's newest and most remarkable features was used to create the result in Figure 11.18. A Photo CD marble texture was first imported and cropped to size to form a substrate. The *Liquid Metal Floater* was then selected from the *Objects* list, opening the *Liquid Metal* dialog box (Figure 11.19). Using the default settings – including the *Standard Metal* map – a number of mercury-like blobs of metal were deposited on the marble surface. Using the *Pick* tool and exploiting the simulated surface tension feature of this plugin, one of the smaller blobs was moved closer to the largest one until it was 'captured' and the two began to merge. Three other blobs were also moved closer to the largest one, so that their shapes began to deform, as if they, too, were about to be captured. A

Figure 11.18 Fatal attraction

Figure 11.19 Liquid Metal dialog box

drop shadow was added to the blobs to en-
hance the impression that they were sitting
on the surface of a marble block.

A number of techniques were combined
to produce the result shown in Figure 11.20
from three separate Photo CD images. First a
background 'canvas' was chosen and the lev-
els were adjusted in Photoshop to soften its
texture. A new layer was created and a cut-
out image of a classical face in profile was
imported to the new layer, where it was in-
verted, its transparency was reduced to 70%
and Photoshop's *Image/Adjust/Hue/Saturation*
controls were used to adjust the colouring of
the image to blend with the background
canvas.

A third layer was added and a cutout
image of fuchsias was imported, scaled, ro-
tated and positioned in the top corner of the
layer. As before, the colouring of the fuchsias
was adjusted to blend with the underlying
layers. Finally, while it was still selected, the
fuchsia image was feathered, copied and a
second copy was added.

Figure 11.20 Profile

With every new release, Corel's PHOTO-PAINT offers interesting new painting and photoediting possibilities. One of these, for example, is the ability to apply one of a range of *PhotoLab* HSV presets to an image to give it a more dramatic appearance (Figure 11.21); another is the ability to apply photographic 'filters' to an image simulating traditional photographic editing effects. These effects were used in the production of the composition in Figure 11.22.

Four photographic images representing spring, summer, autumn and winter were assembled in PHOTO-PAINT and a different effect was applied to each; *Photofilter M20* was applied to spring, the *Orange Cast* filter was applied to summer, *Photofilter 81D* was applied to autumn and *Photofilter 82C* was applied to winter). After assembling the four images in a single window, the *Marquee* tool was used to select the horizontal strip separating the upper two images from the lower two and the *Diffuse* filter was applied twice to break down the sharp boundary and blend

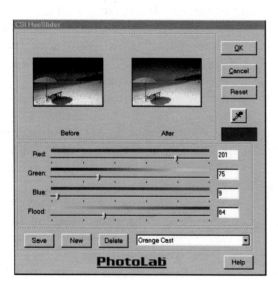

Figure 11.21 PhotoLab dialog box

Figure 11.22 Les quatre saisons

the images together. The same technique was then applied to the vertical boundary. As a further means of bringing the four images together and to provide more texture to the composition, the composite image was opened in Photoshop and *Uniform (Monochromatic)* noise was applied, using the *Noise* filter with the *Amount* set to *25*. Finally, the *Marquee* tool was used to select a narrow strip around the edge of the image and *Lightness* was reduced to create a border effect.

The next two compositions – Figures 11.23 and 11.24 – were created in Bryce. The rock object in Figure 11.23, representing a falling meteorite, was scaled, rotated and positioned just above a water plane. A material texture was chosen to give it an eerie, greenish glow, which was enhanced by choosing a sky containing green and by positioning the lighting to reflect off the front surface. A reflective, rippled, texture was applied to the water plane to reflect and shadow the falling 'meteorite'.

The objective in creating Figure 11.24 was to create the impression of a glass mountain rising from the ocean. A terrain object was placed in position and scaled to size. Its topography was then edited in Bryce's terrain editor to smooth the edges and vary the altitude of the peaks. Various glass textures were tried, to find one with the best reflective and refractive properties and then a reflective water plane was added and its level adjusted. Finally a cool blue-grey sky was selected to introduce reflected colours and the lighting parameters were optimised.

Figure 11.23 Imminent impact

Figure 11.24 Glass mountain

The final example in this chapter involved the use of the remarkable *Alchemy* filters provided with Corel PHOTO-PAINT. The staring image – a clay face mask – was opened in PHOTO-PAINT and the *Alchemy* filter was selected from the *Effects/Fancy* menu. Included in the *Style* dropdown list in the *Alchemy* dialog box are a number of variants of the *Spatula* style; the first of these was selected and applied to the image. A cutout of the result was copied to the clipboard and pasted into the left side of a new image containing only a black fill (Figure 11.26). Two other variants of the *Spatula* style (*Horizontal* and *Angular*) were then applied to copies of the mask and the results were pasted into the centre and right hand side of Figure 11.26. Next a border selection encompassing the boundary between each of the three masks and the black surround was created and the *Diffuse* and *Gaussian Blur* filters were used to blend the faces into the black background. A fine black brush was also used to touch up the edges.

Finally, the *Lasso* selection tool was used to select the eye orbits in the first mask and a radial white-to-black fill was applied, centred on the midpoint between the eyes. The same operation was then repeated for the eye orbits in each of the other two masks ↗

Figure 11.25 Mask

Figure 11.26 Triptych

Summary

A few readers may be old enough to remember sitting in the darkness of a cinema auditorium watching the original screening of the *Wizard of Oz* in which Dorothy, the young heroine played by Judy Garland, is knocked unconscious as the family house is struck by a tornado. The opening sequences leading up to this event were filmed in black and white and then, as Dorothy, still unconscious, begins to dream, suddenly the images on the screen transform into dazzling Technicolor. For me, as a child, this film encapsulated the magical quality of colour, as Dorothy set off, not along a pale grey brick road, but along a bright yellow brick road, in search of the magical land of Oz.

For most of us, who just take colour for granted, it is hard to imagine how life would be in dull monotone. Life without the vibrancy which colour brings to a sunset, a rainbow, the petals of a flower or the plumage of a bird. Thanks to science, we have some understanding of the physical relationships between light and colour, but even today we do not fully understand how the brain perceives colour. We do know, however, from research that colour is an catalyst in the process of communication between people, for example that the visual impact and retention rate of information communicated with the aid of colours is much higher than that communicated in black and white.

In our world with its population approaching six billion people, sharing hundreds of languages and thousands of dialects, the importance of using graphics wherever possible to surmount language barriers is self-evident and colour offers a whole new dimension to the graphic designer and artist in this task.

Over the centuries, artists have sought to reproduce the colours in nature's palette – the blues, greens and browns of a landscape, the delicate skin tones of a living subject – using paints made from nature's materials. As we have seen, such paints rely for their effect on the absorption and reflection of light, so in a sense, today's digital artist is simply using a variation of this technique by using an electron beam to emit light from the phosphor screen of a monitor. What has changed is that the digital artist possesses a level of precise control over the colour of that light that his predecessors could not have imagined.

The technology of satellite communications is already bringing colour television pictures into billions of homes around the globe and the same technology will provide the same homes with access to the Internet. Instead of art galleries displaying coveted works of art for the pleasure of the elite few, free access to virtual art galleries will become available to millions, motivating many of them to participate in the revolution, contributing their own creations via their own Web sites.

In this book we have looked briefly at the way digital colour works and at exciting new ways in which it can be applied to the creation of a wide variety of illustration types. As the digital revolution continues its dizzy pace, the opportunities unfolding before the designer are enormous. The future's bright! The digital future is coloured!

Bibliography

Baird, R.N. Turnbull, A.T. and McDonald, D. The Graphics of Communication, *New York: Holt, Rinehart & Winston, 1987.*

Blatner, D. and Roth, S. Real World Scanning and Halftones, *California: Peachpit Press, 1993.*

Dean Lem Associated Inc. Graphics Master 4, 4th Edition, *Los Angeles: 1988.*

Craig, J. Production for the Graphic Designer, *New York: Watson-Guptill, 1976 (revised edition 1990).*

Craig, J. and Barton, B. Thirty Centuries of Graphic Design, *New York: Watson-Guptill, 1987.*

Craig, J. and Bevington, W. Working with Graphic Designers, *New York: Watson-Guptill, 1989.*

Dalley, T. (ed.). The Complete Guide to Illustration and Design, *London: Phaidon, 1980.*

Gill, R.W. Basic Rendering, *London: Thames & Hudson, 1991.*

Gosney, M. and Dayton, L. The Desktop Colour Book, *California: MIS Press, 1995.*

Gosney, M., Dayton, L. and Chang, P.I. The Verbum Book of Scanned Imagery, *California: M&T Books, 1991.*

Greiman, A. Hybrid Imagery, *London: ADT Press, 1990.*

Heller, S. and Fink, A. Low Budget High-Quality Design, *New York: Watson-Guptill, 1990.*

Hollis, R. Graphic Design – A Concise History, *London: Thames & Hudson, 1994.*

Meggs, P.B. History of Graphic Design, *New York: Van Nostrand Reinhold, 1983.*

Miles, J. Design for Desktop Publishing, *London: Gordon Fraser, 1987.*

Nyman, M. Photoshop in 4 Colors, *California: Peachpit Press, 1996.*

Oliver, D. Fractal Vision, *Carmel, Indiana: Sams Publishing, 1995.*

Olsen, G. Getting Started in Computer Graphics, *Ohio: North Light Books, 1993.*

Parker, R.C. Looking Good in Print, *Chapel Hill, North Carolina: Ventana Press Inc., 1988.*

Peacock, J. et al. The Print and Production Manual, *London: Blueprint (5th edition), 1990.*

Pender, K. Creative PC Graphics, *Wilmslow, Cheshire: Sigma Press, 1996.*

Pender, K. Digital Graphic Design, *Oxford: Focal Press, 1996.*

Pipes, A. Production for Graphic Designers, *London: Laurence King Publishing, 1992.*

Porter, T. and Goodman, S. Manual of Graphic Techniques 2, *London: Butterworth Architecture, 1982.*

Porter, T. and Greenstreet, B. Manual of Graphic Techniques 1, *London: Butterworth Architecture, 1980.*

Rudolf, A. Art and Visual Perception, *Berkeley, California: University of California Press, 1974.*

Sanders, N. and Bevington, W. Graphic Designer's Production Handbook, *New York: Hastings House Publishers Inc., 1981*

Sutton, J. Fractal Design Painter Creative Techniques, *Indiana: Hayden Books, 1996.*

Tektronix Inc. Picture Perfect: Color Output in Computer Graphic, *Wilsonville, Oregon, 1988.*

Turnbull, A.T. and Baird, R.N. The Graphics of Communication, *New York: Holt, Rinehart & Winston, 1980.*

Glossary

24-BIT COLOUR A description of systems which allocate 24 bits of data to each pixel in an image. Usually, the bits are allocated as 8 bits each for the three additive primary colours (red, green and blue). That arrangement provides over 16.7 million colour possibilities.

ALPHA CHANNEL In applications like Photoshop, alpha channels are used to create and store masks. Alpha channels are additional to the three channels of an RGB image or the four channels of a CMYK image.

AMBIENT LIGHT Normal background light, for example daylight, as opposed to artificial light cast by room lights or spotlights.

BEZIER Using the Bézier tool, smooth curves can be created by placing and manipulating Bézier nodes and the handles which radiate from these nodes.

BITMAP A type of graphics format in which the image is made up of a large number of tiny dots (bits) arranged on a closely spaced grid.

BITS/PIXEL A description of the number of levels of information a system stores about each point in an image. For every extra bit, the number of available colours or shades of grey doubles. Also called pixel depth.

BLEND A feature on many digital painting programs that allows softening of the edges or mixing of colours where two objects or regions meet.

BOOLEAN OPERATION – Action that can be performed within solid modeller to allow objects to be differeneced, intersected or joined.

BUMPMAPPING In Photoshop, the Texture Channel in the Lighting Effects dialog box allows use of a greyscale texture to affect how the light bounces off the image. By creating unique textures, or by using general textures like those of paper or water, 'bumps' can be produced in the image which appear to bounce the light off a three-dimensional surface.

CLIPART Copyright-free illustrations, available as conventional artwork and in formats that which can be used directly in DTP-produced publications.

CLONE In a painting application, the cloning tool takes a sample of the original image, which can then be applied to, or painted over, another image. In a drawing application, subsequent changes applied to the original object (the master) are automatically applied to update the copy (the clone).

CMYK Cyan, magenta, yellow and key (black). This is the system used to describe and separate colours for printing. Other systems include RGB (red, green, blue) for transmitted colour, as on computer screens, and HLS (hue, luminance, saturation), a more theoretical description. The Pantone Matching System matches colours by mixing 11 basic colours.

COLOUR CORRECTION The process of changing the colour balance of an image to approach more closely the desired values. Images are colour corrected to make up for the differences between the response of the film and ink and the human eye and to compensate for the effects of the printing process.

COLOUR DEPTH Determines the range of colours and tones that are available in an image, and is usually measured by the number of colours displayed, e.g. 256 colours, or 16 million colours.

COLOUR DISPLAY SYSTEM The colour computer display screen itself, and the graphics card which drives it.

COLOUR GAMUT The range of colours that a device, such as a monitor or colour printer, can produce or detect.

COLOUR MANAGEMENT The process of ensuring that colour is reproduced as accurately as possible by all of the devices in a computer system. The major functions of electronic colour management are gamut mapping, device characterisation and onscreen colour correction.

COLOUR MODE A system which defines the number and kind of colours that make up a bitmap image. Black-and-White, Greyscale, RGB, CMYK and Paletted are examples of popular colour modes.

COLOUR MODEL A simple colour chart which defines the range of colours displayed in a colour mode. RGB (red, green, blue), CMY (cyan, magenta, yellow), CMYK (cyan, magenta, yellow, black), HSB (Hue, Saturation, Brightness), HLS (Hue, Lightness, Saturation), and CIE L*a*b (Lab) are examples of popular colour models.

COLOUR SPACE A virtual representation of a device or colour model's colour gamut in electronic colour management. The boundaries and contours of a device's colour space are mapped by colour management software.

COLOUR SEPARATIONS A set of films for the cyan, magenta, yellow and black components of a full colour image.

COLOUR TEMPERATURE In monitor calibration, colour temperature is the colour of light expressed as an absolute temperature (on the Kelvin scale). The white point of a monitor is defined in terms of colour temperature. 6500 K is bluish white, like daylight, while 5000 K is a yellowish white, like an incandescent bulb.

COMPOSITE IMAGE An image created from the blending of two or more other images, e.g. Photoshop's Mode options, determine which pixels in a floating selection will replace the underlying pixels, based on a comparison of the pixels. Darken mode, for example, pastes only pixels that are darker than the pixels in the underlying image.

CONTINUOUS TONE Artwork or photography containing shades of grey.

CYAN Process blue – really more turquoise in colour.

DIGITISING RESOLUTION The fineness of detail that a scanner can distinguish. Unless otherwise stated, it is the spatial resolution, reported in dots per linear inch (or dots per mm in metric areas).

DITHER PATTERN For a scanner, a pattern of dots used to simulate grey tones or intermediate colours. Also called screen pattern.

DITHERING A crude computer method of screening. Thermal wax and inkjet printers produce their colours by interspersing pixels of cyan, magenta and yellow (and sometimes black) in regular patterns, grouped together in either 2 2 or 4 4 matrices.

DPI Dots per inch, a measure of the resolution or addressability of a raster device such as a laser printer.

DRAWING PROGRAM A computer program which stores images in terms of the lines and curves used to create them. *See also* Painting Program.

DROP SHADOW A copy of an object positioned below it and offset from the original to create the appearance of a shadow. In a drawing program, the tone of the shadow can be adjusted. In a painting program, the edges can be blurred for additional effect.

EMBOSSING A finishing process producing an image in low relief.

ENVELOPING Constraining the boundaries of text or of a drawn or painted object to fit within a predefined shape.

EXTRUDING Applying a three-dimensional appearance to a selected object by adding surfaces to it. In a drawing program, the surfaces become new objects. Extruding an object creates an extrude group which includes the original object and the extruded surfaces.

FEATHER To blend or smooth the edge of a region or shape into a background or other object, especially in a slightly irregular fashion to achieve a natural-looking effect.

FOUR COLOUR PROCESS Full colour printing in which colours are approximated by various percentages of the process colours: cyan, magenta, yellow and black. A full colour image is separated by filters into four different films – one for each of the four process colours – and four plates are used for the printing.

GAMMA CURVE A graphical representation of an image, showing the distribution of pixels in the image with colour values ranging from dark to light.

GEL An image placed between a light source and a surface so that it casts a shadow on to the surface.

GOURAUD SHADING Average quality rendering method which can make polygonal meshes look smooth

HALFTONE A continuous-tone image converted to line by turning it into a pattern of dots, either electronically, by laser, or by photographing it through a screen.

HIGHLIGHT The lightest area on an image being photographed (and therefore the darkest area on the negative).

IMAGE MAPPING Projecting an image on to an object to give it a surface appearance.

IMAGESETTER A high-resolution output device, producing typesetting or whole pages on bromide paper or film.

INKJET PRINTER An output device that creates an image by spraying tiny drops of ink on to paper. *See also* Bubblejet Printer.

LASER PRINTER An output device in which black toner is attracted to an image on a drum that has been electrostatically charged by the action of a laser; the image is transferred to paper and fixed by heat.

LATHING A technique for creating a three-dimensional object with axial symmetry by first creating a two-dimensional outline and then rotating the outline around a specified axis.

LAYER Like the transparent acetates used to build up the layers of a traditional composition, the electronic layers of a drawing or painting program are used to keep elements of a composition separate from each other. The attributes of each layer, e.g. the layer's transparency, can be adjusted independently of the other layers.

LINE ART Illustrations containing only blacks and whites, with no intermediate tones (or similarly a bitonal arrangement of some other colour). Line art can be reproduced without the screening or patterning step most printing processes need to produce a range of tones.

LINE SCREEN Measurement of a halftone screen, short for lines per inch or lpi; the higher the number of lines, the finer the screen.

MAGENTA The process colour red; really more a purple colour.

MASKING Drawing a path around an area of a composition so that an effect can be applied just to that area, or conversely, applied only to the area outside the mask.

MOIRE Unwanted 'basket-weave' effects caused by superimposed regular patterns, such as halftone dots. Screens must be set at angles to minimise moiré.

OFFSET LITHOGRAPHY Usually abbreviated to offset litho, prints first on to a rubber or plastic blanket, and then on to the paper.

OPACITY The property of a layer defining the visibility of objects lying on a lower layer. The converse of transparency.

PAINTING PROGRAM A computer program which stores the image on the screen as a bitmap. *See also* Drawing Program.

PALETTE The collection of colours or shades available to a graphics system or program. On many systems, the number of colours available for use at any time is limited to a selection from the overall system palette.

PANTONE MATCHING SYSTEM (PMS) A widely used proprietary system for specifying flat colour in percentages of 11 standard colours; coordinating papers and markers corresponding to Pantone colours can also be purchased.

PEN PLOTTER A point-to-point output device used mainly for engineering drawings; if equipped with a knife in place of the pen it can be used to cut stencils for screenprinting or vinyl letters for signs.

PHONG SHADING High quality rendering method which adds better smoothing textures, shadows and subtle lighting effects to Gouraud.

PHOTO CD A product launched by the Eastman Kodak Company in 1992 which converts 35 mm film negative or slide into digital format by a high resolution scanning process and stores the images on CD. Images are stored at multiple levels of resolution, allowing users to select a version with a quality and file size appropriate to their application.

PHOTOREALISTIC Description of images that look like they could have been produced by a photographic process. For a computer image, this usually means one with good spatial resolution and sufficient colour depth (number of colours).

PIXEL Short for picture element and refers to the dot on a computer display. The resolution (sharpness) of a raster display is measured by the number of pixels horizontally by the number of scan lines vertically, e.g. 1280 1024.

PLATE A metal or plastic sheet with a photosensitive face on to which an image is chemically etched, either changing the characteristics of the surface as in lithography, or cutting below the surface as in relief or intaglio printing.

POLYGONAL MODELLING Shapes generated by meshes of small polygonal shapes which can approximate to curved surfaces.

PORTRAIT The orientation of a page when the height is greater than the width.

POSTERISE To transform an image to a more stark form by rounding tonal or colour values to a small number of possible values.

PROCEDURAL TEXTURES Object textures which are based on small mathematical algorithms and are resolution independent.

PROCESS COLOURS The four colours – cyan (pro-cess blue), magenta (process red), yellow and key (black) – used to approximate full colour artwork.

RAY TRACING A process for rendering a scene. The ray tracer sends hypothetical rays of light from the sources in the scene and calculates the visual effect for each pixel in the rendering, as rays encounter and reflect from the various objects making up the scene.

REGISTER 1. The alignment of the printed image with its intended position on the page. 2. The alignment of parts of an image with other parts, especially with parts that are printed separately, as in colour separation.

RELIEF PRINTING A printing process, such as letterpress and flexography, in which ink lies on the raised surface of the plate but not in the grooves and is transferred to the paper by pressure.

RENDER To produce an image from a model or description. Usually, this means filling in a graphic object or image with colour and brightness (or just shading for monochrome systems). Realistic rendering takes a lot of computing power and advanced techniques.

RESOLUTION A measure of the fineness and quality of an output device, usually measured in dots per inch (dpi) – the number of dots that can be placed end to end in a line that is an inch long.

RGB (RED, GREEN, BLUE) A system for specifying colour on a computer screen. *See also* CMYK.

SCALING Enlarging or reducing – usually applied to an image – and calculating the percentage of enlargement or reduction so as to anticipate the space it will occupy on a layout.

SCAN 1. To convert an image from visible form to an electronic description. Most available systems turn the image into a corresponding series of dots but do not actually recognise shapes. However, some attempt to group the dots into their corresponding characters (Optical Character Recognition) or corresponding objects. 2. Particularly, to use a scanner (an input device containing a camera or photosensitive element) to produce an electronic image of an object or of the contents of a sheet of paper. 3. A scanned image.

SCREEN PRINTING A printing process using a stencil supported on a mesh or screen; ink is forced through the open mesh but is prevented from reaching the non-image areas of the paper by the stencil.

SEPARATION Film in register relating to one of the four process colours; also artwork or film in register relating to flat colour.

SHARPEN An image enhancement that increases the apparent sharpness of an image by increasing the contrast of edges. Actually, the effect further distorts an image and its repetitive use on the same signal will create a less realistic image.

SHEAR In painting and drawing programs, to slant an object along a specified axis (much the way a type of simple italic might be made by slanting a normal upright roman character).

SKINNING A three-dimensional modelling technique which simulates the stretching of a flexible skin over a series of cross-sectional shapes or formers.

SMUDGE A feature on some graphics programs that blends colours or softens edges that are already in place in an image. The effect is supposed to resemble what would happen if the image was made of wet paint and you ran a finger over the area.

SOLARISE To change the intensity levels in an image in a way that particularly brightens or transforms the middle levels.

SPLINE BASED MODELLING Uses Bézier-like splines to define an object's surface. More precise than polygonal modelling.

SPOT COLOUR Colour that is applied only as individually specified areas of a single ink colour; compare process colour, whereby colours may be mixed and each dot of painted colour must be determined by a more complex overall colour-separation process.

THERMAL-TRANSFER PRINTER An output device that prints by 'ironing' coloured wax on to paper by the action of heat.

 The CD

The CD provided with *Digital Colour in Graphic Design* contains bitmap files of the Workshop images contained within the book. A readme.txt file catalogues the contents.

The purpose of providing the CD is to allow the purchaser to view the images as they were originally created on screen. As explained within the book, the colour printing process fundamentally differs from that used to display images on a colour monitor and, therefore, some differences will be noticed.

The CD images are provided in the widely used TIFF format so that they may be viewed on any of a wide range of painting or photoediting applications on either a PC or a Mac-intosh.

Images are provided to the purchaser for viewing purposes only. They may not be redistributed by electronic or other means or included in a product for sale.

Index